ARTISTS AT WORK

Twenty-five Glassmakers, Ceramists, and Jewelers

Dear Jane,

Maybe someday you'll have the opportunity to visit the Pacific Northwest. Until then I hope the stories and work of the Artist-Craftsmen in this book will touch the kindred creative spirit in you.

With love from your American colleague and friend. xo ♡

December 1990

ARTISTS AT WORK

Twenty-five Glassmakers, Ceramists, and Jewelers

By Susan Biskeborn

PHOTOGRAPHIC PORTRAITS BY
Kim Zumwalt

Alaska Northwest Books™
Seattle • Anchorage

Text copyright © 1990 by Susan Biskeborn
All photographic portraits of artists copyright © 1990 by Kim Zumwalt

All rights reserved. No part of this book may be reproduced or transmitted in any form or by any means, electronic or mechanical, including photocopying, recording or by any information storage and retrieval system, without written permission of Alaska Northwest Books™.

The following publisher has generously given permission to reprint "The Red Wheelbarrow" from William Carlos Williams: *Collected Poems Volume I 1909–1939:* Copyright © 1938 by New Directions Publishing Corporation. Reprinted by permission of New Directions Publishing Corporation. U.S. and Canadian rights; for British rights, refer to:
> Carcanet Press Ltd.
> 208-212 Corn Exchange Bldgs.
> Manchester, M43BQ
> England

Library of Congress Cataloging-in-Publication Data
Biskeborn, Susan.
 Artists at work : twenty-five Northwest glassmakers, ceramists, and jewelers / by Susan Biskeborn ; photographic portraits by Kim Zumwalt.
 p. cm.
 Includes bibliographical references (p.) and index.
 ISBN 0-88240-359-1 — ISBN 0-88240-405-9 (pbk.)
 1. Decorative arts — Northwest, Pacific — History — 20th century.
 2. Glassware — Northwest, Pacific — History — 20th century.
 3. Pottery — 20th century — Northwest, Pacific. 4. Jewelry — Northwest, Pacific — History — 20th century. 5. Artists — Northwest, Pacific — Biography. I. Title.
NK824.B57 1990
745'.092'2795 — dc20
[B] 90-1089
 CIP

Note:
For all reproduced art works, dimensions are given in inches, and height (H.) or length (L.) precedes width (W.), followed by depth (D.). Diameter is abbreviated as Dia.

Edited by Marlene Blessing
Cover and book design by Kate L. Thompson

Cover: Background photo of blown-glass bowl, entitled *Amethyst/Peach,* is by artist Sonja Blomdahl (photo by Lynn Hamrick). Black-and-white portraits of artists, clockwise from upper left, are of: Beth Lo, ceramist; Ken Cory, jeweler; and Ginny Ruffner, glassmaker (photos by Kim Zumwalt).

Alaska Northwest Books™
A division of GTE Discovery Publications, Inc.
22026 20th Avenue S.E.
Bothell, WA 98021

Printed in Singapore through Palace Press La Jolla.

CONTENTS

Preface	ix

GLASS 1

Sonja Blomdahl	4
Flora Mace and Joey Kirkpatrick	10
Ruth Brockmann	16
Paul Marioni	22
Ginny Ruffner	28
William Morris	34

CERAMICS 39

Kerry Moosman	42
Sarah Jaeger	50
Carol Roorbach	56
Richard Notkin	62
Akio Takamori	68
Beth Lo	74
Ronna Neuenschwander	80
Anne Perrigo	86
Marilyn Lysohir	92
Patrick Siler	98

JEWELRY 105

Florence Baker-Wood	108
Kiff Slemmons	114
Ken Bova	120
Gail Farris Larson	126
Ken Cory	130
Laurie Hall	136
Mary Lee Hu	142
Ron Ho	148

Bibliography	155
Artists' Representatives	155
Index	157

To My Dear and Loving Husband
"If ever wife was happy in a man,
Compare with me, ye women, if you can."

And in memory of Virginia Biskeborn and Michael Scott,
my kind mentors

ACKNOWLEDGMENTS

First, I want to acknowledge the help of my good friend and first reader, the gifted novelist and essayist Brenda Peterson. She gently midwifed this book at the same time she was writing two of her own, and I shall never forget that generosity.

I offer special thanks to the curators Vicki Halper (Seattle Art Museum), LaMar Harrington (Bellevue Art Museum), Penelope Loucas (Tacoma Art Museum), John Olbrantz (Whatcom Museum of History and Art), Beth Sellars (Cheney-Cowles Museum), Sandy Harthorn (Boise Art Museum), and Sheila Miles (Yellowstone Art Center); the gallery directors Mia McEldowney (Mia Gallery), Kathryn Helzer (Artifacts Gallery), Gail Severin (Gail Severin Gallery), Johanna Hays (Prichard Gallery), Roberta H. Heinrich (Sun Valley Art Center Gallery), and Leslie Ferrin (Ferrin Gallery).

In addition, I thank art critic Matthew Kangas and Alice Rooney, director of the Pilchuck Glass School; Penny Berk, director of the Pratt Fine Arts Center; Carol Roorbach, director of the Archie Bray Foundation; Julie Cook of the Montana Arts Commission; Gaetha Pace, former director of the Idaho Arts Commission; and Gail Joice, registrar of the Seattle Art Museum. I also wish to thank Richard Helzer, head of the metals department at Montana State University in Bozeman, as well as Kate Elliott, Kay Hardy, Richard Settle, Lauren Goldman Marshall, the Glass Art Society, and numerous crackerjack research librarians at the Seattle Public Library, the University of Washington's art library, and the Seattle Art Museum's library.

Thanks, too, to the jewelers Ramona Solberg and Roberta Williamson and also to the ceramists David Shaner, John Takehara, Liz Rudey, Mike Jenson, Anita deCastro, and my friends Ellen Lannon and Lethe Black, who both taught me how to look. I appreciate the gracious hospitality of Barney Jette, Joe Wheat, Robert Vasquez, J. D. Dolan, Ann Troutner, and Ross Coates. And I thank my family and friends — the soil in which I flourish — and especially Patricia Tuttle-Leavengood and David Leavengood for their assistance, Rose Pike for the amulet, and Ann Senechal, Ella Taylor, Sue Henley, and Susan Herrmann Loomis for their good advice. My particular thanks to J. Kingston Pierce, who initially published Ginny Ruffner's profile in *Washington* magazine, and to Katherine Koberg, who first published the profiles of Sonja Blomdahl and Richard Notkin in the *Seattle Weekly*.

Finally, I am grateful to the Seattle Arts Commission for awarding me a generous Individual Artist Grant to complete this book. And I extend all my gratitude to my editor, Marlene Blessing, for believing in me.

Susan Biskeborn

My first thanks go to Mary Fleenor and Dana Drake of Panda Photographic Lab for their inspired assistance with the black-and-white photographs in this book. For their support and advice, I am grateful to Ann Browder, Penny Berk, Phil Attneave, Henry Aronson, Ann Troutner, Kiff Slemmons, Breta Malcolm, John Galbraith, Ann Senechal, Claudeen Naffziger, Connie Dickinson, Lanaldo Stone; to Laurie Hall, for taking my book jacket photo, and to Flora Mace, who gave me the idea for it. I enjoyed the warm hospitality of Barney Jette, Joe Wheat, Robert Vasquez, and J. D. Dolan. Thanks all.

Kim Zumwalt

PREFACE

The cult of great ideas is dangerous and may destroy the real basis for great achievements, that is the daily, humble work within the framework of a profession.

Jean Renoir, filmmaker

Selecting just twenty-five contemporary artists for this book was a difficult, even humbling, experience, because so many talented glass artists, ceramists, and jewelers live and work in Washington, Oregon, Montana, and Idaho — the four states that make up the Pacific Northwest region of this country. Ultimately, my choices should be considered just that, and not a repudiation of the myriad of fine artists I could not include for reasons of length.

The artists profiled here are at the midpoint in their creative careers, the stage that is most interesting because it marks a foundation of hard-won accomplishment and yet a striving for even greater recognition. Unlike emerging artists, these twenty-five artists have each created a significant *body* of work, work which has not only garnered acclaim from curators and critics as well as fellowships from such organizations as the National Endowment for the Arts, but which is also shown in museums and galleries around the country.

Yet the twenty-five glass artists, ceramists, and jewelers in this book are generally not as well known as their former teachers, such established artists as Dale Chihuly, Robert Sperry, Rudy Autio, Patti Warashina, and Ramona Solberg, leaders I honor in the essays that introduce each of the book's three sections. The three introductory essays also contain short histories of contemporary glass, ceramics, and jewelry in the Pacific Northwest that detail the role played by established artists as well as such important training centers as the Pilchuck Glass School in Stanwood, Washington, the Archie Bray Foundation in Helena, Montana, and ceramic art and metal design departments in the region's universities.

Many of the artists profiled here either teach or were trained at those schools, which have encouraged young artists to view traditional craft materials such as clay and glass and traditional craft forms such as jewelry as vehicles for creating expressive, sculptural forms. And therein lies a major reason why the Northwest is known today for the excellence of its contemporary ceramics, glass, and jewelry, and why these art forms are now shown in museums and galleries that once only featured paintings and sculpture.

Although I consulted museum curators and respected gallery owners to identify artists in each state, this book is not a critical appraisal of the work of twenty-five artists. As the book's title suggests, it relates how these artists came to choose their life's work, and how they do it. May it help to dispel the Romantic-era myth of the tormented, dysfunctional artist and also give voice to more female artists and those of diverse racial backgrounds. All of the profiles are based on interviews I conducted in the artists' homes or studios in 1989 and 1990. I did not include people who primarily work on public-art commissions; rather, I focused on those who make one-of-a-kind objects.

As for the question "Is it art or craft?" — that old chestnut — I would like to comment with a favorite saying of my mentor Michael Scott, the former editor of *The Crafts Report,* a quote he always attributed to Pablo Picasso: "If it's good, it's art; if it's not, who cares?" The work of the twenty-five glass artists, ceramists, and jewelers profiled in this book is very good indeed.

GLASS

ALTHOUGH SEATTLE, WASHINGTON, and Venice, Italy, are thousands of miles apart, the Northwest's largest city and the Queen of the Adriatic have at least two things in common: in addition to the numerous waterways that ring each city, both boast a multitude of highly skilled makers of blown-glass objects. Venice's masters are heirs to a millennium of glass manufacture in that city, an industry that reached a peak of excellence in the sixteenth century, when delicate yet elaborate Venetian glass goblets and colorful beads were exported all over the world. Seattle's history is more recent: it began in 1971, when the Pilchuck Glass School was founded fifty miles north of Seattle in Stanwood, Washington. Today, according to one recent survey, over 150 glass artists live and work in the Seattle/Pilchuck area. Many of these people are the best contemporary glass artists in the world. In locating their studios near Pilchuck, they have transformed the Seattle area into the Venice of contemporary blown glass.

Pilchuck — where classes are offered solely from late May until early September — is one of the few schools in the U.S. devoted exclusively to the study of glass. Each summer it attracts students from all over the world who want to study with Pilchuck's distinguished, international faculty, including the Venetian masters Lino Tagliapietra and Pino Signoretto. Set in the foothills of the Cascade Mountains, Pilchuck's facilities are built on a forty-acre site adjacent to a tree farm. The school is named for a creek that runs through the spectacularly beautiful property. Pilchuck's land was donated by the Seattle art patrons John H. and Anne Gould Hauberg, who were persuaded to do so by an ambitious young glass artist named Dale Chihuly.

In 1971, the year the Haubergs and Chihuly founded Pilchuck, Chihuly was just thirty years old. He had recently returned from a stint of teaching glass at the Haystack Mountain School of Crafts, a summer school in Deer Isle, Maine. Inspired by Haystack, Chihuly decided that he wanted to start a summer school for glass in the Northwest, where he was raised. After receiving a two-thousand-dollar grant from the Union of Independent Colleges of Art, Chihuly approached the Haubergs and they donated the land for Pilchuck as well as additional funds.

Dale Chihuly and the Pilchuck Glass School *are* the history of contemporary glass in the Pacific Northwest. The subject of a 1987 retrospective at the Louvre Museum in Paris, Chihuly is arguably the most famous glass artist in the world. In the last fifteen years, he has produced eight different series of work, including the "Sea Forms," "Macchia" (Italian for "spotted"), "Persians," and "Venetians." The

nesting, anemonelike "Sea Forms" are his most well known series to date; the gorgeously gaudy "Venetian" vessels, based on Italian Art Deco glass, his most recent.

Chihuly now works in a converted boathouse in Seattle that overlooks a bustling ship canal. On a recent spring day, visitors at a glass conference crowded into the courtyard outside his state-of-the-art studio to watch Chihuly sketch designs of flower-and-leaf-laden "Venetian" vessels, which were then executed by Lino Tagliapietra and a lively team of ten other men. Ever since Chihuly lost the sight in his left eye after a car accident in 1976, he has relied on master blowers to realize his designs.

This collaboration between designer and glassblower was a method Chihuly saw firsthand in Italy in 1968, thanks to a Fulbright Fellowship that enabled him to work at the Venini Glass Factory in Murano. A group of islands north of Venice, Murano has been the center of the ancient Venetian glass industry since 1291, when Venice's numerous glassblowers were moved there both to protect the city from the danger of fire from the glass furnaces and also to better guard trade secrets. The Venetian glass industry was considered so important to the economy that glassmakers were forbidden by law to emigrate, for fear that they would export their technical knowledge to other countries. Even in 1968, Venice's glass industry was largely a guild system governed by secrecy, as Dale Chihuly discovered after he received his Fulbright. Although he applied to three hundred glass factories, only Venini accepted him. Chihuly thus became the first American glassblower to work at one of Venice's most respected glass factories. Chihuly has since returned the favor by inviting several glassmasters from Murano to teach at Pilchuck.

Raised in Tacoma, Washington, Dale Chihuly attended the University of Washington in Seattle, where he studied interior design and architecture. While taking a weaving class, he experimented with including bits of glass in tapestries. During this time, he also melted some stained glass and blew his first molten-glass bubble. One year after he graduated in 1965, Chihuly enrolled in the fledgling graduate glassworking program at the University of Wisconsin in Madison to study with Harvey Littleton, one of the two fathers of the studio-glass movement in the U.S.

The movement was born in 1962, when Littleton and Dominick Labino, a vice-president of research at a Toledo, Ohio, glass factory, gave two workshops on glass at the Toledo Museum of Art. During the workshops, the two men introduced small glass furnaces and a new formula for glass that would melt at a relatively low temperature, inventions that revolutionized the making of individual glass objects. Before 1962, glassmakers received their training in factories or shops, where the orientation was inevitably commercial. Although glassmaking is an ancient practice — the material was probably first used around 2500 B.C. as a decorative glaze on clay and stone beads, and glassblowing was probably invented by the Syrians at the end of the first millennium B.C. — it had come to be confined to factories because only large commercial establishments could afford the cost of fuel to heat the material. An individual craftsman could piece together stained glass (an art form that reached its apogee during medieval times in Europe), or slump and fuse glass in a kiln, or do such "cold" glasswork as engraving, cutting, or painting, but he couldn't afford to make hand-blown pieces.

Littleton and Labino's inventions meant that hot glass could now be made in small studios, and the so-called studio-glass movement began. After Littleton established the nation's first hot-glass program at the University of Wisconsin in 1963, other U.S. colleges followed suit. By encouraging individual expression and the making of one-of-a-kind pieces, programs in the U.S. have turned out some of the most innovative glass artists in the world today. For example, Dale Chihuly is a product of the campus glass movement.

After receiving an M.S. in 1967 from the University of Wisconsin, Chihuly headed east to the Rhode Island School of Design (RISD) in Providence, where he studied glass and worked as a studio assistant to Norman Schulman, who founded RISD's glass program in 1965. Nineteen sixty-eight was a significant year for Chihuly: not only was he awarded an M.F.A. in glass from RISD, but also a Tiffany Foundation Grant for work in glass and a Fulbright Fellowship to study glass in Italy. When he returned from Europe in 1969, he became the head of RISD's glass department, a post he held until 1980. Chihuly was an artist-in-residence at RISD until 1983, when he moved back to the Northwest.

Art critic Matthew Kangas has written that "Dale Chihuly is probably the greatest U.S. glass artist since Louis Comfort Tiffany," and the comparison seems apt. Chihuly's wavy "Sea Forms" as well as the serpentine vines and gilded lilies covering his "Venetian" vessels recall the fascination with sinuous organic shapes of his Art Nouveau predecessor. But Chihuly's work also demonstrates a more modern concern with form over function. By consistently emphasizing the sculptural properties of glass, Dale Chihuly has nudged this material over the boundary that has traditionally separated craft and fine art, and in so doing has inspired an entire generation of contemporary glass artists. ◆

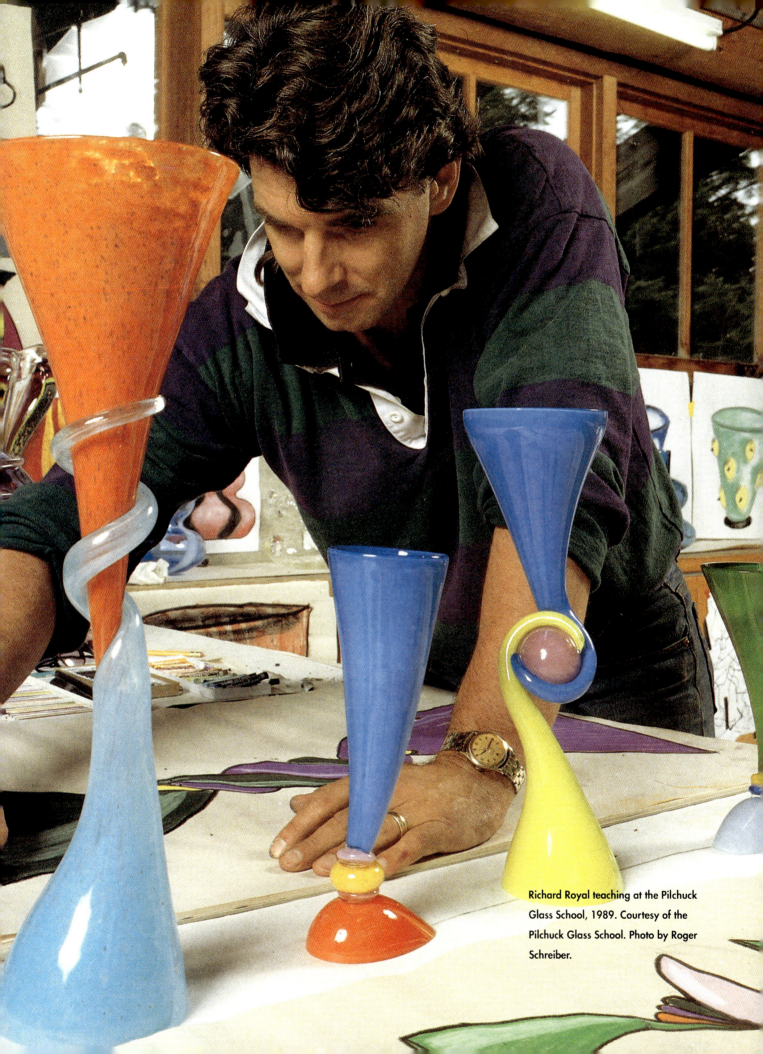

Richard Royal teaching at the Pilchuck Glass School, 1989. Courtesy of the Pilchuck Glass School. Photo by Roger Schreiber.

SONJA BLOMDAHL
Glassmaker

SEATTLE, WASHINGTON

SONJA BLOMDAHL

IF YOU WERE TO SQUINT slightly as you entered Sonja Blomdahl's glass studio in Seattle, you might think you were beholding row upon row of unearthly, beautiful UFOs, hovering in space. Once you opened your eyes, of course, it would become apparent you were actually viewing glass bowls on shelves that reach halfway toward the studio's soaring twenty-five-foot ceiling. But the glass globes are so round and their colors so ethereal it's hard to shake the illusion that they're levitating in midair.

Sonja Blomdahl's large (up to fourteen inches wide and nine inches high), gorgeous bowls are her trademark. They feature one color atop another, bisected by a thin line that clearly separates the top from the bottom, and look like a couple of half-spheres that have been yoked together. That is, in fact, what they are. Sonja learned the old Venetian technique of combining two blown-glass bubbles from an Italian master glassblower in 1978 at the Pilchuck Glass School in Stanwood, Washington. But she's taken it one step further. When she blows each bubble, she layers one color over another, so that the bowl's top and bottom are each a different color, inside and out — a total of four iridescent colors in one bowl.

Amethyst/Peach, 1989. Blown glass. H. 8½" x Dia. 12½". Photo by Lynn Hamrick.

Sonja chooses a different palette of colors for each double-bubble bowl. When light shines through, the colors blend, suffusing the piece with rainbow-hued radiance. Each bowl is as tempting as a wineglass filled with exotic fruit nectars, a notion echoed in her titles: *Mandarin/Blue-Green, Amethyst/Peach Glow,* and *Chartreuse/Pink* (all 1989).

Some people claim they detect a Scandinavian flavor in the vivid colors and clean and simple shapes of Sonja Blomdahl's bowls. Although Sonja, who is of Swedish and Norwegian descent, spent six months at the Orrefors Glass School in Sweden after she graduated from college, she insists that Scandinavian designs did not directly influence her work. Instead, she credits rainy Seattle, where she has lived since 1979, for developing her color sense and her need for color. "If you go to Greece," she says, "it's all so shockingly bright and light that you don't see color. But in Seattle, color pops out against the gray."

It's a typically dank Northwest day when I watch Sonja Blomdahl — who has been dubbed the "Queen of Symmetry" by other glassblowers — make one of her bowls. The building where she lives and works is in an industrial neighborhood near Seattle's Lake Union. Trendy restaurants have gradually replaced the lake's old dry-dock companies and ship chandleries, although Sonja's bedroom loft still overlooks a busy marine landscape of yachts, fishing boats, and seaplanes. The damp easily penetrates the building's cinder-block walls and cement floor, but it's toasty in Sonja's hot shop, at the opposite end of the building from her bedroom. That's because it's warmed by four ovens: a glass furnace filled with clear glass, a "glory hole" where Sonja reheats the glass as she works, and two annealers that she uses both to heat her colored glass and to cool down finished pieces gradually, so they will not shatter. The annealer is set at 1,000 degrees Fahrenheit, which is icy compared to the Hades-hot, 2,000-degree glory hole and the even fierier, 2,300-degree glass furnace.

Sonja Blomdahl's bowls may resemble celestial orbs, but assembling them requires some very down-to-earth hard work involving fire, breath, and constant motion. Heather Horton, Sonja's assistant today, begins the process by picking up a sticky chunk of partially melted, bright orange glass on the end of a hollow metal tube called a *blowpipe*. Sonja buys kilos of colored glass from West Germany; each foot-long bar of glass is wrapped in paper, like expensive hard candy. Heather shapes the orange glass by rolling it back and forth on a steel-topped table called a *marver,* occasionally reheating it in the glory hole. She passes the blowpipe to Sonja, then picks up a hunk of half-melted pale pink glass on the end of a *punty,* or solid stainless-steel rod.

At a signal from Sonja, Heather deposits the pink glass on top of the orange, and Sonja snips it off with shears, as if it were taffy. The blowpipe now bears a mushroom shape with an orange stem and a pink cap. Sonja works with this mushroom, marvering and reheating it, until the pink completely covers the orange. This will be the bottom of the bowl, orange inside and pink outside.

After giving a short toot into the blowpipe to expand the orangy-pink glass bubble, Sonja walks to the furnace and dips the bubble into the molten clear glass. "The mass of the bowl comes from clear glass," she says. She seats herself at her workbench, the blowpipe supported above her lap by two elbow-high, horizontal side rails capped with metal. Reaching her right hand into a pail of water, Sonja dredges out a dripping-wet scoop called a *block* and cups it around the glass as she gently rotates the blowpipe

back and forth with her left hand. "I'm working with gravity and centrifugal force," she explains. She gathers more clear glass and continues to form the bubble at her workbench with a bigger scoop.

One charred section of newspaper, folded into a square, sits on the end of the workbench. Sonja sprinkles water on it and molds it around the glass, using it like a damp hotpad, as Heather sits on her haunches and puffs into the blowpipe that Sonja slowly turns on the metal rails. Although Heather's head gracefully weaves back and forth, following the revolving blowpipe, this process doesn't look easy. "Blow, now stop," instructs Sonja. She picks up a caliperlike metal tool called a *jack* and squeezes its legs together to inscribe a line around the glass bubble, near the point where it's attached to the blowpipe. Heather gathers some clear glass on a punty and sticks it into the other end of the bubble, which has been allowed to cool somewhat. When Sonja bangs her jack against the blowpipe, the bubble easily breaks off the blowpipe and onto the punty. The bottom of the bowl is now complete.

Heather begins the process all over again to make the bowl's top (light blue inside, violet outside), and Sonja is back at her workbench, the punty across her lap. She pokes the jack's legs into the bottom bubble and, as if by magic, it flares open like a cup. Sonja uses the same procedure to open up the bowl's top when it is as large as the bottom.

Now comes the tricky part — joining the top cup to the bottom, lip to lip. "It's kind of romantic," jokes Sonja. Both must be the same temperature and their openings must be the same size when they are coupled. Sonja measures the openings by eye as she and Heather bring both halves heartbreakingly close. But the top is too small, so Heather reheats and reshapes it. The next time they measure, Sonja pronounces them a perfect fit, and they marry the two, blue-violet to orangy-pink.

"We're almost done," Sonja announces, transferring both halves — now one big bubble — to the blowpipe. Suddenly, the pace speeds up. Heather exhales into the turning blowpipe, and Sonja flattens the bottom of the bubble with first the newspaper square, then a wood paddle. After three rounds of reheating, blowing, and shaping, the bowl-shaped bubble is so big it barely fits into the fifteen and one-half-inch-wide opening of the glory hole. As Sonja has mastered the difficult double-bubble technique, her bowls have gotten larger and larger — their size limited only by the dimensions of the glory hole.

Sonja puts the bubble on a punty and pierces its top with the jack to open it up. When she is satisfied the bowl's opening is the right size and shape, Sonja and Heather crack the piece off the metal rod and place it in the annealer, where it must cool for eight hours. Although some bowls take up to one and one-half hours to make, Sonja and Heather blew this one in exactly one hour.

The next day, the eight-inch-high-by-thirteen-inch-wide bowl sits on a table in Sonja's hot shop, surrounded by all the other jewellike spheres, which weigh between five and seven pounds each. After four to six weeks of blowing glass six days a week, Sonja will shut down her furnaces for a month and choose pieces for upcoming shows. She generally blows four bowls a day, two in the morning and two in the afternoon, an exacting schedule that demands both strength and efficiency. Sonja attributes her proficiency to her size (five-foot-ten-and-one-half inches) and native physical coordination, as well as the training she received in 1976 at the famous Orrefors Glass School in Sweden. The school was operated as if it were a

Orange/Celadon, 1989. Blown glass. H. 7" x Dia. 14½". Photo by Lynn Hamrick.

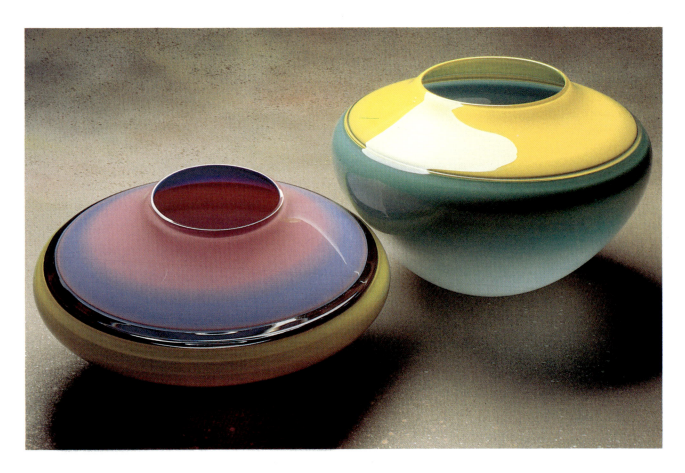

Chartreuse/Pink and *Turquoise/Yellow*, 1989. Blown glass. H. 7 1/2" x Dia. 14" and H. 9 1/2" x Dia. 14" respectively. Photo by Lynn Hamrick.

production factory: students spent their mornings blowing one item such as schnapps glasses, and their afternoons grinding and polishing. Although the work could be numbing at times, Sonja admits it taught her how to work efficiently, an ability that has proved invaluable in operating her own studio. "At Orrefors, you learned to make the glass do what you wanted it to do quickly and not wear yourself out," she says.

Before she went to Sweden, Sonja attended the Massachusetts College of Art in Boston. Her first exposure to glassblowing occurred when she was a freshman, and she relates the encounter as if it were a love story. "I was in a life-drawing class," she says. "It was May and the windows were open. I heard all this noise coming from down below, in the old foundry — a lot of laughter and activity. And it finally got to me. I couldn't just sit there quietly drawing anymore. I had to go down and see what all the excitement was about. And I went down and some students were blowing glass. It was the first time I ever saw it, and it was just like love at first sight. And it just sort of hit me then, that it was much more my style — the activity of it, and people together, and fire. I'm more of an active person and being still doesn't fit me so well. So I started blowing and I just was consumed by it."

Glassblowing was Sonja's passion, but her college didn't have a glass department, so she majored in ceramics. However, the well-known glass artist Dan Dailey taught at the school when Sonja was a senior, and she took advantage of the opportunity to study with him. After she graduated in 1974, she and two other art students started a glass studio in Stockbridge, Massachusetts, where they blew such traditional glass objects as Christmas ornaments, beer mugs, and roundels. Sonja stuck it out for

two years, even after the male partner decamped, leaving Sonja and the other female partner to brave the bitterly cold winter of 1975, when the U.S. was gripped by an energy crisis. Although the thought of living through another winter there impelled Sonja to apply to Orrefors, she values her time in Stockbridge. "I got a lot of practical training and business experience," she says. "I had never even had a checking account before that. We were all pretty green. Of the three of us, I'm the only one who still works in glass."

There's a character-revealing black-and-white photo of Sonja Blomdahl in her bathroom, taken when she was six or seven years old. It shows her standing astride her bicycle on a sandy street in Chatham, Massachusetts, the Cape Cod town where she was raised. The snapshot is unremarkable but for the forthright gaze that the child directs at the camera. The same calm look captured by the photo still emanates from her astonishingly blue eyes, a look that effectively communicates her determination and competence. For example, she arrived at Orrefors in January of 1976 with just $300, and after her six-month apprenticeship at the glass school was over, she was out of cash. So she went to work as a cleaning woman in a Swedish hospital to finance trips to Italy and the British Isles. She returned to Massachusetts, broke again, and worked in a factory, cleaning bushings for microwave ovens. When she was laid off, she blew glass in a New Hampshire glass studio for nine months, until Dan Dailey, her former college teacher, invited her to be his teaching assistant at the Pilchuck Glass School, north of Seattle.

Sonja assisted Dailey at Pilchuck for three weeks in the summer of 1978. It was during that time that she saw the Italian master blower Checco Ongaro demonstrate the double-bubble technique, which immediately appealed to her. "I liked the challenge of it," she says. "I also like round, simple shapes." Sonja honed the method for the next two years, while she worked in the Glass Eye Studio in Seattle and taught glassblowing at night at Pratt Fine Arts Center. In 1981, she had her first solo show at the Traver Sutton Gallery in Seattle, which was also the first time she was confronted with the conundrum of pricing her own work. She solved it in her typically practical fashion. "I had gone to the dentist a few days before the show and one visit was $300," she says. "So I thought, 'If the dentist can get $300 for one visit, I can get $300 for a piece of glass.' " Today, her bowls cost far more.

Her first show was such a success that Sonja decided to leave the Glass Eye Studio in 1982 and journey to Sweden with her father, who had lung cancer. After he went back to the U.S., Sonja traveled on alone until she got word that her father's condition had worsened. She flew back to Boston to be with him, and he died on her thirtieth birthday. The following year she opened her own glass studio, using money from show sales and a $3,000 bequest that she received from her father's pension fund. "My father died, and I turned thirty," says Sonja, "and it seemed like everything had gotten bad. But it's only gotten better since then."

Today, Sonja blows glass for five or six months of the year, and during that time the ovens in her hot shop are on twenty-four hours a day. Drawn to the cozy warmth, Sonja's two cats creep into the shop after the last bowl has been placed in the annealer to cool overnight and the assistant has gone home. And that's when you will see a pretty sight — an orange calico and a black cat sprawling among the splendor of Sonja Blomdahl's bowls like feline pashas lounging amid opalescent soap bubbles. ◆

JOEY KIRKPATRICK AND FLORA MACE
Glassmakers

SEATTLE, WASHINGTON

FLORA MACE AND JOEY KIRKPATRICK

WHEN FLORA MACE MET Joey Kirkpatrick at the Pilchuck Glass School in the summer of 1979, Joey was carrying a whole armful of figurative drawings she had already shown to Dale Chihuly, the now-renowned glass artist who at that time was Pilchuck's artistic director. Twenty-seven-year-old Joey had traveled all the way from Iowa that summer to attend classes at Pilchuck, which is fifty miles north of Seattle in Stanwood, Washington. She had just completed one year of graduate study in glass, although her bachelor's degree was in drawing. She approached Chihuly with her sheaf of watercolor drawings because she wanted to learn how she could transfer her images to glass, but he referred her to his thirty-year-old teaching assistant, Flora Mace. Flora specialized in the tricky process of applying drawings composed of glass threads to blown glass, a method she had developed five years earlier as a graduate student.

Flora knew from experience how difficult it was to incorporate finely detailed imagery into molten glass, and as she studied Joey's delicately rendered drawings, her heart sank. It might take years, she thought, before Joey acquired enough technical skill in glass to duplicate the sensitive lines of those drawings. But Flora Mace is no quitter; she simply suggested that they invent an entirely new technique. Handing Joey a roll of wire, Flora advised her to bend it to match the contours of her drawings. After Joey finished that task, they heated these wire outlines and colored them in with variously hued glass threads, much the way a metalsmith would use overlays of enamel to fill in the spaces between the wire segments in cloisonné jewelry. Then they embedded the colored outlines — vibrant drawings of tumbling and running figures — on the sides of molten glass containers.

And so started a unique collaboration that persists to this day. Although the complexity of working with blown glass necessitates teamwork, Flora Mace and Joey Kirkpatrick are the only two glass artists in this country who co-sign their pieces, which have become increasingly sculptural over the years. As partners who both live and work together in Seattle, they acknowledge that they bring diverse but compatible strengths to the work. Both freely admit that Joey, who still paints and draws, is more conceptual, while Flora is more technically accomplished. In fact, Joey attributes the success of their longtime collaboration to

Vegetable Still Life, 1989 (detail). Blown glass. Photo by Robert Vinnedge.

their differences — the manifestation of their divergent upbringings in Iowa and New Hampshire.

As they talk about their childhoods and how they came to be glass artists, Flora's New England twang provides a counterpoint to Joey's Midwestern drawl. Flora Mace grew up on a farm in Hampton, New Hampshire, a resort town on the Atlantic Ocean. Her family earned a living by working with their hands; in addition to raising sheep, chickens, and ducks for their own table, they fished and clammed, selling their catch to local restaurants. Flora considered attending an agricultural college, but she was also interested in art, so she entered Plymouth (New Hampshire) State College as an art education major. She financed part of her college costs by shearing sheep in the spring.

After receiving a B.S. in 1972, Flora found herself balking at the idea of teaching, so she jumped at an opportunity to represent the U.S. as a member of the International Farm Youth Exchange. For nearly one year, she lived with rural families all over Norway, explaining American farming techniques.

During this time Flora visited a Norwegian glass factory, and her pragmatic nature immediately responded to the technical aspect of the process. "I was thrilled," she remembers, "because I had never seen glass being made before. It was really interesting. It was like going to a car factory as a kid; it's amazing to see how a car is made."

Upon returning to the U.S., Flora enrolled as a graduate student in sculpture at the University of Illinois in Urbana/Champaign. As a sculptor, Flora knew how to weld, so she helped build a glass furnace for the school. Soon after, she began blowing glass herself. She earned an M.F.A. in sculpture and glass in 1976.

Joey Kirkpatrick's route to glass was equally as circuitous as Flora's. Raised in Des Moines, Iowa, Joey decided as a child to be an artist. Her mother's sister was a painter who lived in Chicago, and one summer Joey visited this aunt, who took her along when she attended art classes at the Chicago Art Institute. In the fifth grade Joey followed her older sister's lead and began working after school and during the weekends and summers at her hometown museum, the Des Moines Art Center. At first she assisted the instructors by laying out materials for art classes, but by the time she was in high school, she was teaching life-drawing and mixed-media classes at the art center.

Joey majored in drawing at the University of Iowa in Iowa City and received a B.F.A. in 1975. For three years afterward, she taught at the Des Moines Art Center and painted in her grandmother's basement. Then she caught the glass bug. She had learned how to blow glass months before she graduated from college, and in 1978 she commuted twice a week to nearby Ames, where she enrolled at Iowa State University's fledgling glass program, which was part of the ceramics department.

The next year, Joey attended classes at Pilchuck, where she encountered Flora and began their partnership. By the following year, Flora and Joey were teaching at Pilchuck — the first female instructors to teach hot glass at this prestigious summer school for glass, founded by Dale Chihuly in 1971. They have continued to teach at the school, a forty-acre campus at the edge of a tree farm sited in the foothills of the Cascade Mountains.

In 1981, Flora and Joey built a rustic cabin on Pilchuck's property, and lived there until 1984. During those years, they taught at Pilchuck in the summers, and the rest of the year concentrated on their work — glass

To Bear Fruit, 1988. Blown glass and wood. H. 29" x W. 25" x D. 19". Photo by Robert Vinnedge.

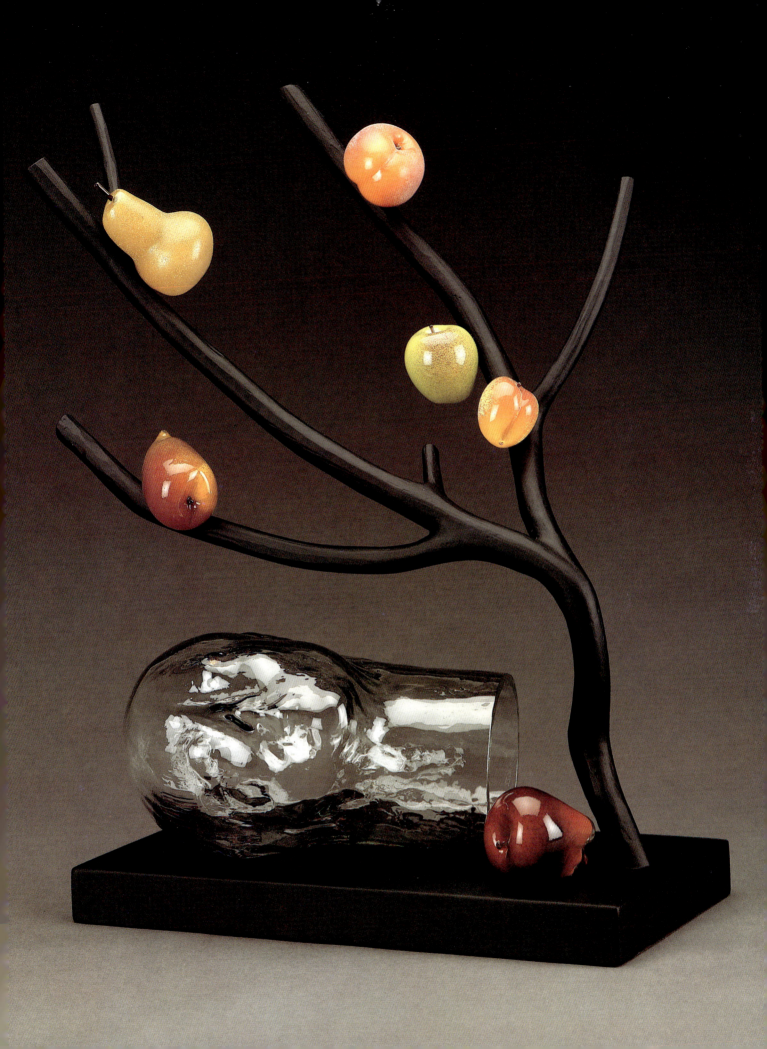

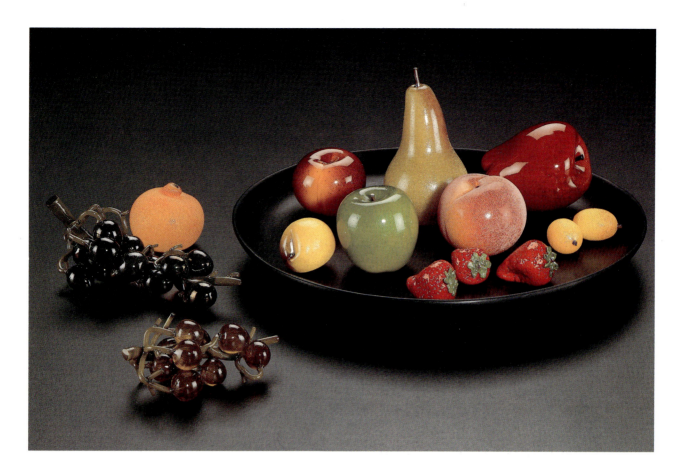

Fruit Still Life, 1989. Blown-glass fruits and wood bowl. H. 8" x W. 24" x D. 16". Photo by Robert Vinnedge.

vessels featuring their signature wire drawings. After a few years, frustrated by the confines of the container and influenced by Pilchuck's arboreal landscape, they began constructing skinny seven- or eight-foot figures from wood they scavenged in the forest near their cabin. Soon after, they made similar elongated figures from milk-white glass.

A slender, blown-glass cylinder served as the body, topped by a tiny doll-like head formed by blowing molten glass into a handmade plaster mold. Facial features — wide eyes and Clara Bow lips — were inscribed and painted on the heads, which resemble Victorian doll faces made of porcelain. After Flora and Joey joined the heads and bodies, they stood a solitary figure on a slate base and grouped it with wooden objects. The sculptures are deliberately stark; apart from the androgynous white figure, the pieces are hueless, a reaction against what Joey perceived as the "prettiness" of their previous work.

Flora and Joey moved to Seattle in 1984, and both their home and studio now overlook Lake Union, which is ringed with ship chandleries, sail lofts, and boat marinas. Affected by this new landscape, Flora and Joey started incorporating nautical imagery into their pieces. At about this time, in studying slides of their work, Joey realized that she particularly liked the close-ups of the figures' heads. And so she and Flora began making bigger glass heads, some of which were white, some clear. Divorced from the figure, these slightly-larger-than-life-size heads are mounted upright or lying on their sides in environments that include oars and bark-stripped tree branches. Sometimes, Flora and Joey painted these branches black. Gradually, they began introducing more color into their sculptures — a green-glass leaf here, a blue ball there.

In 1987, Pilchuck appointed Flora and Joey artists-in-residence, which meant they could use the school's facilities for free to create their own work. Walking across the glass school's campus one day, Joey suddenly turned to Flora and suggested that they include blown-glass fruit in their sculptures. Flora's initial reaction was negative. She remembers sneering, "Joey, no one's doing *fruit*." But when it became clear what Joey had in mind — beautifully colored, realistic-looking pieces of fruit — Flora became intrigued with the idea as a design problem.

At first, Flora and Joey limited themselves to creating simple forms such as apples, plums, and pears, which they included as elements in such sculptures as *To Bear Fruit* (1988) and *Nature's Laureate* (1989). But as their skill increased, they added more fruits and even vegetables to their repertoire. Seeing a grouping of these lusciously colored, ripely mottled glass objects, it's hard to believe they aren't edible. Flora and Joey now blow potatoes, persimmons, plums, small pumpkins, red peppers, oranges, lemons, limes, Bartlett and Bosc pears, Concord and muscatel grapes, Delicious and Granny Smith apples, apricots, strawberries, kumquats, eggplants, mangoes, tangelos, and nectarines. Besides the full-sized versions they arrange in wood bowls as still lifes, Flora and Joey also make smaller fruits and vegetables, which serve as stems for their gorgeous, hand-blown goblets.

Joey says that the concept of creating fruit sprang from a desire to include everyday imagery in their work. "I wanted to be more celebratory of everyday objects," she explains. "And also remind myself, and hopefully the viewer as well, that our visual experiences during the day, every day — like a bowl of fruit on a table — are something to rejoice in."

Watching Flora Mace and Joey Kirkpatrick conjure pieces of hand-blown fruit is to witness a dazzling display of teamwork, skill, and artistry. To create a Bosc pear, Flora gathers a bubble of beige glass that she shapes with tools and Joey blows into it until it resembles the long-necked pear. Then Joey dusts it with five different applications of colored glass powder: first green, then bright yellow, red, and finally bright yellow and another shade of yellow. Joey uses an ordinary tea strainer to sift the colored powders onto the pear, which Flora turns this way and that. "It's like brushing pigment on glass," says Joey. She applies the red to just one area, to give the pear a slight blush. In between applications of powder, Flora reheats the pear in a furnace, melding the powders into the glass. However, she minimally heats the final dusting of yellow, so the mottled pear will have a realistically matte surface and rough texture.

On a table near Flora and Joey's work station is a bowl of ghostly white fruit, a recent venture in pure sculptural form. More recent still are twenty-inch cylinders decorated with still-life drawings made of glass threads — pieces that not only recall the vessels with wire drawings that began their partnership, but also investigate fresh expressions of technique. If anything is a hallmark of the work of Flora Mace and Joey Kirkpatrick, it is a willingness to try something new. "As artists, our job is to explore," says Joey.

And Flora adds a different, though congruent, metaphor: "We're kind of like the tide; Joey has her ideas of what she would like to portray, and I have some of my own ideas, and depending on whose energy is a little stronger at a particular time is which way it fluxes." ◆

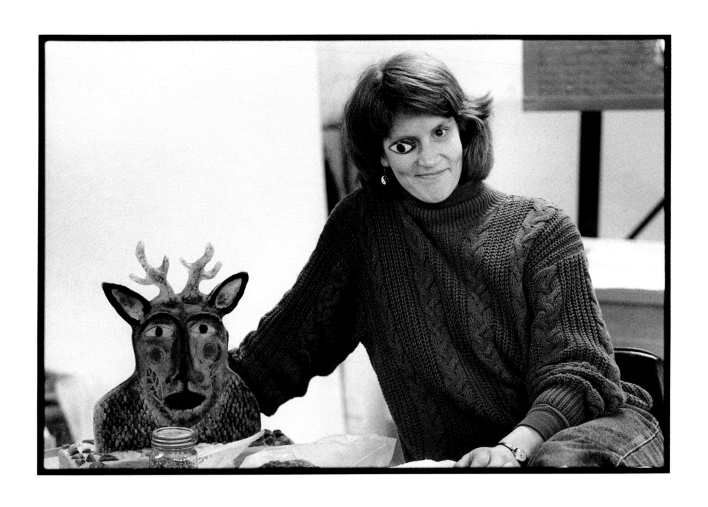

RUTH BROCKMANN
Glassmaker

PORTLAND, OREGON

RUTH BROCKMANN

The Magician, 1983. Fused and slumped glass mask with fired gold lusters. H. 16" x W. 11" x D. 6". Photo by Roger Schreiber.

RUTH BROCKMANN HASN'T set foot on the Barren Islands since she was a teenager, when she and three companions were rescued by a U.S. Coast Guard helicopter — even though she crewed seasonally on fishing boats in Alaska for years afterward to help support herself as an artist. She still owns her hand-drawn map, though, that pinpoints the desolate place where she and her friends buried treasures washed up on the Barren Islands by the Japanese current, sturdy objects made of a fragile material that Ruth eventually chose as her art medium.

Ruth came to be stranded on the Barren Islands in 1974, when she was nineteen years old, because she took a break from college and went to see her older sister, a public-health nurse living in Homer, Alaska, a small fishing village on the Kenai Peninsula, south of Anchorage. On the third day of Ruth's visit, a friend of her sister's mentioned he needed a cook for his crab boat's next outing. Ruth had never worked as a cook, but she had prepared meals for her father and three brothers since she was thirteen years old, the same year her mother died and her sister left home for college. And because she grew up in Vancouver, Washington, a Columbia River town near the Pacific Ocean, Ruth had often accompanied her father and his buddies on deep-sea fishing outings. So she didn't hesitate — she gamely volunteered to cook for the *Widgeon II*'s crew of seven.

Once the crab boat left Homer, it headed south, picking up pots filled with gigantic Alaskan king crabs, some spanning nearly two feet from claw to claw. The captain had invited two friends along on the fishing expedition, and when the boat reached the tip of the Kenai Peninsula, he suggested a side trip to the nearby Barren Islands, which are known for their wild beauty. Ruth and the captain and his two friends put ashore in a skiff equipped with camping gear and food, and the *Widgeon II* went off to harvest more crabs; it was to pick up the foursome in two days. But the early spring weather quickly turned blustery and the U.S. Coast Guard ordered the *Widgeon II* back to Homer.

Meanwhile, Ruth and her companions, unaware they were marooned, amused themselves by feeding wild foxes and gathering Japanese floats and sake bottles, which they planned to bring back to

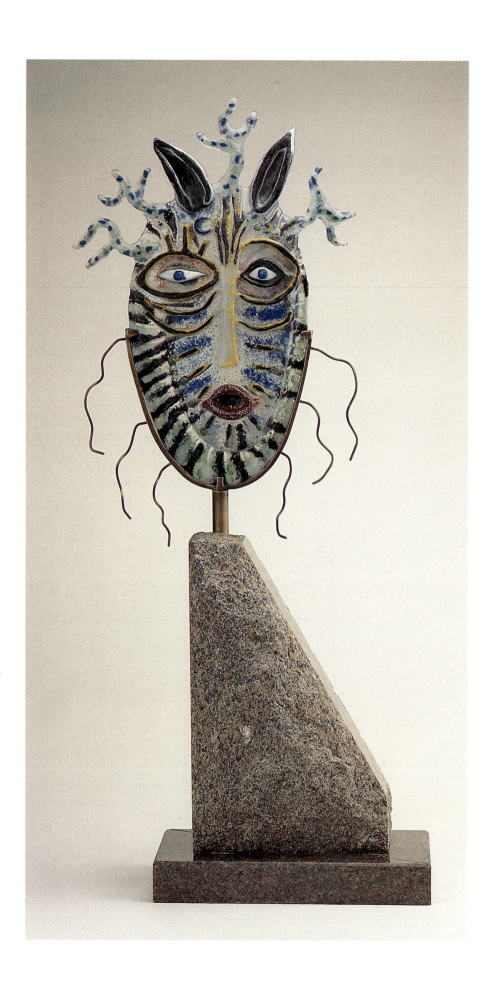

civilization. They were assembling their glass cache when a small Coast Guard helicopter landed near them; its pilot unloaded food and survival suits and told them that another, larger helicopter would arrive to ferry them back to Homer within twelve hours. Spying the glass cairn, the pilot added that the rescue helicopter wouldn't be able to carry the weight of any extra cargo, other than what they could stuff in their pockets.

To pass the time until they were rescued, Ruth and her friends buried their gathered glass and drew a map locating the secret treasure. Although she hasn't returned to the Barren Islands since then, the brief time she spent there bore fruit. Today, Ruth — still as lanky as a teenager — is a glass artist who lives in Portland, Oregon. Since 1982, she has made fused-glass masks and sculptures, which resemble colorful carvings in ice. Perhaps it's not surprising to learn that Ruth connects the glass and ice, given her adventure on the Barren Islands.

"I see glass as frozen water," she explains. "And I see things in nature that could be glass — water, puddles, reflections, ice, rain, ripples. Water and glass are both mirrors, and what I do is a mirror of myself in one way or another, of some part of me."

After Ruth returned from the Barren Islands, she spent the next eight years working aboard commercial fishing vessels during the summer and fall seasons in Alaska, and many of her masks and sculptures reflect that experience. For example, fish earrings dangle from earlobes on some masks, and in *Shaman with Whale Spirit* (1984) the form of an orca breaches the smiling shaman's forehead.

Before she began working with glass, Ruth made leather items and batik wall hangings and sold them from her home when she wasn't in Alaska. She lived in Vaughn, Washington, then, a town on the Key Peninsula in Puget Sound. She and her now-former husband, the glass artist Richard LaLonde, bought ten acres of rural property there soon after they met in 1976, and began building their own house and studio. In 1979, when the two buildings were complete, they started a business — designing, assembling, and installing leaded, stained-glass windows commissioned for homes, restaurants, and churches. Richard had taught himself how to assemble stained glass after reading an article in *Sunset* magazine, and he taught Ruth the process as well. For the seven months of the year when they weren't working on separate fishing vessels in Alaska, Ruth and her husband made commissioned windows as well as their own individual leaded-glass pieces. In addition, they tended their garden, canned fruit and vegetables, and raised sheep, geese, rabbits, and chickens for their table.

Things continued in this way for three years, until 1982, when a slump in the construction market dried up orders for leaded-glass windows. Ruth and Richard decided that one of them should forgo fishing that summer and attend to their business, so they flipped a coin, and Richard went to Alaska. A few months later, Ruth was invited to attend a glass-fusing workshop at the Bullseye Glass Company in Portland, Oregon, which manufactured the sheet glass Ruth and Richard used in their stained-glass windows. Unlike a leaded-glass window, in which the glass pieces are not heated but rather yoked together by soldered lead cane, glass fusing entails heating glass shards together in a kiln.

During the glass-fusing workshop, Ruth created a portrait of a woman, but she didn't like its flat surface. So she placed it on top of a rounded mold and reheated it in the kiln until it slumped over the form,

Moon Deer Renewal, 1989. Frit cast glass, metal, and granite. H. 41" x W. 18" x D. 7½". Photo by Roger Schreiber.

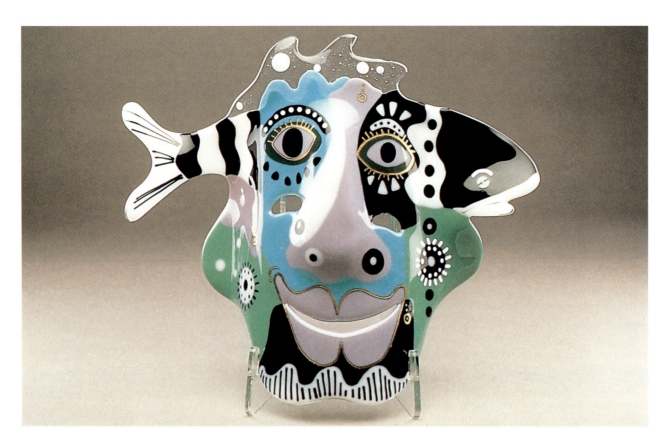

Shaman with Whale Spirit, 1985. Fused and slumped glass mask with fired gold lusters. H. 14" x W. 16" x D. 5". Photo by Roger Schreiber.

the way an oven-hot caramel cookie will droop around a rolling pin. Ruth's face-sized, curved glass portrait gave her an idea — she would construct fused-glass, slumped masks.

Back in her studio, Ruth cut shards of colored glass into different shapes — noses, eyes, eyebrows, ears, spiky hair — and arranged them on top of and alongside each other, like pieces in a jigsaw puzzle. When she heated her assemblage, the jigsaw pieces fused into a portrait. After it cooled, she balanced this flat portrait over a mold and reheated it, to slump it into the shape of a mask.

In their playful fracturing of facial features, Ruth's masks resemble cubist paintings. The likeness extends even to her "Shaman" masks, which often depict imagery indigenous to the Pacific Northwest. Like Northwest Coast Indian legends, which tell of a time when animals such as raven, as well as humans and spirits, could assume different forms, Ruth Brockmann's masks are concerned with transformation. Many of her "Shaman" masks, for example, include both animal and human characteristics, a combination Ruth observed in the totem poles that she saw in museums and field sites in Alaska. "I've always been attracted to the Northwest Indian culture and arts," she says. "I remember when one of the dams was being built on the Columbia River, my family went to see some of the Indian petroglyphs before they were going to be completely flooded over."

Magic, mythology, and metamorphosis also figure in Ruth's series of "Genie" masks. According to Muslim demonology, genies were spirits that could adopt human forms. Ruth's "Genie" series began with *Best Wishes* (1983), a present to her younger brother when he married. One of Ruth's most flamboyant masks, it is adorned with a beard of human hair as well as necklaces and earrings of brass bells and glass beads. Some genie masks

sport three pairs of eyes, and others mischievously stick out their tongues. In fact, many of Ruth's masks feature protruding tongues, a gesture that reminds her of childhood.

Personal experience figures in Ruth's "House" masks, as well. Made between 1987 and 1988, during a time when Ruth lived alone after her marriage dissolved, they were her way of bidding farewell to the home and life she and her husband had created together twelve years before.

After she sold her house and land in 1988, Ruth lived in Seattle for one year before moving to Portland, and during that time she adopted a new way of working. Instead of fusing cut-glass shards and then slumping the flat glass image over a mold, Ruth switched to packing a plaster composition mold with *frit,* glass particles ranging in size from rock salt crystals to fine powder. Ruth makes her frit from glass scraps saved over the years; she grinds glass, one color at a time, in a Maytag garbage disposal and then sifts the resulting particles through mesh screens to separate them by size.

Ruth begins each piece by modeling an image in clay or wax and then using it to create a refractory mold composed of plaster, silica, and heat-resistant fiber. This mold is a negative of the original image. Employing a technique developed by French artists at the turn of the century, during the Art Nouveau period, Ruth fills the mold's cavity with frit, layering the pieces of colored glass to fill in facial characteristics and define designs. In effect, Ruth paints her mold with glass pebbles, much the same way that pointillist artists stippled their canvases with pigment. Only, Ruth's glass pieces meld together in the kiln, which is where the mold is placed once it's packed. The result is a cast-glass sculpture, polished after it cools to smooth the surface.

A trip to the Baja peninsula in Mexico in the winter of 1989 supplied the imagery for a recent series of cast-glass sculptures, which Ruth calls her "Deer People." In Baja, Ruth visited caves and viewed ancient paintings of deer. The images so haunted her that when she returned home, she projected slides of the cave paintings onto her studio walls and painted the images. She also researched mythology on deer and found that the animal was considered an emblem of the birth-giving goddess and symbolized rebirth because of the annual loss and regrowth of its antlers.

Soon after, Ruth began casting glass sculptures of deer heads. In contrast to her vividly colored masks, the hues in this work are more muted. In addition, the sculptures are backed with clear glass, which allows a ghostly glimpse of the deer's face, even when the work is viewed from behind.

Because the deer sculptures — which bear such titles as *Passage* and *Breath of Life* (both 1989) — concern death and rebirth, Ruth decided to mount them on granite bases made of broken or rejected gravestones that she buys from monument yards. (Reasons why gravestones are discarded include misspelled names or incorrect dates.)

For example, *Rebirth of Tree Goddess* (1990) sits atop two carvings inscribed for a twenty-one-year-old woman who was a student of the Cabala, a medieval, mystical Jewish text. One stone, decorated with a tree of life symbol, rests on a plinth that reads "The Tree, Her Path . . ."

By combining stone and glass in her work, Ruth Brockmann continues on a path that may have begun over fifteen years ago, when she gathered glass on the windswept Barren Islands, and took the time to notice what endures. ◆

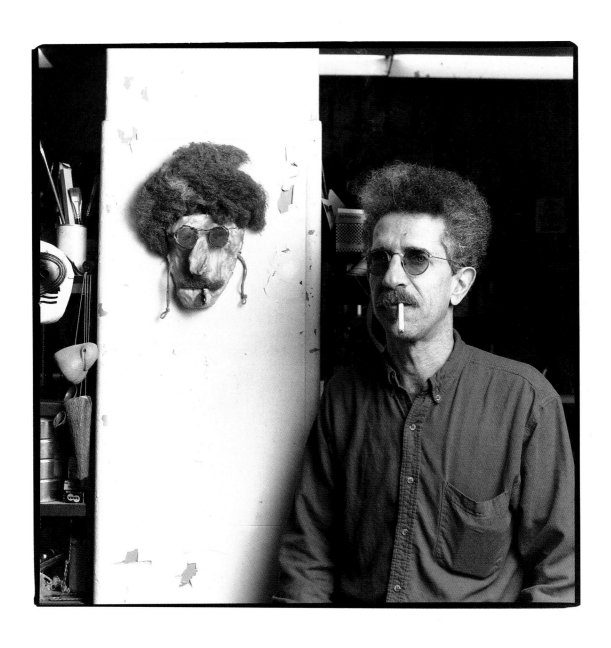

Paul Marioni
Glassmaker

SEATTLE, WASHINGTON

PAUL MARIONI

IT'S UNLIKELY THAT Hollywood would ever make a movie about the life of Seattle glass artist Paul Marioni — a casting director would be hard-pressed to duplicate his frizzy halo of hair or his scratchy voice, the oral equivalent of beard stubble — but if it did, the credits would have to include a nod to the Teamsters Union. After all, it was Paul's membership in the union that persuaded him to become an artist.

Paul belonged to the Teamsters for the three years he worked as a body-and-fender repairman for a car dealership in San Francisco. Even though he was the only one in the shop who had not only studied poetry with Donald Justice but also had a B.A. degree in English literature and philosophy, Paul was good at fixing cars. That's because he had tinkered with hot rods ever since he was a teenager growing up in Cincinnati, Ohio, in the fifties. (He was born in 1941.) And in college at the University of Cincinnati, he supported his wife and two small children by buying wrecked cars and then overhauling and reselling them.

So when he couldn't find a job in his field after graduating from college in 1967, he and his family moved to San Francisco, where his brother Tom lived, and Paul got a job in the car dealership. Things did not run smoothly. As Paul recalls, he was "ridiculously arrogant and independent" in those days, and he consistently came in to work late and left early. He also demanded a pay raise every three months. He always got what he asked for, though. In fact, his boss secretly paid him wages that were above the union scale because he valued Paul's specialty — repairing cars that had been completely totaled. The other repairmen, who all hammered out small dings and dents, owned huge rolling cabinets filled with an assortment of tools. They often wondered aloud how Paul could fix cars smooshed by trucks or trains with the few tools stored in his suitcase-sized tool chest. Paul used to reply, "Because the toolbox fits in the left hand and the right hand's free to wave goodbye."

After he was bodily ejected from a Teamsters meeting for

Hiroshima, 1985. Cast glass. H. 15". Photo by Paul Marioni.

persistently questioning the union president, Paul got to thinking. Two of his three brothers were artists — his older brother Tom was a sculptor and his younger brother Joe a painter — and Paul realized that although they didn't make much money, they spent their time as they wished.

Increasingly, Paul's time was occupied with movies. A class with the San Francisco filmmaker Robert Nelson spurred Paul to make two black-and-white, 16-millimeter films: *Self-Portrait*, a three-minute study in optics and motion, and *Hole*, a pseudodocumentary about a man obsessed with holes. In 1970, Paul and his wife divorced, and he quit his Teamsters job. Soon after, he was awarded custody of his son and daughter, who were six and four years old at the time.

As a parting gesture to his days as a body-and-fender repairman, Paul stretched a 1963 Corvair on an automobile frame rack until it split in half. The event was documented by Robert Nelson, who released the film as *R.I.P.;* it premiered in San Francisco in 1970. Not long after, Paul met a glass artist at a street fair who recognized him from the film. This woman and Paul became friends, and she taught Paul how to cut pieces of colored glass and assemble them with solder to make leaded-glass windows. Paul liked it so well, he gave up filmmaking and devoted all his time to glass.

In 1972, he had his first glass show at a gallery in San Francisco, which created quite a sensation. Both *Artweek* and the San Francisco *Chronicle* reviewed the solo show of twelve leaded-glass windows and wall pieces. One window, *Howling at the Moon,* contained color photo

Bagman 1 & 2, 1989. Blown glass. H. 12" and 13". Photo by Roger Schreiber.

transparencies laminated between two thin pieces of clear glass. Stained-glass purists who painted on glass or pieced shards together to form a picture were scandalized that Paul used ready-made images.

"It had never been done before," says Paul. "But I couldn't paint — I'd never taken a drawing class, I'd never been to art school — so I found another road. I had a clear vision of what I wanted to make, and I didn't know how to make it, so I found ways, invented ways of expressing my vision. All the glassmakers at that time were the traditionalists doing church work. I didn't care about the traditional ways, because I didn't like the traditional work."

The following year, Paul learned how to blow glass at the California College of Arts and Crafts in Oakland, whose glass department was headed by Marvin Lipofsky, a pioneer in the U.S. "hot glass" movement. Some ten years earlier Lipofsky had introduced glassblowing classes at the University of California at Berkeley, one of the first schools in the country to offer such courses.

While teaching at the California College of Arts and Crafts in 1974, neophyte glassblower Paul Marioni came up with one solution to a problem that has plagued glassblowers for centuries — how to put a detailed picture on molten glass. One day Paul simply used masking tape to write his first name on one side of a multilayered piece of glass. Then he sandblasted around his masked-off name, through one layer of the glass, until his name remained in raised relief, as if he had cut a cameo. Finally, he

heated this cameo name and applied it to a bubble of molten glass. As he blew into the bubble to expand it, his name (which came out backward on this first try) melded into the hot glass and got bigger and bigger, the way a picture drawn on a balloon will enlarge as the rubber inflates. Two years later, with the support of a fellowship grant from the National Endowment for the Arts, Paul refined his invention further at a German glass factory. He was granted a U.S. patent for the process in 1977.

In 1978, after receiving a public-art commission for a cast-glass window in a Seattle community center, Paul moved north to tackle another problem: developing a quick, inexpensive, and efficient mold for casting molten glass. Metal molds had traditionally been used for casting glass, but the expense of that method was better suited to duplicating repeated images from one mold, whereas Paul planned to make some thirty different molds. The Spectrum Glass Company in Seattle invited Paul to work out the problem at its factory, and he spent five months there in 1979. He experimented with a number of materials, including zirconium, but couldn't devise a satisfactory solution. In fact, he nearly blew himself and four co-workers to oblivion when he radically reduced an industrial formula for graphite and it became volatile.

Finally, Paul remembered a quote of Albert Einstein's — "When you get a simple answer, you know it's God speaking" — and he switched to sand-casting. In 1980, he installed his commission, a clear, cast-glass window called *The Boxers*, in Seattle's Delridge Community Center, which houses a boxing program. *The Boxers* depicts a boxing match and spectators. Ever since he made that piece, Paul has used a sand-casting method for most architectural cast-glass commissions, which he now designs and executes with the glass artist Ann Troutner.

Ann and Paul live in a former telephone-exchange building in Seattle. An ever-roaring glass furnace in the basement heats this sixty-year-old edifice, which contains the studios and apartments of two commercial fishermen, a few performing artists, and a handful of other glass artists, including Paul's son Dante Marioni, famous in his own right for his "Etruscan" vases. Some of those tall, brilliantly colored vases line shelves that reach toward the eighteen-foot ceilings in Paul and Ann's living room and hold their extensive glass collection, mainly castoffs or trades with other artists.

Grouped together on one shelf are some of Paul's pieces from "Visitors from Neptune," a show held in August 1989 at a Seattle gallery that coincided with a historic event in the U.S. exploration of outer space — the time the spacecraft *Voyager 2* flew past Neptune and transmitted photographs of the planet back to earth. "I think the space program is the single achievement of modern humanity," says Paul, whose oldest brother is a retired aeronautical engineer who formerly worked on designing reconnaissance satellites.

"Visitors from Neptune," a series of blown-glass vessels and sculptures, features Paul's whimsical pictures of imaginary inhabitants of that planet. The cast of characters includes *Captain, Navigator, Pilot, Crew, Cook, Poet, Poetess, Alchemist, Singer,* and *Trader,* as well as wry self-portraits such as *Stargazer* and *Greeter.* All the drawings of these glass creatures were affixed to the blown glass, using Paul's patented process.

Two characters are especially haunting: *Bagman* and *Baglady,* fringed glass faces with tiny ears, almond-shaped eyes, beaky noses, and downturned mouths that resemble Paul's mustache. It's the kind of owlish

Greeter, 1989. Blown glass. H. 11".
Photo by Roger Schreiber.

face a child would draw on a paper bag and make into a mask. It's not surprising, then, to learn that Paul connects this character with paper bags — "disposable luggage," he calls them — as well as homeless people and even the Watergate and Mafia "bagmen" who carried the money for illegal payoffs.

"Visually, the *Bagman* figure is based on a Cree Indian figure that I've interpreted in my own way," Paul explains. "The Cree figure is called *Wetigo* and it represents kind of cabin fever; it's not a friendly spirit, but it's not a dangerous one either. The Cree live in the extreme northern part of Canada and they use this figure in a ritual dance. All I've seen is a photograph of a Wetigo costume. It's a leather hood that essentially comes down to the waist, or a little below. And it's a complete, enclosed hood, it covers the face and has arms and fringe on the sides and two little ears on top, like a dog, kind of. And a long, droopy, pointed nose."

Paul walks over to a shelf and picks up a small, kiln-cast *Bagman* and holds it up to the sun that streams in through a nearby window. In the light, the opaque, reddish figure suddenly changes color and glows blue, as if touched by a wizard's wand. The reason this *Bagman* changes its hue in the sunlight is that it's made of dichroic, or two-colored, glass, which is thinly coated with various metals and minerals. The coating affects certain wavelengths of the visual spectrum, depending on whether light is reflected or transmitted. Developed for the aerospace program, dichroic glass was first used in lasers and solar cells before it was discovered by glass artists.

Although he understands the scientific explanation for why dichroic glass changes color, Paul prefers to attribute the transformation to magic. "I love mystery," he says, turning his *Bagman* this way and that, openly admiring the feat of optical sorcery. And then this former Teamster, an inventive, iconoclastic Trickster, grins and adds, "Mystery and magic are the two keys to my work." ◆

GINNY RUFFNER
Glassmaker

SEATTLE, WASHINGTON

GINNY RUFFNER

SEATTLE GLASS ARTIST Ginny Ruffner likes eyeballs — single ones rimmed by a fringe of long lashes. She's also partial to plump hearts and molars, roots and all. Snakes and carrots show up in her work, too.

"I like carrots a lot," she says. "I mean, not to eat. To eat they're okay, too, but I just think they're great objects. I like them like I like all the other root vegetables. Whenever I had a garden, that's all I grew because they're a surprise. They're hiding under the ground and you pull them up and there they are. They're like vegetables of the subconscious."

If her symbol-laden glass sculptures are any indication, Ginny Ruffner has more fun with her subconscious than most of us. For example, *If You Square Dance with Your Fears You Can Make Them into a Charm Bracelet* (1987) features a skeleton holding a lightbulb and surrounded by a tooth, an outstretched palm, a heart, an eye, a question mark, and an olive. *The Tornado of the Heart Cast Out of the Conversation* (1989) bristles with little corkscrew shapes edged with wings and hearts and apples. Most of Ginny's colorful glass scuplutres measure from twelve to twenty inches in both height and width, and are typically six to ten inches deep.

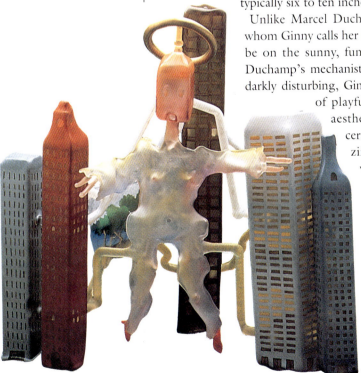

The Goddess of the Thanksgiving Day Parade Blesses the Architecture, 1989. Glass and mixed media. H. 20" x W. 21" x D. 16". Photo by Mike Seidl.

Unlike Marcel Duchamp, the absurdist Dada artist whom Ginny calls her hero, her subconscious seems to be on the sunny, funny side of the street. Whereas Duchamp's mechanistic assemblages are prankish yet darkly disturbing, Ginny's glass constructions are full of playful images that recall the Funk aesthetic favored by West Coast ceramic artists. In a national magazine Ginny once described her work as "user-friendly sculptures that wear too much eye makeup but really know how to have a good time in a bar."

In a field that has been dominated by men who make Serious Glass Vessels, Ginny Ruffner has reinvented the wheel. Rather than hand-blowing her glass, she softens, shapes, and fuses glass rods and tubes in the heat of a

ARTISTS AT WORK

Making Peace with Green, 1988. Glass and mixed media. H. 22" x W. 14" x D. 8". Photo by Mike Seidl.

flame. This technique, known as lampworking, was used in the eighteenth century to make Venetian glass beads, and in the nineteenth and twentieth centuries to manufacture everything from scientific apparatuses and glass eyes to paperweights and carnival souvenirs such as glass animals and ships.

Because of its commercial associations, lampworking used to play second fiddle to hand-blowing in glass art. But Ginny Ruffner's work has helped change that attitude. Her witty sculptures are taken very seriously indeed in the art world these days. The subject of numerous solo exhibitions in respected galleries and museums across the country, Ginny has also participated in several major public art projects in Seattle. In 1989 Absolut Vodka commissioned her to create a piece for its national print ad campaign, which had previously featured work by such famous painters as Keith Haring and Andy Warhol. The Absolut assignment came about because of Ginny's own initiative. "I called them up and sent them my resume and slides," she says matter-of-factly.

With her wide eyes and curly blonde hair, Ginny has the face of an angel and a drawl as smooth as Karo syrup. Born in Atlanta in 1952, she grew up in the small town of Fort Mill, South Carolina, once headquarters of Jim and Tammy Bakker's PTL Club. But her Southern charm doesn't obscure her obvious intelligence and drive. "I have always, always been directed," declares Ginny. "I always knew that I wanted to be an artist. Period. The end."

One summer afternoon, I sat beside Ginny in her studio as she heated a transparent glass tube over the flame of a gas-oxygen torch. Holding the glass tube by its tapered end, she turned its flared, open end this way and that over the blue flame, as if she were toasting a marshmallow. When she cut lengthwise into the flared-open top with scissors, the two flaps she created flattened out until it looked like she was gripping a flyswatter. "I'm not sure what it's going to be, actually," Ginny mused over the background whoosh of the torch.

Next, she frilled the flyswatter's edges with a glass rod. Then she pulled the four ends until they extended into points. It didn't resemble a flyswatter anymore. Finally, she quickly touched the center of the flat part with a rod four times, raising four buttonlike bumps. It looked like . . . "a little dress," announced its maker. A hand-sized version of the tiny tabbed dresses that children wrap around paper dolls. "What I'm thinking is that I can put a nude figure behind it," Ginny said with a laugh.

With that, she put the finished piece in an annealing oven near her work table so the dress would cool down at a gradual temperature. (If it were to cool in the open air, it would shatter.) It had taken her one hour to make the small dress.

Ginny sandblasts her pieces, which finely pits the surface and allows her to draw and paint on them with a variety of materials — pencil, colored pencil, watercolor, acrylics, oils, graphic marker dye, enamels, crayons, and pastels. Afterward, they're sprayed with a fixative so that the colors are permanent. Ginny estimates it takes as much time to paint and draw on her pieces as it takes to make and sandblast them.

"I will take a flat sheet of glass and draw on it so that a chair, say, really looks like a three-dimensional chair," she says, "so that you almost have to touch it to find out that it isn't three-dimensional." Sure enough, the drawing of a stuffed green armchair in *Making Peace with Green* (1988) is so convincing you'd swear you could set a thumb-sized figure in it.

After seeing examples of Ginny's considerable drawing ability, it's not

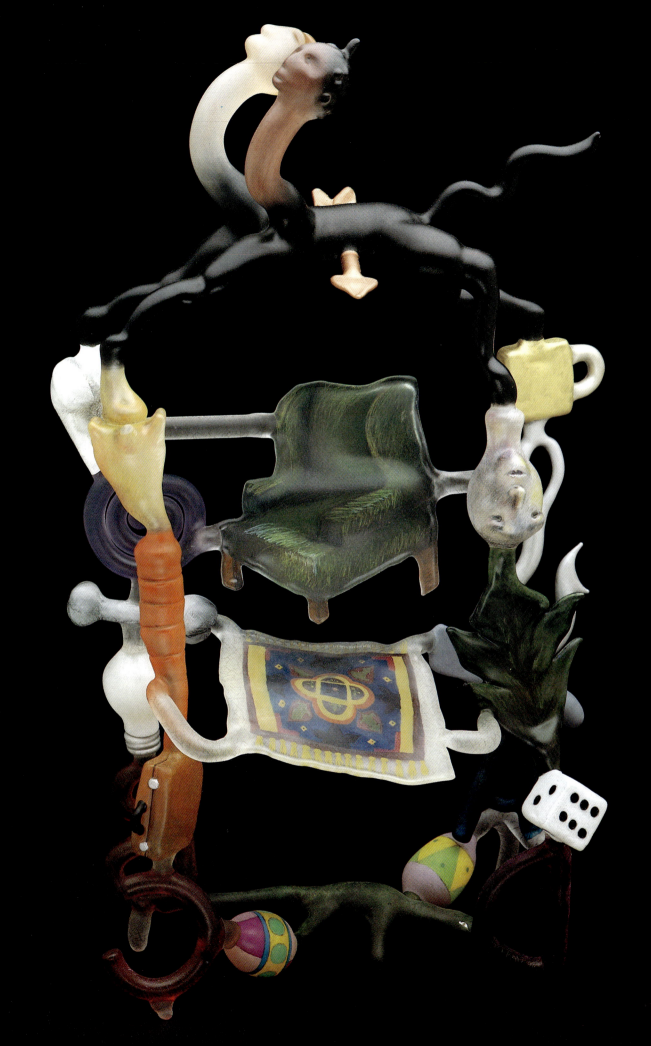

surprising to learn that both of her degrees, an M.F.A. (1975) and B.F.A. (1974) from the University of Georgia, were in drawing and painting. But what's amazing is that because the schools in her small hometown didn't offer any art classes, Ginny had no training until she was a senior in high school. That's when she took a children's art class at the nearby Mint Museum in Charlotte, South Carolina.

"Everybody else in the class was in the fifth grade," she recalls. "But it was the only place to take art. And we had these little dorky projects, but I had never had anything like that — NOTHING! I had no knowledge of materials. My parents bought me paints, they were always real supportive, but buying a box of paints is one thing, what to do with them is another."

Ginny first became interested in glass in graduate school after seeing reproductions of Marcel Duchamp's *The Bride Stripped Bare by Her Bachelors, Even,* an enigmatic, freestanding construction of objects such as wire and cloth, sandwiched between two glass panels, which is also known as *The Large Glass*. Ginny had been trying to figure out a way to get more light into her paintings, and the transparency of glass appealed to her. "Duchamp made me think about possibilities," she says. "He gave me a diving board that had an awful lot of spring in it. When I jumped up and down on it, it sent me into the ionosphere."

After she earned her M.F.A. in 1975, Ginny worked at a stained-glass studio in Atlanta. But stained glass bored her, so she talked her way into a job as a glassblower and engraver at another Atlanta studio. She went on to work at yet another glass studio in Atlanta before moving to Seattle in 1985, one year after she first taught at the prestigious Pilchuck Glass School, north of Seattle.

Since she has lived in Seattle, Ginny's work has become both more representational and flamboyant. So have her titles, which have grown from one-word affairs (*Consummation, Marriage, Scorn,* and *Transcendence*) to great domino lines of words: *The Goddess of the Neon Tetras Shows Off Her New Oven Mitts; The Theory of Evolution, Before Animals Descended from the Trees; The Tunnel of Love Wears Heartbreak Pyjamas,* and *The Road to Architecture Is Paved with Chandeliers*. "As the pieces have grown more complex, the titles have, too," she says, a fact she attributes to her lifelong love of reading.

"When I was a little kid, I used to read five books a week and my parents were worried about me," remembers Ginny, the oldest of four children. Her father was a career FBI agent and her mother a typing teacher. "They'd say, 'Go play outside,' so I'd go sit outside with my book. You can ask me about a book that I read ten years ago and I can tell you my vision of what the inside of the house looked like, or what the characters were wearing, or what it smelled like when they were cooking. I don't have a TV and I don't really like movies that much. And the reason is that they don't *give* you nearly as much for your imagination."

The phone rang and Ginny answered it in her spacious loft apartment, a few doors down the hall from her studio. Both are in a downtown Seattle building filled with artists' studios and lofts. The novelist Tom Robbins, a former boyfriend, was on the phone. He and Ginny talk on the phone every day at lunchtime, when he reads her what he wrote in the morning. The main character in his book, *Skinny Legs and All,* is based on Ginny.

After she said goodbye to Robbins, Ginny showed me one of her notebooks. Messy, chock-full of smudgy sketches in pencil or colored pen,

the notebook also contains single words or paragraph-length descriptions or stories.

"The notebook drawings have a lot of words in them," Ginny explains, "because with words you can retain the *idea* in a sketch without tying yourself to a specific image. In other words, I can write 'chair' without drawing a chair. My dreams come in, too. I have really elaborate dreams. So a lot of times I will use an image or a whole story from a dream." As she continues flipping the notebook's pages, I read this fragment: "I dreamed they wanted me to be president. I didn't want to, I was nude. I fainted when I came to."

Sometimes a piece starts with a title. Other times, Ginny designs a whole piece around an object she wants to make, as was the case with the central figure in *The Goddess of the Thanksgiving Day Parade Blesses the Architecture* (1988). The aforesaid goddess, ghost-bodied and crowned by an industrial-strength halo, is encircled by five skyscrapers that showcase Ginny's mastery of color, painting, and form.

Many of Ginny's pieces contain edifices, a preoccupation with architecture stemming from a desire to buy a building to house her living and working space. "Whatever happens to me in my life always gets into my work," she says. "I did a great heartbreak series when I had a broken heart." Even Ginny's Isuzu pickup, Susie, was immortalized in a 1987 piece — the flower-bedecked *My Pickup Truck in the Garden of Eden*.

Some writers have described Ginny's work as whimsical, a word she dislikes. "The reason is that it implies a lack of thought, a capriciousness," she says. "However, I believe very strongly in humor. Humor teaches things and teaches them in a more palatable way than beating people over the head. If something makes you laugh, it's considered a second-class citizen in the art world. I disagree with that vehemently."

Ginny has excelled in an artistic medium that is as male-dominated as sculpture. She is often the only woman exhibitor in many glass shows. A feminist, Ginny puts her money where her mouth is by employing two female assistants. "My assistants have always been female," she says. "I think it's harder for women artists to make it in general, harder for them to get jobs to support their art. Men can support themselves with manual labor, which pays a lot more than waitressing does. And so I have always hired, and *will* always hire women to work with me for that very reason — because I believe in supporting them."

As one of the few women who has made it in the glass field, Ginny Ruffner has developed her own idiosyncratic iconography that is seriously silly. And where does she get the ideas for her innovative pieces? "Well, I don't know where my ideas come from," she says. "I think they come from Mars or something. You just notice them. All of a sudden they're sitting in your brain, like the Cheshire Cat." ◆

WILLIAM MORRIS
Glassmaker

STANWOOD, WASHINGTON

WILLIAM MORRIS

WILLIAM MORRIS FELT restless. By now — this was in 1978 — he was a junior in college and it seemed like he was just spinning his wheels. More than anything, he wanted to learn about the intricacies of working with molten glass, but circumstances had conspired against him thus far. For instance, after Bill graduated from high school in Carmel, California, he entered California State University in Chico, where he planned to enroll in the glass program. But it was difficult for an undergraduate to get into the popular glass classes, and besides, Bill discovered he couldn't abide the head of that department. So he studied ceramics until the glass teacher departed on sabbatical, and then switched to glass.

Although Bill had taken classes in both ceramics and glass in high school, he much preferred glass. For one thing, this youngest child of five liked making glass objects because it demanded teamwork. Glass also appealed to him because it called for plenty of physical activity. An avid rock climber, Bill was the youngest person to scale the northwest face of Half Dome, a sheer granite rock in California's Yosemite National Park that is nearly one mile high. He accomplished this feat with a girlfriend in 1975, when he was only eighteen years old.

Now, three years later, he was a student at Central Washington University in Ellensburg, Washington, where he had transferred after two years of college in California because he was tired of living in his home state. Unfortunately, he had transferred to a school without a viable glass program — the school's sole glass instructor had died in a car accident. Unable to quickly find a replacement, the university had assigned its woodshop teacher to the post, even though this man knew nothing about glass. However, he did know the bursar of the prestigious Pilchuck Glass School, located fifty miles north of Seattle, and when he learned that Pilchuck needed a summer driver, he urged Bill to apply for the job.

Bill got the job, and it marked the turning point in his life. He never went back to college, but instead stayed on

Artifact Still Life, 1990. Glass, blown and worked offhand. H. 21½" x W. 25" x D. 18". Photo by Robert Vinnedge.

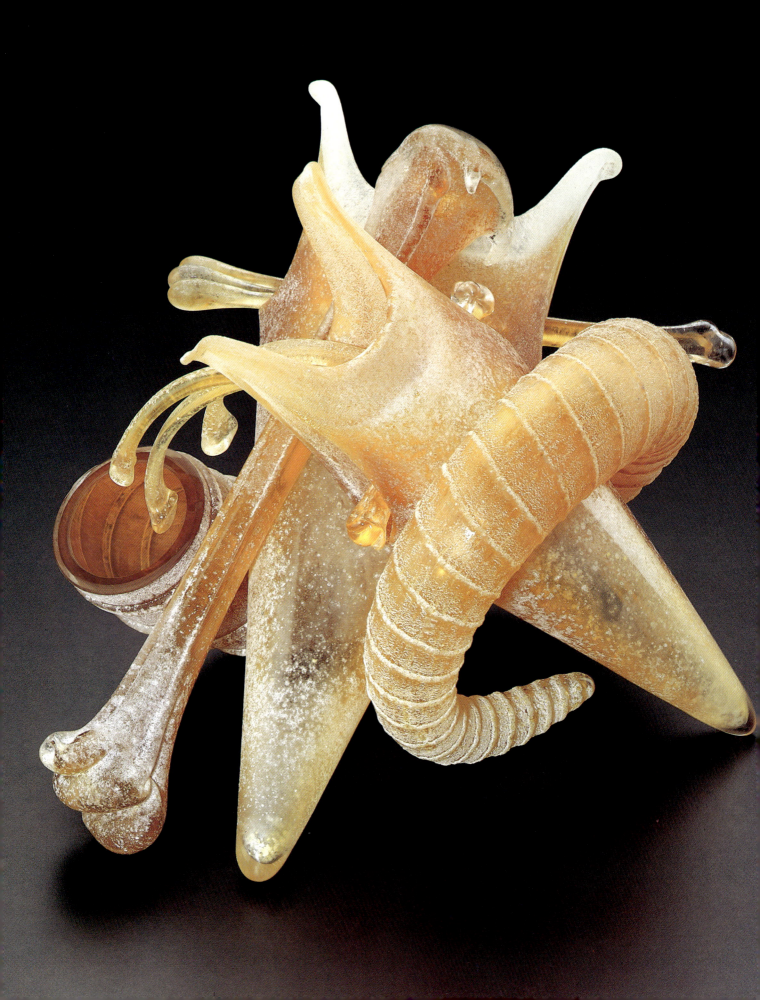

at Pilchuck, where he received an enviable education in the art of making glass. For ten years Bill worked alongside Dale Chihuly, Pilchuck's founder and artistic director as well as this country's most famous glass artist. Today, William Morris is Pilchuck's assistant artistic director and a respected glass artist in his own right, whose elegiac glass sculptures and vessels are exhibited in galleries and museums all over the world.

Bill was just twenty-six years old when he made his first significant series of work, fifteen- to twenty-inch-high blown-glass vessels covered with brooding drawings of standing stones and stone circles. These drawings, composed of glass threads applied to the molten surface, were inspired by megaliths Bill saw on trips he took with Chihuly to Brittany in France, England's Scilly Islands, and especially Scotland's Orkney Islands. Unlike Stonehenge in southern Great Britain, the Orkneys' remote prehistoric monuments are still surrounded by wilderness. In describing their setting, Bill's voice conveys the excitement he felt upon encountering them on the Isle of Hoy. "Nothing there grows higher than heather," he says. "And it's barren and windswept and the seas are swift and the weather's just wild. And there are these HUGE standing stones out in the middle of nowhere in these perfect circles in these beautiful shapes. The whole picture is really overwhelming. It's just the way it's been for the last four thousand years."

The "Stone Vessels" series was soon followed by actual "Standing Stones," massive and angular glass sculptures created by blowing forty- to sixty-pound bubbles of glass into three- or four-foot-tall wooden molds designed by Jon Ormbrek, Bill's longtime friend and member of his glass team. Jon, whom Bill describes as "a wizard maker of anything," crafts all of Bill's tools and exhibition brackets, and executed the detailed drawings on Bill's recent series of "Petroglyph Vessels." After Jon interprets Bill's sketches of animals and hunters in powdered glass on a metal plate, the plate is heated on top of a gas burner and Bill rolls a molten glass cylinder once over the colorful petroglyph drawing, as if he were picking up sand on a sticky lollipop. As Bill blows into the glass bubble to expand it, the drawing enlarges, too, the way an image would on an inflating balloon. The petroglyph drawings — fighting stags, grazing bison, and spear-toting figures — reflect Bill's interest in hunting. Each fall, he hunts for elk and deer by himself, armed only with a bow and arrow. Sometimes he makes coats or blankets from animal skins for his son and daughter, who were born in 1984 and 1986.

The "Petroglyph Vessels" also possess the mystery and expressiveness of Indian rock carvings, which Bill first spied as a child roaming the hills and valleys near his home along central California's coastline. He and his two brothers and two sisters would spend whole days scouring Indian burial sites for arrowheads, primitive tools, pottery, and bones. Bill no longer owns any of those unearthed treasures, but he has recently fashioned his own versions in glass. Bill's "Artifacts" series, begun in 1988, includes ghostly groupings of glass tools, urns, upright talismanic figures, huge mastodon ribs and tusks, animal and human skulls, and armorlike breastplates and helmets.

Some of the "Artifacts" are as shiny and shimmery as icicles, while others are chemically coated to give them a patina like that found on long-buried, ancient glass. Bits of gold foil are occasionally incorporated into the coated pieces. Arranged on tables in an empty workshop at the Pilchuck Glass School, ready to be shipped east to upcoming shows in Chicago,

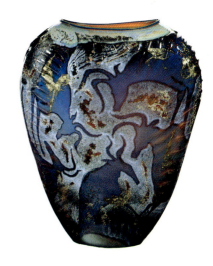

OPPOSITE:

Artifact Still Life, 1990. Glass, blown and worked off-hand. H. 13" x W. 15" x D. 16". Photo by Robert Vinnedge.

ABOVE:

Petroglyph Vessel, 1990. Blown glass. H. 26½" x W. 21" x D. 7". Photo by Robert Vinnedge.

Boston, and Washington, D.C., the "Artifacts" look as if they were just excavated by an archaeological team.

Meanwhile, the team that actually made these "found" objects creates more in Pilchuck's adjacent hot shop, as the glassblowing studio is called. Using tools to shape and stretch molten glass, Bill and his assistant Paul DeSomma employ sculptural techniques they learned from Venetian glassmaster Pino Signoretto during a trip to Murano, Italy, in 1988. Already a skilled glassblower, Bill traveled to Italy's glass center — and took Paul with him — to study how to manipulate solid masses of molten glass so he could build, rather than blow or cast, glass sculptures. Venetian glassmasters like Signoretto use the method familiar to only a few U.S. glass artists to fabricate such virtuoso pieces as torsos and horse heads.

Even with its numerous roaring glass furnaces, Pilchuck's hot shop, an open-sided, shedlike building, is cold on this early March morning. Sheets of tacked-up plastic screen out a sudden snowstorm, but snowflake showers sift into the studio through the peaked roof's large opening, designed to ventilate furnace-generated heat in the summer months, when school is in session. As one of Pilchuck's directors, Bill lives and works on campus, and he takes advantage of the nine months when students aren't in attendance to concentrate on his own work. Four days a week, he and his team, which also includes Karen Willenbrink, are in the hot shop from six in the morning until four in the afternoon.

Pleased with one "Artifact," a helmet big enough to fit a Brobdingnagian, Bill and Paul and Karen promptly make another. After blowing two large glass bubbles and forming each into a bowl, they join the two bowls, lip to lip, and open one end of the double bubble so it becomes an even bigger bowl. Flattening and widening the sides a bit so that the piece resembles a helmet, they also pierce two holes in the giant helmet's lip, on opposite sides. Then Karen flips open a booklet of gold foil, presenting the paper-thin sheets to Bill, who delicately plucks them out with a large, tweezerlike tool called a *jack*. As Paul twirls the helmet on a blowpipe, Bill randomly places gold foil here and there, flattening the scraps against the surface with the rounded end of the jack. One snippet of foil escapes and floats upward, like a butterfly riding a thermal. Satisfied he has applied enough foil, Bill sprinkles the piece with a chemical mixture that etches and finely pits the glass but doesn't affect the foil.

By midafternoon, the snow stops and the sun emerges, warming the studio so much that Bill strips down to a sleeveless T-shirt. An impromptu barbecue has been organized nearby, and the tantalizing smell of sizzling pork ribs wafts into the hot shop. Jon Ormbrek wanders in, a beer in hand, waiting for the ribs to finish grilling. Once they do, Jon piles some onto a plate, and feeds a few pieces to Bill as he works. It has been almost two hours since Bill and his team began making the helmet, and after Bill signals that it's done, Paul places it in a kiln called an annealer to cool down gradually. Immediately after, Bill grabs a few more ribs and heads for the empty workshop where his "Artifacts" are stored to discuss exhibition brackets with Jon.

A few diagrams later, they have agreed how to anchor upright pieces such as an eight-foot-by-ten-foot mastodon rib cage — a mammoth glass version of the barbecued pork ribs they are gnawing. Contemplating the tusks and tools and talismans, the urns and helmets and bones scattered on various tables, Bill muses, "These pieces that I make are the kind of artifacts I would like to find. For me, putting them together is like the finding." ◆

CERAMICS

Patti Warashina. *Sea Escape,* 1987. Clay and mixed media. H. 23" x W. 36" x D. 18". Photo by Roger Schreiber.

WHEN THE TIME COMES for critics and curators to assess the art produced in the U.S. during the last half of the twentieth century, American ceramics will undoubtedly be accorded pride of place alongside sculpture and painting. No longer a mere stepchild of the fine arts, contemporary American ceramics is increasingly recognized as an impressively vital art form in its own right, one that includes both sculptural and painterly elements, yet boasts its own unique artistic traditions and history.

Entire chapters in the history of contemporary American ceramics were written in the Pacific Northwest, beginning with a landmark workshop in 1952 at the Archie Bray Foundation in Helena, Montana. The "Bray," as it is affectionately known, is a ceramic art center founded in 1951 on the site of a brickyard and named after the company's president and manager. Three distinguished visitors conducted the Bray's

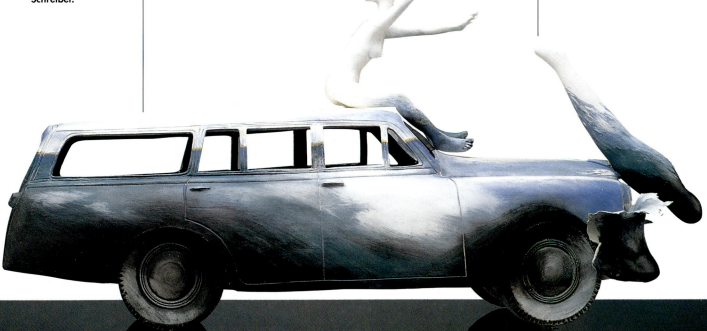

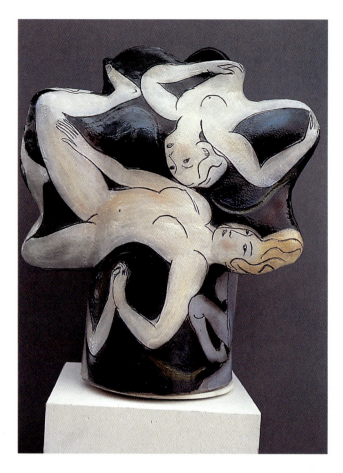

LEFT:
Rudy Autio. *Follies,* 1990. Stoneware. H. 34¾" x W. 30" x D. 24". Photo by Rudy Autio.

ABOVE:
Robert Sperry. *Plate #916,* 1989. White slip over black glaze. Dia. 27". Photo by Robert Sperry.

week-long workshop in 1952: the British ceramist Bernard Leach and two Japanese colleagues, Shoji Hamada and Dr. Soetsu Yanagi.

Leach, a Japanophile and student of Zen Buddhism, was already known to American artists through *A Potter's Book,* his philosophical and technical exposition on the ceramist's craft, published in 1940. Hamada and Yanagi — one a potter, the other the founder of the *Mingei* or Japanese folk-art movement — were esteemed in Japan, but relatively unknown in the U.S. before they toured with Leach. As the trio traveled around the country from Los Angeles to North Carolina, Yanagi and Leach discussed Zen Buddhist aesthetics and Hamada threw and painted pots. The three men attracted large crowds wherever they went, but they particularly affected two young resident artists at the Bray — Peter Voulkos, born in 1924, and Rudy Autio, born two years later — who had recently earned M.F.A.'s from the California College of Arts and Crafts in Oakland and Washington State University in Pullman, respectively.

Autio, the son of a Finnish miner, and Voulkos, the son of Greek immigrants, grew up in Montana. Both studied ceramics as undergraduates at Montana State University in Bozeman with Frances Senska, whose own work reflected the "good design" principles of the Bauhaus School. Founded in 1919 in Germany, the Bauhaus School espoused the making of well-made, useful objects for the masses. A migration of Bauhaus-trained artists fleeing wartorn Europe influenced post–Depression-era design in this country; "Fiesta" ware is probably the most famous example of a Bauhaus-inspired, functional design.

Leach, Yanagi, and Hamada advocated a more Zenlike, or mystical and intuitive, attitude toward clay, one that favored the subtle, natural look of wood-fired stoneware as well as simplicity and spontaneity, asymmetry and even accident. Hamada's loose, free treatment of clay, with its implicit emphasis on risk and expression coupled with technical ability, bowled over both Autio and Voulkos. As Autio — who is now famous for his colorful figurative vessels painted with deftly drawn nudes and horses — has written, "Hamada showed how he could energize form and surface by very simple means, with finger marks made on a pot after one or two spins of a potter's wheel, or with simple brushstrokes when decorating."

Voulkos also took this hands-on, spontaneous approach to heart, although when he left Montana in 1954 to head the ceramics department at the Los Angeles County Art Institute (now the Otis Art Institute), he went on to embrace another kind of spontaneity — abstract expressionism. In the mid-fifties Voulkos ushered in a brave new world in ceramics by slashing, poking, and painting his pots, which he treated as canvases for personal expression. Voulkos's

revolutionary work helped liberate contemporary American ceramics from the constraints of strict functionalism and European-influenced design. He taught for many years at the University of California at Berkeley, and still lives in California.

After Voulkos left the Archie Bray Foundation, Autio stayed on another three years as director, before assuming a professorship of ceramics and sculpture at the University of Montana in Missoula, a position he held until his retirement in 1985. He lives in Missoula and continues to make his painterly ceramic sculptures.

Voulkos and Autio, the first directors of the Archie Bray Foundation, have been succeeded in that post by a number of respected ceramists, including Ken Ferguson (born in 1938), who now heads the prestigious ceramics department at the Kansas City (Missouri) Art Institute, and David Shaner (born in 1934), a studio potter living in Bigfork, Montana.

In the summer of 1954, Robert Sperry, a twenty-seven-year-old painter who had just graduated from the Art Institute of Chicago, arrived at the Archie Bray Foundation. He spent that summer learning how to throw clay on a potter's wheel and working with Rudy Autio and Peter Voulkos. Sperry was on his way out to Seattle, to study with the Swiss artist and ceramist Paul Bonifas, the head of the ceramics department at the University of Washington. After he received an M.F.A. in 1955, Sperry taught in that school's ceramics department, which he headed from 1960 until he retired in 1982. Under his leadership, the ceramics program at the University of Washington developed into one of the nation's most innovative. Sperry lives in Seattle with his wife, the ceramics sculptor Patti Warashina.

Sperry's most significant body of work is a series that he began in the 1980s — black-glazed wall panels and plates painted with white slip, or liquid clay. The all-over, black-and-white brushwork in these pieces demonstrates Sperry's affinity for abstract expressionist paintings and the gestural slipwork of Japanese ceramics, an affinity he shares with numerous ceramists of his generation, including Peter Voulkos and Rudy Autio.

During Sperry's tenure at the University of Washington, he presided over a younger generation of students and teachers, many of whom were stimulated by a more outrageous aesthetic called *Funk*. Funk originated in the San Francisco Bay Area in the late 1960s, and dominated American ceramics into the 1970s.

Two perpetrators of Funk in Seattle were Fred Bauer and Patti Warashina, students who received their M.F.A.'s in ceramics from the University of Washington and then taught there. Bauer, born in 1937, made such irreverent ceramic items as cameras with penis lenses and a teapot with a plastic bicycle-grip handle and reflector lid. He left the University of Washington to teach at Mills College in Oakland, California, in 1970.

Patti Warashina, born in 1939, now heads the University of Washington's ceramics program. She is known for her surrealistic tableaux, populated by white, doll-like figures, although her recent figurative sculptures are more statuesque, standing at least eight feet in height.

Howard Kottler, the Northwest's high priest of Funk, taught at the University of Washington from 1964 until his death in 1989, at the age of fifty-nine. Kottler covered his kitschy, nonutilitarian ceramics with everything from garish glazes to wood-grained contact paper to Last Supper decals. Several of his former students, including Anne Perrigo, have won national recognition as ceramics sculptors.

Numerous other men and women have contributed to the Northwest's stellar reputation for contemporary ceramics. They include John Takehara in Boise, Idaho, F. Carlton Ball in Tacoma, Washington, and Bennett Welsh in Portland, Oregon, just three of the many artists and teachers discussed in depth in LaMar Harrington's exhaustive *Ceramics in the Pacific Northwest: A History* (University of Washington Press, 1979). The fine ceramists who have lived and worked in the Pacific Northwest during the last fifty years have left an enduring mark on the history of modern art. Their legacy is as durable as the fired clay in which it is written. ◆

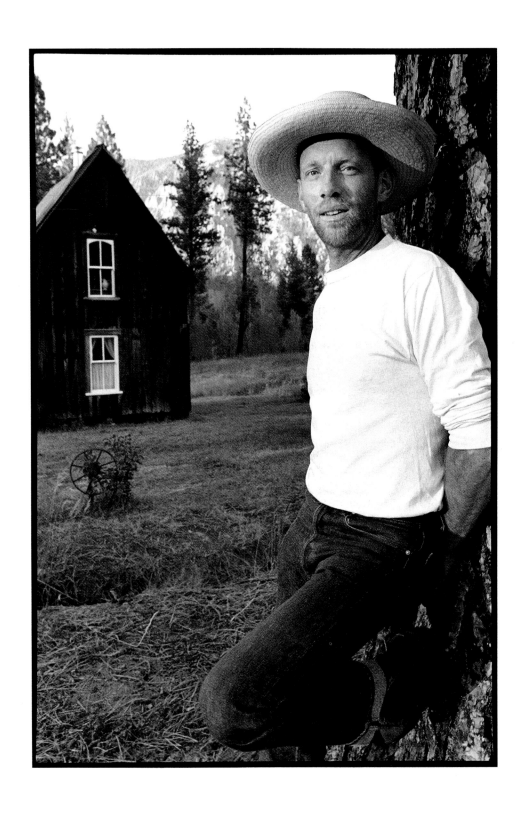

KERRY MOOSMAN
Ceramist

ATLANTA AND BOISE, IDAHO

KERRY MOOSMAN

TO REACH KERRY MOOSMAN in Atlanta, Idaho, you could call the Whistle Stop Tavern, one of the two bars in this old gold-mining town of about thirty residents, and leave a message. That is, unless the phone lines are down. Or you could drive the 101 miles from Boise to Atlanta, past the Lucky Peak Reservoir, fed by the Middle Fork of the Boise River — the same Rocky Mountains river that hugs Atlanta — and past Idaho City, the frontier town where Frank Church, former Democratic senator from Idaho, declared his bid for the presidency in 1976.

After 60 miles, it's time to head toward the Sawtooth Mountain Wilderness on a one and one-half lane, dirt Forest Service road full of mammoth logging trucks driven by guys who seem to derive job satisfaction from barreling around hairpin turns. People will warn you that parts of this road might be washed out after a heavy rain, but it's usually not anything that hard labor with a shovel couldn't fix. The ruts in the last seventeen miles, though, will bounce your Japanese-made compact around as if it were an old buckboard. Four hours after you started, three if you don't encounter too many logging trucks, you'll see Kerry's one-story cottage, beyond the firehouse with the vintage truck and water tank that once nearly tipped over on its way to a blaze on the uphill side of town.

Kerry Moosman lives in Atlanta, Idaho, for six months every year, during the summer and fall, restoring the town's derelict buildings, many of which were built soon after the town was founded in 1864, twenty-six years before Idaho became a state. The other half of the year, from late November until early June, he lives in Boise, making large red earthenware vessels he painstakingly builds by hand and burnishes with a small stone until their surfaces gleam like old gold.

In a time when most people consider their hometowns a dim memory, Kerry Moosman continues to live in both the village and the city where he was raised. The son and grandson of gold miners, he grew up in Atlanta, Idaho, until his family moved to Boise in 1959, when Kerry was in the third grade.

Vessel, 1987. Burnished terracotta. H. 32" x Dia. 14". Photo by Rick Jenkins.

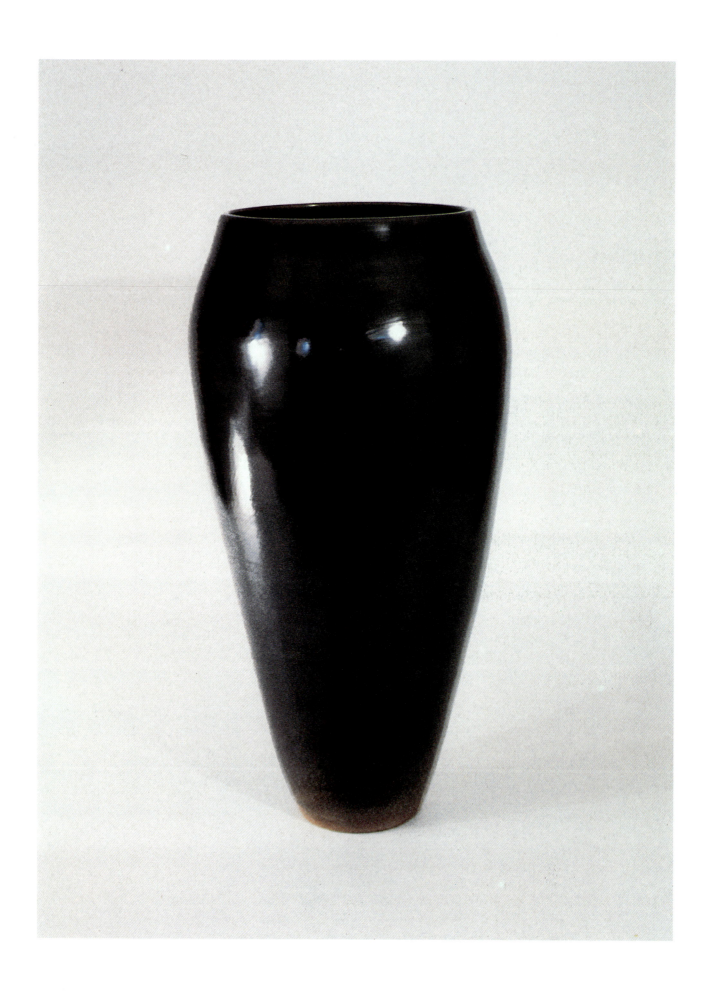

His life today is one that Thoreau would envy. His circa-1870 house in Atlanta, part of the town's National Historic District, has neither electricity nor running water. Kerry heats this five-room house with and cooks his meals on a wood stove. He fills pails with sweet water from a pump outside his back door. An outhouse sits a few steps beyond the weatherbeaten kitchen porch. Kerry's cozy house, filled with Victorian-era curios he has collected over the years, cost him nothing except the considerable time it took to return it to a habitable condition. (The original owner's descendants willingly gave him the rat-infested, abandoned house.) He scavenged for lumber and nails for the renovation among other, more ruined houses. Famous among his friends for his frugality, Kerry still talks about the time someone bought him an old ironstone platter for the shockingly high price of $12, which was exactly $11.50 more than he had paid for a similar piece.

Kerry Moosman counts pennies so that he has the luxury of spending one month or more to make each one of his thigh-high terra-cotta vessels, which vary in shape and sell in a Boise gallery. Because he only works as a ceramist for six months of the year, he must stretch the income from those sales. It helps that his grandmother, who no longer lives in her Boise house, allows him to live there rent-free. (He pays taxes, utilities, and insurance.) Also he receives a free studio space at a local art center in return for teaching classes.

To assemble his vessels, Kerry layers coil upon coil of clay, the same method used by potters in ancient times to make huge storage jars for grain and oil. "I like the idea that coiling is an ancient technique," says Kerry. "I can look at hand-built pottery from different cultures, and it's just like a common language."

After constructing a circular slab base for each new piece, Kerry rolls out five- or six-foot-long ropes of stiff, red earthenware clay. Draping a clay coil across his long arms, he holds one end of it in one hand and deftly uses his other hand to attach the opposite end to the base. As he builds the pot from the bottom up, Kerry smooths both the inside and outside with a wooden paddle. When the vessel is finished, he lets it dry, then rewets it and stone-polishes the surface as it dries again. Sometimes, after he low-fires each unglazed piece once in an electric kiln, he puts certain pieces inside a larger form called a *saggar*, packs manure under or around the pieces, and refires them in a hotter gas kiln. The organic material in the manure burns off, leaving glossy black markings. If Kerry doesn't like the results, he can always pop his pots back in the electric kiln and burn off the deposits, until they are once more the earthy color of burnt sienna.

During the months Kerry lives in Boise, he does little besides his work and some historical research on Atlanta. Describing himself as "single-minded," he explains: "When I work, that's all I want to do, that's all I really want to concentrate on. I don't want any distractions." He usually arrives in his studio in the afternoon, after classes in the art center are over, then works into the evening.

As an undergraduate at Boise State University, Kerry studied both ceramics and sculpture, and he admits he is attracted to making large vessels because they seem more like sculpture. He also attributes his fascination with large objects to living in mile-high Atlanta for the first eight years of his childhood. "Things are big up here," he says. "The trees, the mountains, the valleys. I think I just absorbed that feeling of scale."

On his mother's side, Kerry Moosman is a fifth-generation Idahoan, the descendant of pioneers who settled in the Payette Valley near Boise.

Vessel, 1988. Burnished terra-cotta. H. 28½" x Dia. 12". Photo by Rick Jenkins.

Kerry's paternal great-great-grandfather was a weaver in Switzerland who converted to Mormonism in 1850 and emigrated to Utah in 1860. Both his grandfathers came to Atlanta, Idaho, with their families in the 1930s to work in the gold mines. "My father's father had been working in a mine in Utah, and he heard about a job opening up in Atlanta, so he came over here with my grandma and my dad, who was a little baby, and the first night they were here they got snowed in, so they stayed," says Kerry dryly.

Atlanta was a boomtown when Kerry's mother and father, who were childhood sweethearts, were youngsters. Three shifts of men worked around the clock, digging ore from mines named Minnie, Minerva, Monarch, Old Chunk, Last Chance, Big Lode, Baltimore, Bagdad, and Buffalo. Then they hurtled it down water-fed chutes to the gold processing mill on the Boise River. The noise must have been stupefying. The machinery is mostly gone now, but the boulders overturned by earlier gold workers, including Chinese indentured laborers, remain — an earth-moving project worthy of any pharaoh.

Between five and six hundred people lived in Atlanta during the prohibition era. Kerry, the unofficial town historian, says, "They were so isolated up here in Atlanta that there were a lot of people who were making whiskey and selling whiskey. They were really living it up. They had their own little world up here, making money and gold mining."

Things had quieted down some by the time Kerry was born in 1951, and his tales of childhood are probably similar to those of someone in his grandfather's generation. There were abandoned houses and two old hotels to explore, and outhouses to tip over at Halloween. In the winter, Kerry and his friends sledded and skied; in the summer, they swam and rode horses. Only one family in town owned a TV, so in the evenings Kerry and his folks listened to the radio as his mother and grandmothers made quilts and rag rugs. Sometimes Kerry helped the women piece together the coils of brightly colored rags, his first experience with the technique he now uses in his ceramics.

As children, Kerry and his friends in Atlanta spent hours combing the countryside for relics — bits of broken bottles and dishes. Sharp-eyed Kerry noticed that the old shards of crockery still bore the indentations made by the potter's fingers. "And I thought that was fascinating," he recalls. "That somebody had made this stuff and that it was soft at one time. And I remember finding broken dishes and thinking it was real cool that they had survived. They hadn't rusted or deteriorated, and you could still see the designs."

For the first two years of grade school, Kerry attended a two-room schoolhouse with eleven other children in grades one through eight. His teacher, Mrs. Inama, still teaches the one student in town who goes to the elementary school. Each weekday morning, as she tolls the schoolbell at 8:30 and again at 8:45, you can't help but think that Atlanta — where it's common to hear the squeak of water pumps and the crackle of kindling in wood stoves — should be declared a national museum of old-fashioned sounds.

When Kerry Moosman was eight years old, his family moved to Boise. "I went from a school that had twelve kids in it to a big public school that probably had five hundred kids," he says. "It was a shock for kids like us who had never been around TV and who really didn't have much of an idea what was going on in the rest of the world. We had never heard of football or basketball. We didn't do organized sports. When we were in

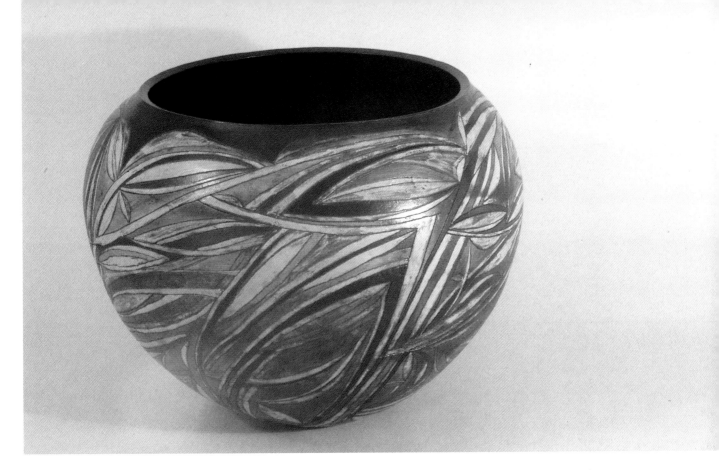

Vessel, 1982. Earthenware. H. 16" x Dia. 21". Photo by Rick Jenkins.

Atlanta, all the kids played together, and the boys played with the girls. But when we went to Boise it was, 'All the boys play football!' Living in the city was a lot more restrictive."

But every summer he would go back to Atlanta to spend time with his grandparents, a practice he continued even after he went to college. To earn money for school, Kerry did everything from planting trees and bartending, to working his grandfather's gold claim and running a scrap iron business. During the time that he was in high school, a number of old buildings in Atlanta had been torn down, so when he was in college in the early 1970s he drafted a petition to the state legislature that set aside approximately three acres in town for historic preservation. The buildings on this land include the town jail and a lawyer's office, as well as Kerry's house and two smaller houses that he owns, all of which he has either restored or is in the process of restoring. Due to Kerry, these buildings are also listed on the National Register of Historic Places.

After he graduated from Boise State University in 1975, where he studied with the Korean-born Japanese ceramist John Takehara, Kerry worked there as a ceramics instructor for two years. It was during this time that he acquired his house in Atlanta and began renovating it. In 1982, he became an instructor at Fort Boise Community Art Center, a half-year position he holds to this day.

In the early 1980s, Kerry coil-built tall, cylindrical vessels — at that time he used stoneware clay — that were more directly influenced by the nature he saw all around him in Atlanta. He decorated his pots with colored liquid-clay drawings of the dragonflies and kingfishers he spied while bathing in a hot-springs pool facing 9,300-foot Greylock Mountain. But he tired of stoneware because this type of clay must be high-fired in gas kilns, which are notoriously temperamental. Some ceramists relish the unpredictability of gas kilns, but Kerry wanted more control. So he switched to

red earthenware, which is fired in an electric kiln. "It's a simpler process," he says, "and I always loved the color of that red clay. And it's stiffer clay and it works nicely for hand-building, for coiling." His earth-colored vessels also reflect Kerry's appreciation for the simplicity of Native American ceramics from the Southwest and have a similarly sunbaked, warm surface.

Kerry likes Southwest food, too. During the week, when he's alone in his house in Atlanta, he's as likely as not to open a can of tuna for dinner. But on the weekends, when his friends Robert Vasquez and Joe Wheat visit from Boise, they bring along groceries as well as the fixings for the kind of food that Robert watched his mother cook. One night, Robert produced a feast of pork chili with homemade hot sauce, *arroz con pollo,* and refried beans. Another friend named J. D. Dolan, a New York writer whose Atlanta cabin contains the only fax machine for miles around, contributed homemade corn bread.

After dinner, by the light of a kerosene lamp, the four men entertained two women visitors with ghost stories, bad Mormon jokes, and gossip about the Atlanta townsfolk, many of whom make a living working for the Forest Service. For example, the man they've dubbed "The Abdominals" would win a gold medal if there were such a thing as a "Barroom Olympics." From a standing position on the floor, while holding a mug of beer, he can leap onto the four-foot-high bar in the Whistle Stop Tavern without spilling a drop.

Kerry and his friends also told about the black bear who had recently ended up as bear steaks after he went on a rampage that began with swiping the townsfolk's hummingbird feeders and escalated into house break-ins. He grew so bold that not even The Abdominals' dog, who is half-wolf, could scare him any longer. The final straw, though, was when the bear got into Randy and Sandy Nye's truck and threw it out of gear. The truck rolled downhill with the bear in the driver's seat and slammed into a tree, which literally scared the scat out of the bear. Soon after, the bear met his demise at the end of a shotgun.

Although it is early fall, the next morning is sunny and hot. Freckle-faced, fair-haired Kerry dons the straw sombrero he calls his "Van Gogh" hat and tours us around his domain, looking like a latter-day Huck Finn. He leads us first up a hill just outside of Atlanta to the cemetery, where a few wooden grave markers surrounded by picket or iron fences still stand. Suicides and desperadoes were buried downhill from the more respectable townspeople, Kerry comments. We follow him back into town and inspect the church being built on the site of an old brothel, where Pegleg Annie, a pioneer prostitute infamous in these parts, undoubtedly entertained some of her customers. Kerry shows us the old board-and-batten building he's fixing up as a guesthouse for his sister and her family.

On the way home, Kerry steals a fat turnip from a neighbor's garden and checks his mailbox — the U.S. Postal Service trucks in mail six days a week during good weather and twice weekly otherwise. Kerry studies a postcard and rifles through some utility bills for his house in Boise. Then he summarily stuffs the bills back into his mailbox. In two more months, he'll return to Boise and assume all the responsibilities of modern life. In the meantime, the bills can wait until the King of Atlanta, Idaho, is ready to reenter the twentieth century. ◆

Vessel, 1989. Burnished terra-cotta. H. 27" x Dia. 16". Photo by Kim Zumwalt.

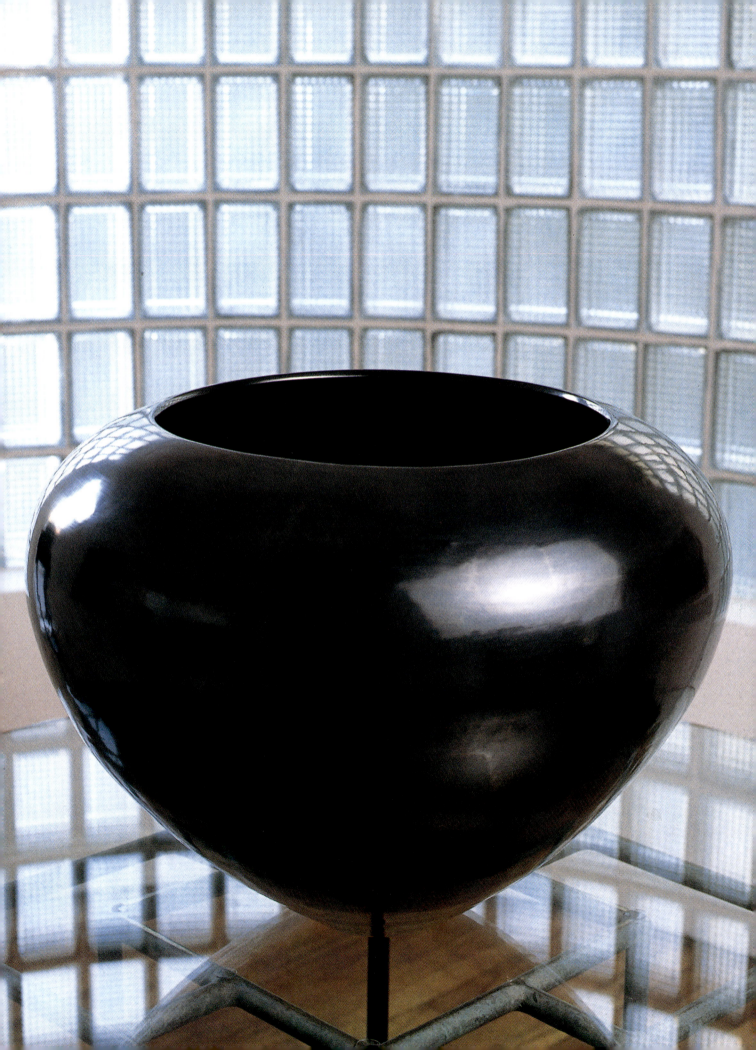

SARAH JAEGER
Ceramist

SARAH JAEGER

FOR AS LONG AS SHE CAN REMEMBER, Sarah Jaeger has loved the look and feel of handmade, functional objects. Growing up on the East Coast, she lived in three different pre-Revolutionary farmhouses — one in northwest Connecticut, another on the eastern shore of Maryland, and still another outside of Princeton, New Jersey — but the furnishings were always the same: copper pots and pans, colorful braided rugs, pewter candlesticks, and the eighteenth-century, country pine furniture collected by her father. To this day, Sarah recollects the mellow patina of the dresser and the blanket chest in her bedroom, and how smooth and satisfying they felt when she ran her hands over them. "It was almost like petting a cat or a dog with a nice coat," she recalls.

Some of the things Sarah grew up with are now transplanted to her own house in Helena, Montana (built in 1890), including two braided rugs and a wooden wall candlestand designed by her father, a reproduction of a useful eighteenth-century American item. Sarah calls herself a "nester," and her two-story house reflects that instinct. Piles of books and sections from the Sunday *New York Times* share space with baskets made in the Philippines. A handmade tea cozy hanging next to her stove marks her as a serious tea drinker, as does a collection of teapots on a nearby shelf. Pottery by friends such as the noted ceramists Akio Takamori and Betty Woodman line her cupboards, along with the richly colored functional ware of her own making — teapots, cups and saucers, dinner plates, bowls, and casseroles. In the home showroom adjacent to her dining room, a spray of fragrant lilacs fills one of Sarah's large oval ceramic buckets. The vessel's form resembles an early-American, salt-glazed crock.

Kurt Weiser, the former director of the Archie Bray Foundation, who headed this world-renowned ceramic school in Helena during the three years — from 1985 to 1988 — when Sarah was a resident artist there, once characterized her work as "elegantly folky," a comment she considers a compliment. "That's exactly the feeling I want in my work," says Sarah. "I want it to invite use."

Not only is Sarah's porcelain dinnerware used by people who buy it in galleries from Los Angeles to Washington, D.C., but it is also

Bowl, 1990. Porcelain. H. 8½" x Dia. 16". Photo by Doug O'Looney.

set on many tables in Helena, the town of twenty-five thousand people where she has chosen to live. Sarah's local customers often buttonhole her at the grocery store or coffee shop and launch into descriptions of their favorite items. Many mention her cups. It's easy to imagine Sarah carefully listening to these stories, her expressive, alert face reacting to every detail. Sarah Jaeger's work is respected by ceramists across the country, but she's no aloof artiste, closeted in her garage studio. Both Sarah and her elderly dachshund, Lola, are familiar sights around Helena. On summer nights, Lola waits patiently in Sarah's 1983 Honda Civic as her mistress sits in the bleachers behind first base, watching the Helena Brewers play their own brand of minor-league baseball, and eating the vegetarian food she brought from home.

As someone who likes to cook, Sarah chooses her ceramic glazes carefully, to set food off to best advantage. Seeing bright green stalks of broccoli, for example, arranged on one of her chocolaty dark platters would make even Dennis the Menace want to eat his vegetables. And because she drinks tea, Sarah enjoys making teapots and cups and saucers, but especially cups. Unlike many ceramists who complain about the monotony of throwing cups on a potter's wheel, Sarah relishes the Zen-like repetition of that form.

"I love to make cups," she says. "I guess it's the mundane quality that I enjoy. Sometimes, repetition is just great. I mean, I don't have an idea every day. There are times when it's just wonderful to sit down and make cups. And also I guess with cups you know that they'll be held and looked at, and that they kind of enter into your life in a very casual and unassuming way. So I enjoy making cups and I enjoy thinking about people using them that way."

Sarah took her first ceramics class in an art center in Cambridge when she was a senior at Harvard University, majoring in English literature. "I just got the idea that I wanted to take a pottery course," she says, "as an escape from words as much as anything." At that time — the late 1960s — Harvard emphasized criticism over creativity; it offered many courses in art history, but few studio art classes. Sarah recalls the Harvard of her undergraduate years as a stuffy place where a Chaucer professor once reproached a student who wanted to start a poetry magazine with the words: "Harvard is above the struggle."

After she graduated from Harvard with a B.A. in English literature in 1970, Sarah spent two years working for the citizen's lobby Common Cause in Washington, D.C., and Denver, Colorado, and one more year at the University of Chicago Press as a direct-mail researcher. During those years, she dabbled in ceramics, but it wasn't until 1975, when Sarah and her then-husband (they divorced in 1979) moved to Denver, that Sarah took her work seriously. For the next eight years, she concentrated on making functional ware. Largely self-taught, Sarah occasionally took ceramics workshops during this period. It was at one of these workshops — taught by Ken Ferguson, a strong advocate of functional pottery and the head of the ceramics department at the Kansas City (Missouri) Art Institute — that Sarah decided to attend that prestigious art school, even though doing so meant enrolling as an undergraduate.

"Art school boot camp" is how Sarah describes her first few months at Kansas City in 1983. "Starting out, it was just terrifying," she says. "I had been out of school for thirteen years. I had never taken art. My first semester I was in Foundations, which is the freshman studio-art program,

Covered jar, 1988. Porcelain. H. 13" x Dia. 12". Photo by Sarah Jaeger.

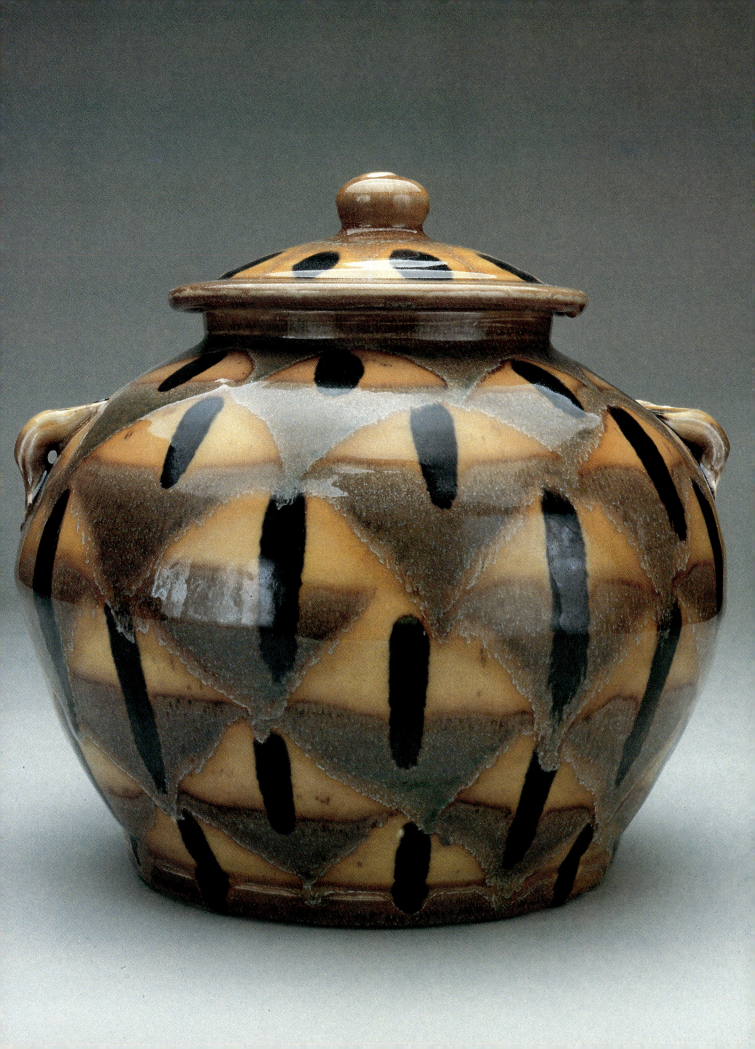

where you have assignments every day. And I thought, 'My God, I'm thirty-three years old and I'm walking in with all these eighteen-year-old art geniuses. Help!'"

As time went on, Sarah calmed down. By the time she graduated with a B.F.A. in ceramics in 1985, she felt more assured as a potter. She applied for a resident artist position at the Archie Bray Foundation in Helena, Montana — her Kansas City mentor Ken Ferguson was a former director — and was accepted. Sarah worked at the Bray for the next three years, honing her own work and teaching community ceramics classes.

Ferguson included Sarah's work in the 1988 "Ceramic Annual," a select show of emerging artists held each year at Scripps College in Claremont, California. The show demonstrated how sculpture dominates American ceramics today. Of the fourteen artists picked for the 1988 show by eleven different curators, Sarah was one of the few functional potters. Although she explored different sculptural forms in clay when she attended the Kansas City Art Institute, Sarah ultimately decided she was more interested in traditional, wheel-thrown pottery. "At the end of my two and one-half years at Kansas City," she says, "I realized that I really like to make pots. Sometimes I'm glad that I live in a place like Helena, because I can just do my work and not spend a lot of time worrying that I'm not following the latest trend."

One of Sarah's pieces displayed at the 1988 Scripps annual — a porcelain covered jar that is twelve inches in diameter and thirteen inches high — has the sturdy presence of a large cookie jar, yet it's embellished with subtle, sophisticated glazes and patterns. Charcoal-black brush marks and greeny-gray triangular shapes seem to melt into a honey-colored background. The jar's decoration gives the illusion of depth and makes you feel as if you could reach around the triangles and pollinate your fingertips with the golden undercolor. Sarah says the forms and soft colors of her covered jars remind her of Tang Dynasty funerary urns, although those Chinese pots were smaller and made of earthenware. Her appreciation for textiles has also influenced her work; she decorates her pieces with the same wax-resist method used by makers of batik fabric. "I love textiles and textile patterns," she says.

To underscore her assertion, Sarah runs upstairs and hauls down an armload of fabrics she collected during a three-month trip throughout northern Thailand and southwestern China in 1988. She carefully unfolds the items as though she were unwrapping Christmas presents and holds each up to her small, sinewy body. Sarah is only five-feet-three-inches tall, but she would win an arm-wrestling match hands down. Years of throwing clay on a potter's wheel have given her arm muscles that would be the envy of a professional athlete.

In Southeast Asia, Sarah traveled with a curator and research associate from the Denver Museum of Natural History, who were assembling a collection of tribal crafts. The three visited remote villages where people handcrafted baskets, bamboo boxes, silver jewelry, and textiles.

"For me," says Sarah, "it was really inspiring to be in a place where functional crafts are still an integral part of the culture. You know, you would walk into some village, and it's thatched huts, there's no running water, and there's no plumbing. It's very primitive, and yet the women are sitting in the doorways, doing their needlework. And they weren't doing it because they heard we were coming. They have two things that I think are in many ways lacking in our culture — they have time and also a sense of

living with beauty on a daily basis. The presence of beautiful things that are just assumed to be a part of daily life.

"I guess one of my political convictions," she continues later, "is that beauty is not at all extraneous. A lot of things that can't be measured — beauty, dignity and respect, fairness — have a really important place in people's lives."

Since she graduated from college, Sarah has worked as a volunteer for many organizations, including Denver Artisans, a nonprofit cooperative helping Hmong refugees from Laos market their traditional needlework. Today, Sarah works half time as the fundraiser for the Montana Committee for an Effective Legislature (MontCEL), a nonpartisan, grass-roots organization. It recruits progressives to run for the state legislature and then provides them with assistance during their campaigns. "MontCEL tries to get at political reform through the political structure," she says.

Living in a small town, Sarah has found the time to be a political activist and a functional potter, roles she views as interrelated. "Those same values of community inspire my clay work, I hope, as much as my political work," she says. In Helena, Montana, she has partially recreated the life she so admired in the craft villages of Southeast Asia — a life that includes making beautiful things that are meant for everyday use. Sarah Jaeger's cups and platters and saucers remind us that even in this frantic modern world, the humble, ordinary acts of eating and drinking are sacred, too. ◆

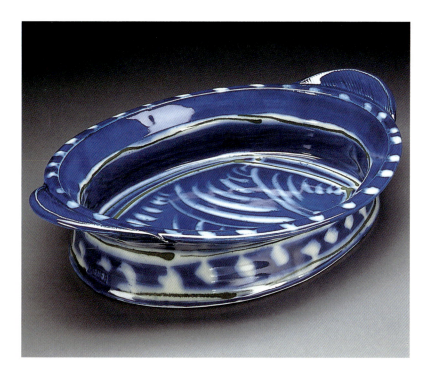

Oval baking dish, 1990.
Porcelain. H. 3" x W. 17" x D. 11".
Photo by Doug O'Looney.

CAROL ROORBACH
Ceramist

HELENA, MONTANA

CAROL ROORBACH

IF HELENA, MONTANA, WERE a harbor, wind would be its ocean. In the winter, when it floods down into Helena from the nearby Continental Divide, the wind slams against anything in its path. Even the town's brick houses feel its gale force. In summertime, the wind is more playful, puddling around the corners of the solid buildings like pools at low tide. The aquamarine sky over Helena is oceanic, too — a soundless blue that is as all-encompassing and ever-present as an omniscient narrator in a Victorian novel.

Sky and wind penetrate everything in Helena, including a shuttered, abandoned brickyard on the outskirts of town, part of the old Western Clay Manufacturing Company. Built in the early 1900s, this brickyard used local clay deposits to make bricks, sewer pipes, hollow tiles, and flowerpots. Helena's many brick buildings attest to the success of Western Clay, the largest producer of brick in Montana until World War II. In 1951, the company's president and manager, Archie Bray, Sr., set aside one corner of the brickyard as a pottery for artists. He envisioned his ceramic art center — to be administered by the Archie Bray Foundation, a nonprofit educational corporation — as "a fine place to work." Nine years later, Western Clay went bankrupt, but the Archie Bray Foundation continues to thrive. Today, this world-renowned ceramic center owns the defunct brickyard, more than twenty adjacent acres of land, and a successful business that supplies clay to schools in Montana.

The Bray's current director, Carol Roorbach, interrupts her own ceramics work this summer day to show me the old brickyard buildings, which are listed on the National Register of Historic Places. As she unbolts various padlocked doors, we hear the muffled scrabbling of wild cats and pigeons. Piles of dung and bird feathers litter the ground, as do the handcarts that workers used to transport the molded clay products to the drying sheds and the beehive kilns.

Five of these aptly named kilns still stand. The kilns were once gas-fired infernos for baking clay,

Cup, 1989. Stoneware. H. 5" x Dia. 5". Photo by Carol Roorbach.

but entering them now is like setting foot in round, early-Christian churches. Approximately two stories high, all the beehive kilns are empty, save for one that is still half-loaded with stacks of fired sewer pipes. Despite the hush inside the domed kiln, you can feel the presence of the wind and sky outside, just as you can almost sense the bustle of the men who used to work here. "Ghosts," says Carol.

Carol Roorbach is the first female director of the Archie Bray Foundation. She follows a line of notable male ceramists who previously managed the art center — Peter Voulkos, Rudy Autio, Ken Ferguson, David Shaner, and Kurt Weiser. Although the facilities at the Archie Bray Foundation are humble, from the director's home to the studios, artists from all over the world apply for the privilege to study and work here.

Almost from its inception, the Bray has been considered a mecca for ceramists. After all, this is where the British ceramist Bernard Leach and his Japanese colleagues, Shoji Hamada and Dr. Soetsu Yanagi, conducted a week-long workshop in 1952 that helped change the course of American ceramics. Leach, a Japanophile and student of Zen Buddhism, was already known to American artists through *A Potter's Book*, his philosophical and technical exposition on the ceramist's craft. Hamada and Yanagi — one a potter, the other the founder of the *Mingei*, or Japanese folk-art movement — were revered in their own country, but they were relatively unknown in the U.S. until they toured this country with Leach.

At the time, American ceramics was dominated by Bauhaus-influenced, "good design" principles. Austere, white porcelain plates, which some critics dubbed "hygenic hotelware," were ubiquitous. Leach, Yanagi, and Hamada had a different approach toward functional ware, one

Oval casserole, 1987.
Fired stoneware. H. 10" x Dia. 12".
Photo by Carol Roorbach.

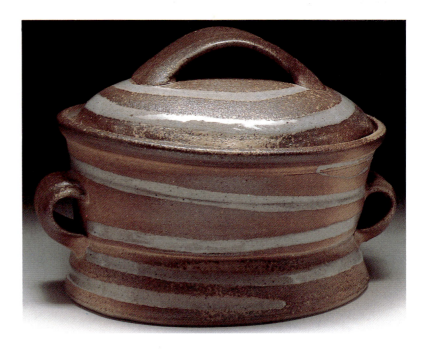

that championed the natural look of wood-fired stoneware. Yanagi's talks on Zen Buddhist aesthetics and Hamada's loose, free treatment of clay — the embodiment of the Zen concept of beauty, which emphasized risk and expression — influenced many American ceramists, including Rudy Autio and Peter Voulkos, the managers of the Bray at the time. Autio and Voulkos eventually turned toward making sculptural vessels, but Yanagi and Hamada's reverence for the simple beauty of wood-fired, functional pots continues to influence ceramists to this day.

Although she was born three years after their workshop at the Archie Bray Foundation, Carol Roorbach is the spiritual daughter of Bernard Leach, Soetsu Yanagi, and Shoji Hamada. "When I first started making pots," says Carol, "Leach's book was very important to me. I spent hours reading it over and over and over. And Hamada's work has an incredible strength of form."

In a time when many ceramists scorn so-called "brown" pots in favor of vividly hued ceramics, Carol prefers the subtlety of wood-fired stoneware. Her functional containers — cups and casseroles, pitchers and cruets, teapots and coffeepots — are glazed in soft colors and then fired in a wood-stoked kiln. Carol relishes the unpredictable results produced by such a kiln. For example, wood ash sometimes fuses onto the side of a glazed pot and deepens its color.

Because sticks of wood must be fed intermittently into them, wood-fired kilns require constant attention and are thus more labor-intensive than gas-fired or electric kilns. In addition to tending her own firing, Carol also splits the wood herself, a task that can take up to one week. She finds the whole wood-firing procedure exhausting but enjoyable. "When I finish a firing," she says, "I never want to do it again. It is so much work. I feel sick for a week afterward, but I keep going back. I love being involved with the whole process, from splitting the wood to being outside with the kiln for twenty-four hours or longer."

The time-consuming method also makes Carol feel connected to a time when wood-fired country ware, such as faience, was made. "A lot of my functional pots are bound in history," she says. "They're really in the tradition of country ware. That's why I'm just in love with the romance of the wood firing."

Despite her infatuation with the historical past, Carol Roorbach is no hopelessly impractical dreamer. Her slightly amused, level gaze defines her as calmly competent. This is a young woman who came to her interview for the directorship of the Archie Bray Foundation armed with a statement that raised several issues confronting the forty-year-old institution. These issues included the future of the old brickyard and where the Bray's permanent ceramics collection — most of it in storage — would be displayed. Since becoming the new director of the Bray in 1989, Carol has added several new members to the board, hired a part-time fundraiser to raise money for an endowment and artists' scholarships, and converted an old studio space into a museum. As we sit talking in her cozy kitchen during a summer storm, we hear the faint din of nearby hammering — the sound of finishing touches being made to the Bray's museum. Soon the two teapots made by Hamada that now grace Carol's living room will be moved to the museum.

Carol and her husband, the Northwest mountaineering writer Malcolm S. "Mac" Bates, live in the remodeled, two-story chicken coop that has traditionally housed the directors of the Bray. The small house now

has five rooms, including an adjacent office that holds a constantly ringing phone. In the summer, when up to twenty artists work at the Bray, the traffic in and out of the house can be measured by how often the front screen-door creaks open and slams shut, and by the number of flies zooming around the house.

All this activity doesn't seem to faze Mac and Carol, who worked as teachers and houseparents at Westover School, a private girls' school in Middlebury, Connecticut. Carol taught ceramics there for two years after receiving her M.S. in art education in 1982 from the New York State College of Ceramics at Alfred University. Meanwhile, she was conducting a long-distance romance with Mac, who lived in Seattle. In 1984, Westover hired Mac as a journalism and history teacher, and he joined Carol at the girls' school, where they lived and worked until 1986. "It was a blast," says Carol. "It gave me a lot of freedom to do my own work, since I was only teaching one class two days a week. I would get out to the studio by eight in the morning and work until six. We ate all our meals with the girls. Everything was kind of this big happy family."

The Westover School must have seemed like home to Carol, who was the middle child of five. Growing up in New Canaan, Connecticut, she and her younger sister were responsible for washing the dishes and dusting their mother's collection of heirloom china. Carol also liked to make ceramic ware of her own during art classes at elementary school or summer camp. When she was eight years old, her family visited Sturbridge Village, a collection of pre-Revolutionary buildings in Massachusetts that features craft demonstrations done by artisans dressed in period costumes. As soon as Carol spied a potter, she decided what she wanted to be when she grew up. "I remember saying, 'This is it,'" recalls Carol. "The whole lifestyle — working in clay, working with your hands — really appealed to me."

After concentrating in pottery at New England College in Henniker, New Hampshire, Carol graduated in 1978 with a B.S. in visual arts. She and a classmate moved back to southern Connecticut and set up a pottery studio. During the day, Carol worked at the check-out counter of an apple orchard. At night, she made pots until three in the morning. When the two young women held their first Christmas sale, Carol's friend sold about $600 worth of ceramics, while Carol sold $40. "And $30 of that my Dad bought!" wails Carol. "I was devastated. I thought, 'I'm never making another pot again.'"

And she didn't — for two years. Another of Carol's skills is sewing, and she started making and selling girls' hand-smocked dresses. Each one took two full days of work. Although Carol charged $120 per dress, she once calculated that she earned approximately 85 cents an hour. Nevertheless, Carol calls this period a "healing time" that enabled her to recover her confidence after the disastrous Christmas ceramics sale, yet continue working with her hands.

Eventually, however, she missed clay, and so went back to school at Alfred University to concentrate in pottery and earn her M.S. in art education. The Westover School hired her soon after she graduated in 1982, and Carol lived and taught at that girls' school for the next four years. In 1987, she and her husband Mac moved to Colorado after Carol was selected to be an artist-in-residence at the Anderson Ranch Arts Center in Snowmass Village, Colorado. To help support them, Mac worked as a residential security guard in Aspen during Carol's months at Anderson Ranch.

After that time, Carol and Mac moved back East so that Carol could

attend Alfred University again. Mac taught in a high school during the time that Carol was in graduate school, earning her M.F.A. in ceramic art. "It was a very difficult two years," says Carol. "At Alfred, there was constant criticism about your work. It was a very analytical environment."

As capable as she is, Carol found the intellectualism of graduate school stressful because her approach to her work is intuitive and emotional. One of her favorite words of praise for either pots or people is "dopey," which she says relates to the "quirkiness, or the quality of personality in each pot." Her slightly lopsided footed cups, especially, demonstrate the Roorbachian ideal of dopiness. They are as subtly asymmetrical as Shoji Hamada's pots, but somehow more humorous and American. Three of Carol's cups lined up on a table resemble a trio of tipsy sailors telling each other bawdy jokes.

In the same way Carol reveals the goofy side of her personality at a minor-league baseball game in Helena by trying to incite the small crowd in the bleachers to do "The Wave," she expresses her sensuality when she talks about the importance of touch in her work. She not only wants her pieces to show the mark of her hands, but also wants them to feel good in the user's hands. For example, she pays particular attention to the handles on her cups, cruets, casseroles, and pitchers. "I've always been really interested in handles," says Carol, "because that's the part your hand is going to touch. And when I put handles on pots, I can be really expressive with the way I push the handle into the side." Carol picks up one of her small creamers and points out the way the handle nuzzles against the pitcher's body. "This handle grabs on like someone pinching a cheek," she observes.

Like a good marriage, Carol's work derives at least part of its strength and beauty from the intimacy of daily acquaintance. At first, you may not notice that her spouts always pour without dripping, but once you do, using her pitchers will give even more pleasure.

"My work is really quiet," says Carol, "and it's something that you do have to live with to begin to notice the subtleties of the way I push the handle on, the way the lid fits, the way I've connected the foot, or the gesture I've put into the pot. Sometimes I walk into a gallery and the pots that jump out at me are the brightly colored ones, and I think, 'Oh, how come I'm not doing that? It's just stupid! I could be selling like crazy.' But there's something that keeps drawing me back to wood-fired pieces. They're bound with the earth and a way of living." ◆

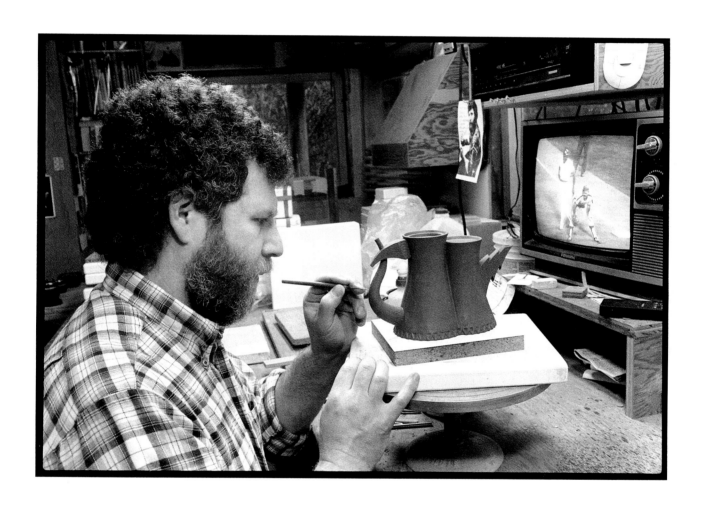

RICHARD NOTKIN
Ceramist

MYRTLE POINT, OREGON

RICHARD NOTKIN

TAKING HIS TIME, RICHARD NOTKIN leans into his worktable, wielding a dissecting tool and carefully incising tiny scratches on the handle of a seven-inch-high stoneware teapot shaped like the twin cooling towers of a nuclear power plant. On a shelf over his right shoulder sits a cardboard box neatly labeled "Small Skulls, Misc. Bones." For a moment, it's easy to imagine a sensational headline: "Bespectacled, Mild-Mannered Artist Buries Bodies in Oregon Woods Near Studio." But then your eye rests on a photo of a tiny porcelain goat skull cradled in the palm of a hand. Oh, *that's* what's in the box, *ceramic* skulls. Close by is a case crowded with more memento mori — a ceramic skull mug and an "ashes to ashes" ashtray, a plastic skeleton key chain with rhinestone eyes, and a meerschaum skull pipe — a kitschy collection Richard has amassed since childhood.

His clay charnel chamber in Myrtle Point, Oregon, overlooks a pastoral landscape of Douglas fir, cedar, and western hemlock dripping with mists that waft from the nearby Pacific Ocean. This is big-timber country, and logging roads crisscross the mountains behind Richard's property, twenty rural acres he bought in the early 1970s. He and his wife, the painter Charlee Deaton Notkin, built a low-slung studio building as well as a two-story, six-room house, where Richard now lives with his two children, Jessica Willow and Ethan Oak, born in 1975 and 1977. Both studio and home have a funky, counterculture feel, in contrast to the sleek satellite dish that he installed for better TV reception of Chicago Cubs baseball games. Richard, who grew up in Chicago, is such a fanatic Cubs fan that he tapes selected games on his video cassette recorder each summer to sustain him through rainy, baseball-less winters.

A Cubs/Mets game recorded during the 1989 National League East division playoffs is progressing on the TV set on Richard's worktable, but he doesn't even glance up. He's too busy scoring the teapot handle — shaped like a utility pole, insulators and all — to resemble wood grain. Occasionally he pauses to mist the stoneware clay with water, so that it remains pliable. His glasses are off, and his

Heart Teapot: Beirut, Yixing series, 1988. Stoneware and glaze. H. 11 3/4" x W. 4 7/8". Courtesy of Garth Clark Gallery. Photo by Richard Notkin.

nearsighted, engrossed expression is one he must have worn as a child, when he painstakingly painted each section of his model airplanes and ships.

Richard Notkin's metier is the miniature. His exquisitely detailed teapots — cast in molds of his own design and making, and then decorated and finished by hand — are small sculptures inspired by the diverse forms and fine craftsmanship of the world's first teapots, those from Yixing county in the southern Chinese province of Jiangsu. Yixing (pronounced ee-shing) teapots are left unglazed, because the stoneware clay of which they are made is so beautiful in texture and color, ranging from a highly prized purplish-brown to reddish-brown, beige, and black. These teapots were first produced at the end of the sixteenth century, when tea leaves replaced powders for brewing the beverage. Tea had been prepared from powder by whisking it into a froth with hot water in a bowl. However, the steeping of tea leaves demanded a covered container from which the infusion could then be poured. At first, wine and water ewers were used for the purpose, but Chinese potters soon invented the teapot form.

Yixing teapots, like most teapots, have four distinct parts — spout, handle, body and lid — but they can be shaped like almost anything. Some resemble vegetables and fruits such as gourds, melons, pumpkins, and persimmons. Others duplicate chrysanthemum, narcissus, and magnolia flowers. There are even teapots that mimic the appearance of a knotted napkin, a square letter seal wrapped in cloth, or a bundle of bamboo. And because these are Chinese teapots, each form has a particular meaning; for example, a teapot shaped like a peach symbolizes longevity. In the past, writers and scholars at times collaborated with potters in designing particular teapots, some of which were inscribed with poems.

Like their Chinese predecessors, Richard Notkin's teapots are fashioned of unglazed stoneware and modeled in different forms that are also full of meaning. However, unlike Yixing ware, the shapes of Richard's teapots — his cooling towers, skulls, and almost anatomically correct hearts — are more sinister or disturbing images, ones that pack a potent political message.

As an undergraduate at the Kansas City (Missouri) Art Institute, Richard studied first painting and then sculpture before he finally settled on ceramics in his junior year, one year before he graduated with a B.F.A in 1970. Despite one flirtation with large-scale sculpture — a mixed-media flyback toy scaled up one hundred times — Richard mainly made small ceramic sculptures. The ceramist Kurt Weiser, a fellow student at Kansas City, remembers Richard injecting liquid clay into the mold of a tiny insect with a hypodermic needle. After attending a Vietnam peace march in Washington, D.C., in 1969, Richard began sculpting little dioramas poking fun at that city's monuments and at President Richard Nixon.

While he was an undergraduate student in Kansas City, Richard would often amble across the street to view the extensive collection of Oriental ceramics at the Nelson-Atkins Museum of Art. As a child, Richard had been exposed to Oriental art through his father, a lawyer who received gifts such as ivory carvings from his numerous Chinese clients. Richard caught his first glimpse of Yixing teapots at the Nelson-Atkins, but it wasn't until he attended graduate school at the University of California at Davis and began making occasional forays to the M. H. de Young Museum in San Francisco, that he really fell for Yixing ware. Originally, he had been attracted to the de Young Museum's holdings of Japanese *netsuke,* tiny and

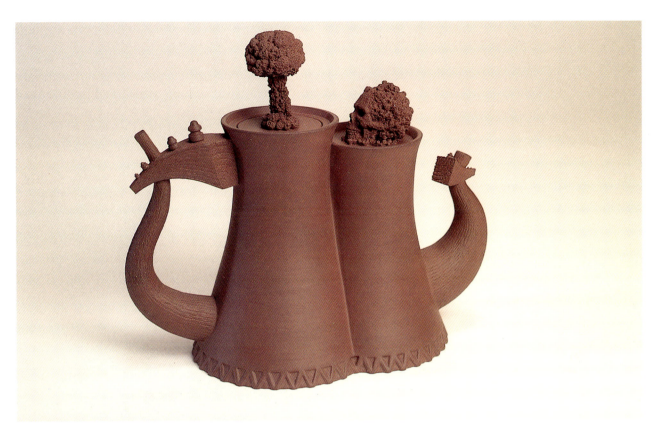

ABOVE:

Cooling Towers Teapot (Variation #23), Yixing series, 1988. Stoneware. H. 6½" x W. 7¾" x D. 3¾". Courtesy of Garth Clark Gallery. Photo by Richard Notkin.

LEFT:

Cube Skull Teapot (Variation #9), Yixing series, 1989. Stoneware. H. 5" x W. 4¾" x D. 3". Courtesy of Garth Clark Gallery. Photo by Richard Notkin.

intricately carved, ornamental belt toggles. But his affections soon shifted to Yixing teapots, which he prized for their scale and refinement.

"They pack a maximum amount of impact into a minimum amount of space," he explains. "They had that introspective quality that small things have. You have to enter that miniature world, and in entering that miniature world you kind of ignore the larger world. It's a very introspective activity, not only making small pots but also beholding and viewing them. To my sensibility, they're much more thought-provoking than large-scale ceramics."

Focusing on diminutive and fastidious clay objects was also Richard's way of rebelling against Funk, an outrageous style of ceramic sculpture that originated in the San Francisco Bay Area in the 1960s and dominated the ceramics department at the University of California at Davis. The department was headed by Robert Arneson, a Funk artist notorious for his scatological clay urinals as well as *Typewriter,* a 1966 sculpture that slyly substituted red fingernails for the machine's keys. Seeing this piece in a surrealism show at New York's Museum of Modern Art convinced Richard to study with Arneson, but once he got to California he realized that Funk wasn't for him.

"I tried to be a Funk sculptor for a very short time and was very unhappy," Richard recalls. "It wasn't me. My attitude toward craftsmanship didn't jibe with Funk. So I started doing my real tight, refined pieces again."

After receiving an M.F.A. from the University of California in 1973, Richard continued living in Davis for another year, making ceramic sculptures. By 1974, just four years since he had graduated from college, his work had been included in over twenty gallery and museum shows across the country, including one at the downtown branch of the Whitney Museum of American Art in New York. The money from gallery shows financed Richard and his wife's move to southwest Oregon in 1974, when Richard was twenty-six years old.

For the next nine years, Richard conducted workshops all over the country and concentrated on tiny sculptures such as his "Endangered Species" series of animal skulls and a series of human skulls shaped like pyramids, which evolved into skull teapots. The near-meltdown in 1979 of the Three Mile Island nuclear power plant near Harrisburg, Pennsylvania, eventually prompted Richard's series of double-cooling-tower teapots, a form that was also inspired by a photo of a seventeenth-century Yixing teapot shaped like two joined, wrapped boxes. The "Cooling Towers" teapots, first made in 1983, kicked off his Yixing series, the body of work that critics acknowledge as his masterpiece.

Just as J. S. Bach's "Goldberg Variations" spins out a series of thirty variations on one aria, so Richard's two hundred-odd Yixing teapots exhibit an astonishingly inventive diversity, even though they generally portray just four basic images: the skull, the urban curbside, cooling towers, and the heart.

Variations exist within variations. For example, the bodies of Richard's curbside teapots are either ovals or hexagonals, but one side on some of the six-sided teapots is bricked in and indented, like a subterranean sewer cutaway. Handles and spouts shaped like water mains adorn the curbside teapots, although each assemblage of pipe is configured differently. In addition, tires, reclining dogs, garbage can lids, cinderblocks, and boards — all modeled from stoneware — sit atop the pipes, bridging the area

between the teapot body and the handle. Sawed-off tree trunks act as lid handles on certain teapots, while in others, fire hydrants serve the purpose.

The street scenes in Richard's curbside teapots exist both as political commentary on urban decay and personal references to the neighborhood of his childhood, which was the Jewish and Irish-Catholic section of Chicago's south side. The middle child of community-minded parents — his father worked as an immigration lawyer and his mother as a nurse — Richard spent quite a bit of time as a boy with his mother's father. "He was a wild old Russian Jew who had escaped the czar and come to America," says Richard. Many neighbors were more recent refugees, those who had fled Nazi Germany.

"Our synagogue," Richard remembers, "was probably about 25 percent refugees, people who had left Europe. The lucky ones got out in the mid- to late thirties. The unfortunate ones were survivors of the concentration camps. My religious education began in 1952, so this was only several years after World War II. I remember seeing very graphic footage of the death camps from the time I was about four years old. People with very thick German accents would always tell us what it was like. And the thing they instilled in us was to be activists, to speak our minds, to react to the world around us."

A draft resister during the Vietnam War, Richard continues to criticize humanity's murderous and rapacious instincts through his art. Just as Francisco Goya's "Disasters of War" etchings and Pablo Picasso's *Guernica* recorded the atrocities of war, Richard's Yixing series of teapots protest twentieth-century horrors such as environmental blight and nuclear war. Richard has called his work "three-dimensional political cartoons," a description that certainly fits the cooling-tower teapots as well as the toothy skull and curbside teapots. His human heart teapots, the newest addition to the Yixing series, are something else again.

In contrast to Richard's other teapots, which can often be coolly clever, the hearts successfully marry political conviction and emotion. They are powerful images partly because they are so realistic; arteries serve as spout, lid, and handle.

"I wanted an image that was really vitally human, that didn't signify death," explains Richard. "The skull has very strong connotations of death. What I'm exploring is the capability of all human hearts to be very kind and loving, but also to be very evil and destructive."

Many of Richard's heart teapots bear the names of cities or countries devastated by war; *Hiroshima* (1988) looks charred, while *Beirut* and *Salvador* (both 1988) are covered with riveted armor and camouflage patterns. Others have more generic titles, such as *Hostage* (1988), a chained heart. These chained, armor-plated, and battle-scarred human hearts are as affecting as elegies.

Like a Talmudic scholar, Richard Notkin sees fresh meanings in studying the same text, over and over. In focusing on the teapot form and a small repertoire of images, he has created a significant body of work that compresses layers of meaning into just seven inches of clay. The Yixing series resembles a cycle of lyric poems, and renders the political poetic. ◆

AKIO TAKAMORI
Ceramist

VASHON ISLAND, WASHINGTON

AKIO TAKAMORI

EVEN WHEN HE WAS SIX years old, Akio Takamori knew which books in his father's library were considered off-limits to children, and he looked at them whenever he got the chance. Akio's father, a doctor, ran a clinic for venereal diseases in the red-light district of Nobeoka, a small industrial town on Kyushu, the same southern Japanese island where Nagasaki is located. Akio was born five years after World War II ended, the youngest of three children. While his sister and brother practiced the violin and piano, Akio would steal into his father's study and pull down his favorite books. His tastes were eclectic: he enjoyed scanning his father's medical tomes for photos of disfiguring skin diseases as much as he relished art books on Picasso and Bruegel. In fact, he so admired one Picasso sculpture — of a she-goat with huge teats — that he constructed a wire-and-plaster copy for a school art project.

But the book that delighted Akio most of all was Junichiro Tanizaki's *Kagi (The Key),* the story of a woman wed to an older man who is titillated by her infatuation with their daughter's boyfriend. It wasn't until many years later that Akio actually read this erotic novel, which was published in 1956, but as a child he loved studying its illustrations, black-and-white wood-block prints by the artist Shiko Munakata. One in particular fascinated him; it showed the married woman stretched out in bed, her husband's thick-lensed glasses atop her naked belly.

"What I liked was the realism," recalls Akio. "Love and sex are not necessarily Hollywood-like or romantic. The old man's glasses falling off, it's kind of clumsy, very close to real life. I thought it was a completely different way of looking at sexuality."

Perched on a stool, occasionally puffing a cigarette, Akio Takamori looks as though he's sitting in a sophisticated club rather than in his studio, which is separated by a fir grove from his house on rural Vashon Island, Washington, near Seattle. Lining the studio walls are large pencil sketches of breasts and buttocks and sly faces, the drawings that precede each of Akio's ceramic figurative vessels. In these sculptures of frolicking naked bodies, couples clasp, greedy babies grasp their mothers' breasts, and single figures lounge or twist into acrobatic postures. Whether male or female, Akio's hairless figures speak a body language all their own, one that bristles with sexual energy. They are clay made flesh.

Just as Akio hungrily took in the pictures in his father's books as a child, his artistic influences range from the miniature paintings that illuminated Persian medieval manuscripts to *Shunga,* Japanese erotic

Flower, 1989. Porcelain. H. 21" x W. 22" x D. 8". Courtesy of Garth Clark Gallery. Photo by Charles Backus.

69 | ARTISTS AT WORK

woodblock prints. Shunga prints are considered one of Japan's artistic legacies, but because of Japan's censorship laws, Akio had never seen unexpurgated copies until he came to this country to get his B.F.A. and M.F.A. in ceramics. In graduate school at Alfred University (New York), while poring over a library book of colored woodblock prints by the eighteenth-century artist Kitagawa Utamaro, Akio came across one erotic print he liked so well he ripped it from the book.

The print, which Akio still owns, shows an embracing couple lying side by side, fully clothed. Only their entwined legs and the woman's bare derriere are exposed, pale flesh contrasted against elaborately patterned kimonos. The woman's back is toward us, and her hair is upswept, revealing the curving nape of her neck. The man faces us, but most of his features are hidden. All we see is one knowing eye, the same sidelong glance one sees in Persian miniature paintings, and which Akio depicts over and over in his ceramic sculptures.

"It's interesting the way each different culture expresses eroticism in art," says Akio. "In Japan, they almost ignore breasts. But they show a lot of expression in fingers and especially toes and eyes. So you can see when a woman is having sexual stimulation — the toes kind of curl up. And in the Persian old paintings, I think the figures have a lot of expression in their eyes. They have long eyes, and they're always kind of looking. So eye movement becomes a very important part of the painting."

Years after he pilfered the photo of Utamaro's print, Akio discovered it in one of his sketchbooks and thought, "Oh, maybe I could make this into a vessel." In his mind's eye, he suddenly saw the woman's body as the front of a vessel, the man as its back, and the space between the lovers as a container. It was then that he started making the figurative slab sculptures for which he is famous. Each of Akio's ceramic vessels comprises a front, back, and bottom porcelain clay slab that are separately hand-formed before they are joined together.

"I'm not dealing just with form," says Akio, who speaks accented but fluent English. "I make a form to put the pictures on it. That is the most important part. So the vase seems like it works really well that way. It's completely different from 3-D sculpture, at the same time different from 2-D painting. It seems like a vase is so limited an area but you learn so much, you discover each time something new. I enjoy working within a certain kind of limitation. It's a challenge."

A prolific artist, Akio Takamori makes approximately thirty large pieces a year. His workday starts at 10:00 or 11:00 A.M. and ends at 11:00 P.M., with breaks for lunch and dinner with his wife Vicky and their two children, who were born in 1986 and 1990. Rigorous as this schedule is, it must seem almost easy to Akio, who worked for two years in a Japanese folkware pottery, throwing 250 teacups a day on a potter's wheel. He was allowed just one day off each month. It was in 1972, right after he graduated from a Tokyo art college, that Akio began apprenticing in this traditional pottery in the village of Koishiwara, on the same island where he had grown up.

"In a way, I felt really comfortable," remembers Akio, "because you just work like a machine, you don't need to think. Every day is routine."

A visit to the pottery by the American ceramist Ken Ferguson snapped Akio out of inertia. Ferguson, the head of the ceramics department at the Kansas City (Missouri) Art Institute, encouraged Akio to attend his school. Heeding his advice, Akio came to the U.S. and studied

PRECEDING PAGE:
Human, 1987. Porcelain. H. 17½" x W. 28" x D. 7". Courtesy of Garth Clark Gallery. Photo by Akio Takamori.

with Ferguson from 1974 until 1976, when he received his B.F.A. in ceramics. During this time, he began to make small figurative vessels, which he associated with the dolls he formed as a boy by molding papier-maché on Coke bottles.

In graduate school at Alfred University, Akio's teachers criticized him for concentrating exclusively on figurative work. He recalls being asked, "Why are you doing something Picasso did back in the twenties?" Akio switched to making large ceramic wall slabs, which he thought of as shrines. Although these pieces didn't deal overtly with the human form, Akio was sneaky — he was still thinking of bodies. He made the shrines because he was fascinated with the way a tombstone or shrine can come to symbolize the human body after someone dies. "Right before I left Japan," Akio explains, "my grandpa died. So the next time I 'saw' him, he was in a shrine. I thought of the transition of an actual body changing into the symbol of a shrine. So if you go to the tombstone, you still feel the presence of your grandpa."

After he received his M.F.A. in 1978, Akio went back to live in Japan. He rented a studio and made functional ceramic tableware, but he wasn't happy. "I felt like I was in Japan, a different society, so I should make something sellable," says Akio. "But my functional pots were bad. I realized that there is a lot of good functional pottery in Japan, so why was I making the bad?" Not long after that, he abandoned functional ware to create his true love — vessels covered with human figures.

In 1983, Akio returned to the U.S. to teach for one year at Montana State University in Bozeman. Meanwhile, his career was soaring. His first solo show was held in 1983 at the Garth Clark Gallery in Los Angeles; the New York showroom of this prestigious gallery featured Akio's second solo show the following year. By the time his teaching stint in Montana was up, Akio was married to the weaver Vicky Lidman, an American citizen, and they decided to remain in the U.S. Akio worked at the Archie Bray Foundation, a ceramic school in Helena, Montana, as a resident artist from 1985 until 1988, when he moved to the Seattle area.

Showing a visitor his studio, Akio pauses to lean affectionately against the bent knees of one of his vessels — *Human* (1988) — a reclining man propped up on both elbows, his head turned to one side. The hollow cavity of the man's body forms the container of the vessel, and you can peer inside and see a realistic drawing of his intestines.

By celebrating every part of the human body, Akio transforms the profane into the sacred. A story from his childhood is telling. When he was five years old, he noticed maggots in the toilet of his family's outhouse. He was about to kill them with boiling water when one of the young nurses who worked for his father stopped him. Instead of lecturing him on how maggots aid in decomposition, she told Akio he couldn't act out his plan because he would kill the toilet goddess who lived in the outhouse — a beautiful, blind woman with long black hair. Instead of being repulsed by this tale, Akio was captivated by the image of the toilet goddess. "I always liked the strangeness of mythology," says Akio, "and this story really intrigued me, because it combined the beautiful and the dirty."

Akio has created a universe populated by lusty clay creatures who recall the multitudes of men, women, and children in Walt Whitman's *Leaves of Grass,* lovingly detailed multitudes who make us feel that "To be surrounded by beautiful, curious, breathing, laughing/flesh is enough." Like Whitman, Akio Takamori sings the body electric. ◆

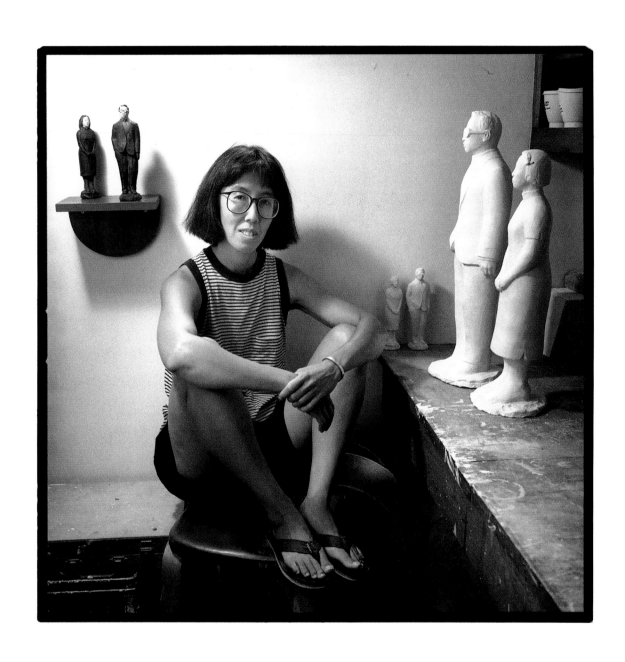

BETH LO
Ceramist

MISSOULA, MONTANA

BETH LO

IN THE LAST TRIMESTER OF her pregnancy, Beth Lo would come home after teaching ceramics at the University of Montana, eat dinner, then push the dishes out of the way so that she could draw at the kitchen table. Too tired to work in her clay studio, she nevertheless dashed off three or four sketches at a time, imagining all the while that she was collaborating on a children's book with her older sister. They had come up with this idea the previous Christmas, although neither had gotten around to discussing the story line. That didn't matter to Beth, who simply wanted to play around with styles of illustration.

At first, she drafted a series that included one face with a landscape, or a face and trees. The greenery gradually disappeared and its place was taken by another face. Both were androgynous, but Beth thought of them as women's faces. Eventually, just before her son, Tai, was born in 1987, Beth found herself drawing a mother and child. After Tai's birth, Beth drew only babies. Despite the subject matter, these are not idealized madonna and bambino images, as a tour of Beth's house in Missoula, Montana, will reveal. For instance, a child and mother — she has a green face — peer over Tai's crib. In his parents' bedroom next door, two fat-faced babies stick out their tongues, mirroring the gesture Beth made in a childhood snapshot, now pinned on a bulletin board in her basement ceramics studio. One of Beth's larger paintings hangs in the living room, its wailing baby's face filling the entire frame.

Tai — who is named after the Chinese mountain Tai San — perches on his heels below that painting on this muggy summer afternoon, blithely banging an empty oatmeal box with a set of chopsticks. Beth sits on the floor with her toddler, tooting a toy saxophone, as engrossed as when she sings or plays electric bass with the Big Sky Mudflaps, the jazz-oriented rhythm-and-blues band that her husband, David Horgan, co-founded in 1975. From Beth's calm manner, you would never guess that David's family is visiting during a week when the Mudflaps are scheduled to play three concerts. Beth Lo — ceramist, teacher, musician, wife, and mother — puts the lie to the myth that artists can only create when they are far removed from the demands of daily life. If anything, her work has gotten stronger since the birth of her son, which seemed to kindle

Tai San, 1988 (front). Porcelain. H. 17" x W. 10" x D. 10". Photo by Beth Lo.

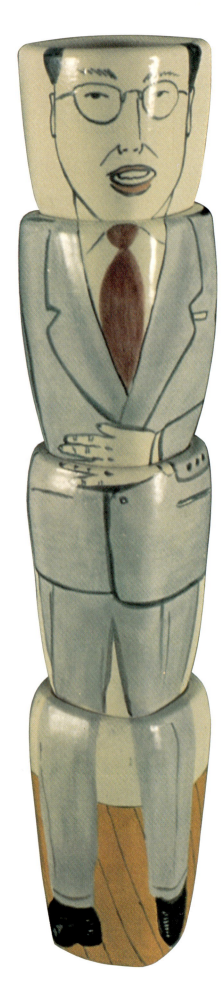

in her an interest in exploring family relationships and her Chinese-American heritage.

Downstairs in Beth's studio, she is working on two pairs of male and female figures modeled after her parents, who emigrated to this country from China in the early 1940s. One duo stands almost twenty-five inches tall, the other twenty-two inches. Both unglazed, white porcelain pairs look exactly the same, although the smaller couple was cast in a mold; the larger was first thrown on a wheel, then hand-carved to detail features and clothing. Beth plans to exhibit both pairs together, although she will also cast duplicates of the smaller couple and arrange those multiples in various configurations. For example, she plans to place the female figure, with hands primly folded in front of her Chinese dress, slightly behind the bespectacled male figure, right hand jauntily stuck in the pocket of his suit.

"That's how I remember them as a child," Beth says of her parents, who now live in Oregon, as does her sister. "My father wanted to become Western much more than my mother did. She was definitely more passive in the partnership and a little bit more conventional. When they would go out, that would be the outfit — Western suit and Chinese dress."

Her father, a former professor of aeronautical engineering, was born in Hunan province and her mother in Shanghai. He attended college in that city and they met and married shortly after the Japanese invaded China. In 1943, he left for the U.S., and his wife followed him the next year to the University of Michigan, where he received a Ph.D. His first job was in Newport News, Virginia, Beth's sister's birthplace, and then the family moved to West Lafayette, Indiana, where Beth was born in 1949.

Although Purdue University is in this town, Beth characterizes West Lafayette as "conservative." "It had a quality of no horizons, no future, nothing beyond that little town," she adds. "You just didn't get the sense of it having a character. Something to stand up for or be proud of. For me it had a slight quality of deadendness."

Only a few other Chinese-American families lived in Beth's hometown, a place where her parents encountered discrimination when renting or buying houses. Beth herself says she denied her Chinese background and wanted to be all-American when she was an adolescent. It's a time she commemorated in a platter called *The Introvert and the Extrovert* (1985). The platter bears the heads and partial torsos of two abstracted figures: a black-haired introvert on the left and a busty blonde extrovert on the right. "The two characters are me and the sort of blonde-bombshell person," says Beth.

Until she made this platter, Beth reflected personal experiences in her work indirectly, through the use of pattern. "I was trying to get my feelings out," she says, "but in much more abstract ways by putting everything into pattern, to show how pattern can reveal tension, conflict, or humor. I started thinking that the patterns and the colors 'speak,' but they don't speak to what I really want to talk about, which is much more specific, so I started trying to be much more direct with it."

After *The Introvert and the Extrovert*, the imagery in Beth's work became more figurative, a change she attributes in part to becoming an assistant professor of ceramics at the University of Montana in 1985. Once she had a steady income, Beth felt freer to experiment. In addition, after her son was born in 1987, Beth's time was limited and she was forced to use it more productively. "I used to waste a lot of time in my studio walking around in circles, cleaning up, and going shopping," she says. "Having the baby focused my time more. I would say, 'Okay, I have three hours; he's

asleep, get to work.' I think it made me a lot more direct. I have an idea and just put it down and I think that changed my style of working."

More recently, a book on the Ohio artist Jack Earl — whose ceramic tableaux depict his family members and other personal images — inspired Beth to pattern her male and female figures on her mother and father.

When she was growing up, Beth's parents encouraged her to be a scientist or engineer, despite her interest in art. "I was going to do chemistry for a while," she recalls. "I liked it, but I was a klutz. I was not good at it, I made too many mistakes." Beth didn't take art classes until she enrolled at the University of Michigan, her father's alma mater. That's where she discovered how much she liked the feel of clay and the calming effect of throwing clay on a potter's wheel. "It's mesmerizing," she says. "It felt like time went by without my knowing it."

After graduating from college, Beth spent a summer session at the New York State College of Ceramics at Alfred University, which is a well-respected program. In 1972, she moved to Missoula to attend graduate school at the University of Montana, another school with an acclaimed ceramics department. Her reason for coming to Montana was to study with Rudy Autio, who is now world-renowned for his vessels painted with voluptuous horses and women. As a teacher, Autio was invariably encouraging, says Beth. "There was no such thing as a mistake," she adds. "He always picked out what he liked and said positive things about it." After Autio retired from teaching at the University of Montana, Beth was offered and accepted his position. She and her husband have since moved into the same suburban neighborhood where Autio has lived for more than thirty years. Autio's art graces the cover of the Mudflaps' third album, *Shake, Rattle & Roll*.

Beth received her M.F.A. in ceramics in 1974 and joined the Big Sky Mudflaps soon after. For the next ten years, she made her living primarily as a musician. She worked in her ceramics studio when the band wasn't on the road. It used to be that the Mudflaps performed in concerts, clubs, and jazz festivals all over the country. But now that Beth teaches, and another band member is a county commissioner, the band mainly plays in regional gigs such as the annual summer party at the Archie Bray Foundation in Helena, Montana.

On the site of an old brickyard, the Bray has been one of the foremost pottery schools in the U.S. since it was founded in the 1950s. Every August, the Bray's director and ceramic residents and students throw a boisterous "Brickyard Bash" in one of the school's warehouses. Tonight, a crowd of two hundred fifty quaffs cups of draft beer and waits for the Mudflaps to tune up so they can dance. Beth blew out her electric-bass amplifier at a concert last night, so the Mudflaps are a little late in getting started, but once they begin to play around 10 P.M., they continue until 2:00 in the morning.

The Mudflaps hit their stride in the second set of the evening, and by the time they swing into Chuck Berry's "Sweet Little Sixteen" and "Johnny B. Goode," it's hard to muscle onto the dance floor. The Mudflaps, most of whom wear glasses, challenge the stereotype of dissipated rock-and-roll or blues musicians. It would be hard to find six more wholesome, studious faces, except in a chamber orchestra. But the prize for most intellectual looking goes to Beth Lo, whose long, elegant fingers handle the electric bass as delicately as if she were Yo Yo Ma playing the cello. Her womanly voice is another matter entirely. When she croons

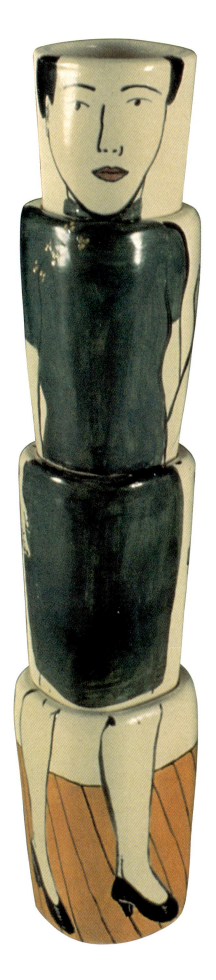

"Mama, He Treats Your Daughter Mean," she reveals herself as a true sensualist.

For the last five years, the Bray has paid the Mudflaps for their performances with ceramics made by resident artists such as Akio Takamori and Kurt Weiser, and some of these pieces line the fireplace mantle in David and Beth's family room. His guitar and her bass usually sit to one side of the fireplace; at the other end is a stereo and a quirky collection of albums, including *Too Many Rivers* by Brenda Lee, *Julie Is Her Name* by Julie London, and *The Brightest Smile in Town* by Dr. John.

A ground cover of toys creeps throughout the rest of the house, but the rubble is densest in the living room, near the piano. That's where Tai has parked his pint-sized red Jaguar, which makes an appearance in Beth's 1988 piece *Tai San*, as does his yellow "Animals of Alaska" T-shirt. *Tai San*, a twenty-inch-high porcelain sculpture composed of four separate vessels that stack on top of one another, displays two different scenes. On one side, an apple-cheeked child wearing Tai's brightly colored T-shirt rides a toy car; on the other side is an earth-toned rendering of the Chinese mountain Tai San, which the Chinese once considered as impregnable a stronghold as the Rock of Gibraltar. *Tai San* is a moving portrait of Beth's Chinese-American son, driving out into the world with the name of the last American frontier emblazoned across his small chest, the mountain for which he is named behind him.

Beth created several other stacking vessels in 1988, including *The Wedding*, a portrait of her parents, *Conscience*, and *Night and Day, You Are the One*. The two latter pieces show sitting women with diapered children atop their heads. All of the stacking pieces bear two images. For instance, in *Night and Day* a woman is depicted as awake on one side, asleep on the other.

The stacking form of all these sculptures was inspired by Tai's playthings — his building blocks and stacking toys — another example of how her baby sparked a new direction in Beth's work. But unlike many Renaissance madonna and child paintings, Beth's ceramic sculptures are not sentimentalized visions of maternity. The child may embody moral scruples in *Conscience*, and Cole-Porterish, blissful love in *Night and Day*, but there's also something vaguely sinister about the idea of a woman having a baby on her brain at all times, night and day.

Although she radiates serenity, Beth is a modern American mother who occasionally succumbs to the stress of a busy life. "It's real nuts during the school year," she admits. "There are weeks that go by where I don't end up doing my own work. I know that I'm not healthy unless I do something, even if I only work an hour a day. It releases a great deal of tension to work a little bit."

Just as she spent the last months of her pregnancy drawing her way toward having a baby, Beth Lo's modeling of porcelain figures after her septuagenarian parents seems to be an elegiac meditation on their aging, even as it looks back to a time when they were newly arrived in this country.

"My parents think it's weird that I'm doing images of them," says Beth. "I think it's too personal for them. They're very supportive of me doing what I want to do, but it makes them a little bit uncomfortable for me to be doing something this close. I can understand it. They're reserved people. I just hope they don't mind, because it keeps me feeling connected to them. It feels like it's a way for me to give energy to them now that they're older and I can't be with them all the time." ◆

PRECEDING PAGE:
The Wedding, 1988. Porcelain.
Each figure H. 17" x W. 4" x D. 4".
Photo by Beth Lo.

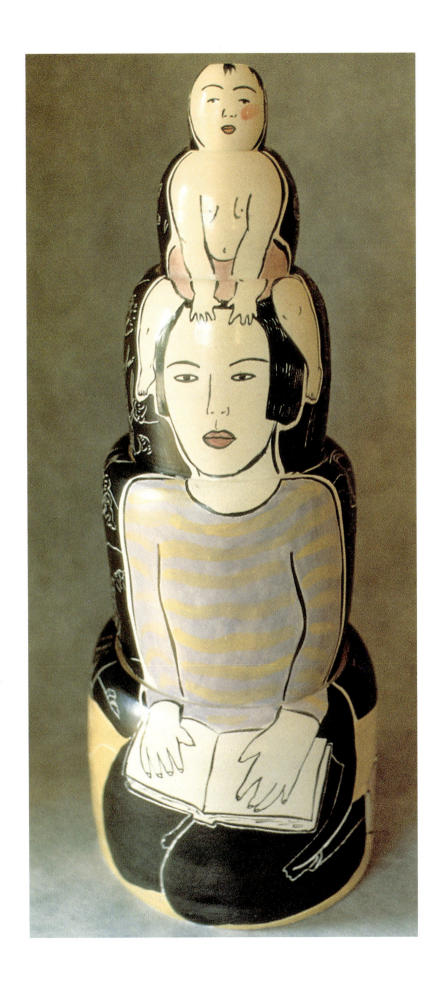

Conscience, 1988. Porcelain.
H. 28" x W. 15" x D. 10".
Photo by Beth Lo.

79 | ARTISTS AT WORK

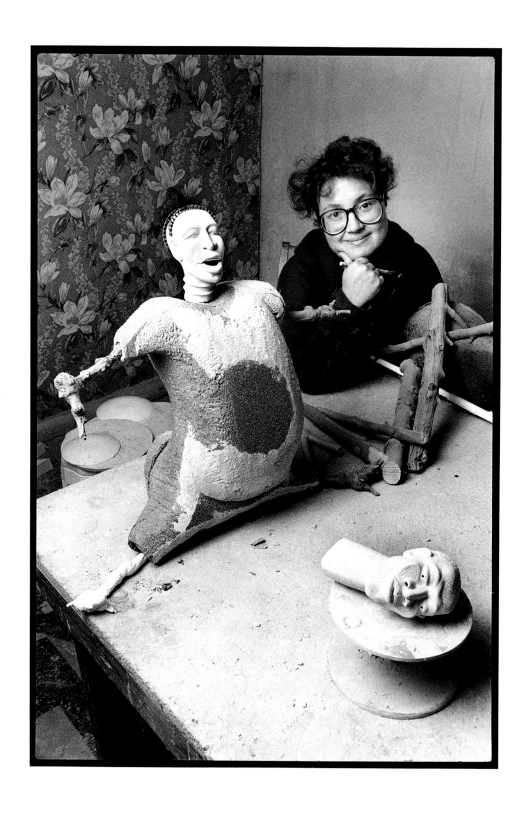

RONNA NEUENSCHWANDER
Ceramist

RONNA NEUENSCHWANDER

WHEN RONNA NEUENSCHWANDER, a ceramic sculptor who lives in Portland, Oregon, reminisces about West Africa — her husband's homeland and the inspiration for her art — she repeatedly speaks of sounds. For example, the sound of street noise when she met her husband, Wague (pronounced wah-gay) Diakite, over a makeshift foosball game he had set up in front of his family's house in Bamako, the capital city of Mali. And the collective sigh of relief she and seventeen other people breathed when they spotted a vulture, the first sign of life they saw after one day of being lost in the desert following a trip up the Niger River to Timbuktu.

Ronna first traveled to Mali in 1983, to study the camel caravans that transport blocks of salt carved from mines in Taoudenni — near Mali's border with Algeria and Mauritania — to Timbuktu, some three hundred miles south through the Sahara desert. In the early 1980s Ronna was making small earthenware sculptures of camels and elephants. What fascinated her was how these animals had been used throughout history as laborers and warriors.

For instance, in 900 B.C. an Assyrian queen ordered ox hides to be sewn and stuffed into the shape of elephants and then placed atop camels during battles to frighten enemy troops. Ronna sculpted a series of twelve earthenware pieces — "Queen Semiramis's War Elephant #1 - #12" — to commemorate this military event. These 1981 pieces anticipated Ronna's series of more disturbing sculptures that depict flayed animals' skins on sawhorses and frames, work that was also influenced by taxidermy photographs that Ronna saw while researching animals at the Museum of Natural History in New York in 1982.

In December of the following year, Ronna and a friend flew first to Dakar, Senegal, and rode a train east to Bamako in Mali. It was the first time that Ronna had ever traveled outside the U.S. She and her friend then took a plane to Timbuktu; after touring this centuries-old desert outpost, they hitched a ride with sixteen other people — mostly Arab and African merchants — in a Land Rover bound for Mopti, a port city some one hundred miles down the Niger River. It was an ill-fated trip from the beginning, when shallow waters forced a barge that ferried the vehicle across the Niger to put ashore at a place unfamiliar to the driver and the navigator. The two men kept looking for familiar landmarks to guide them across the trackless desert, but found none.

Assa, the Stubborn, 1988. Earthenware, adobe, concrete, and nails. H. 49" x W. 22" x D. 12". Photo by Ronna Neuenschwander.

"That first day was sort of shocking," remembers Ronna, "just because there was not any sign of life. There weren't tracks, there weren't bones, there weren't animal droppings, there weren't birds, there weren't lizards. It was as if no one or nothing had ever lived there. There weren't even any flies. So at the end of the day, when this huge vulture flew by, everyone was so happy. It was life, it meant something was out there. Isn't that interesting to think of a vulture as a sign of life?"

By nightfall, they spotted a goatherd and his flock. The man not only directed them to his village, but also sold them one of his animals. Dinner that night was goat-intestine soup (everyone had canteens of water), and breakfast the next morning was goat head. That night they made it to a village near Mopti, after two days of blazing sun and cold desert nights.

As Dorothy in *The Wizard of Oz* might have said, Ronna Neuenschwander wasn't in Hoxie, Kansas, anymore. Ronna was raised in this small farming town (population: seventeen hundred) in northwestern Kansas, the second youngest of five children of a doctor and his wife. "I had a very rich, stable childhood," says Ronna, who was born in 1954. "I feared nothing of life." Her parents, who had both grown up elsewhere in larger Midwest towns and cities, enjoyed hosting the interns who came to study in Hoxie's hospital. The couple particularly liked introducing their children to people of diverse ethnic and religious backgrounds, says Ronna, an experience that made her vow to live in a city when she was older.

Hoxie was not noted for its cultural amenities. The town's only movie theater burned down when Ronna was in the seventh grade, one year before the schools offered any art classes. In high school, Ronna took both mechanical drawing and ceramics, but her highest marks were in math, so she enrolled at the University of Kansas in Lawrence as a math major. However, she grew disenchanted with the level of competition among math students, and switched to ceramics halfway through her freshman year.

After she graduated with a B.F.A. in 1976, she moved to the college town of Corvallis, Oregon, to help a friend with a fiber commission for a church. When the project was over, Ronna headed north to Portland, where she divided her time between working as a secretary and making ceramic cups and teapots along with kitschy sculptures.

In 1978, five years before her ordeal in the African desert, Ronna had her first brush with death. Flying back to Oregon after spending the Christmas holidays with her family in Kansas, she was aboard a jet that crashed in Portland after losing its landing gear and fuel. Although 10 of the 189 passengers were killed, Ronna was completely unharmed. Unlike the panic she would suffer while lost in the desert, Ronna felt an unexpected sense of calm aboard the disabled airplane. "I had no trauma," she says, "but it made me confront a lot of things in my life." The result was that she quit her secretarial job and became a full-time artist.

Ronna is only five feet tall, but her hearty laugh could easily inhabit a larger frame. She seems like a sturdy craft able to weather vicissitudes that would capsize others. Even as a neophyte traveler in Africa, she spunkily embraced whatever came her way, be it speaking French, eating new foods, or learning how to sleep to the sounds that filled the airless African nights. "I felt like I was on Pluto, just a totally different planet," says Ronna. "Nothing that I knew existed there; it just wasn't part of life. It was so different that it couldn't be frightening, it had to be only exhilarating."

Following her harrowing episode in the Sahara desert, Ronna went

back to Bamako to spend more time with Wague, whom she had met before leaving for Timbuktu. Like Ronna, Wague is one of five children, and at night his family gathered to sing, tell stories, dance, and doodle. Because African children attend cash-poor schools that cannot provide textbooks, they grow up drawing in copybooks whatever they study, whether it's the world's rivers or the human digestive system. "No one is intimidated by drawing," says Ronna. "It's part of the process of everyday life there. No one would ever say, 'Oh, I can't draw,' like people do here, or 'No, I'm not an artist.' "

Although Ronna continued using animal imagery when she returned to the U.S., her sculptures became starker, reflecting Mali's desert and drought-stricken landscape. In addition to earthenware, she also began to experiment with grainier materials such as adobe and cement. And she started placing her animals atop models of African buildings such as granaries.

Meanwhile, she and Wague wrote to each other until he relocated to this country in 1985, when he and Ronna were married. He knew very little English — he and Ronna spoke in French — and was thus unemployable. To provide him with a way to earn a living, Ronna gave him the molds she had once used to produce a line of Art Deco-inspired cups and saucers. Wague had never touched ceramics; in West Africa only women are potters. Nevertheless, he quickly learned how to cast the black-and-pink porcelain ware.

Wague now makes his own line of functional pottery, decorated with sinuous snakes, lizards, storks, and other creeping, crawling creatures. Both his colorful, glaze-painted porcelain dinnerware and his terra-cotta sculptures of people and animals are sold in galleries in California and Oregon.

The northwest United States is a long way from exotic West Africa, but when Ronna and Wague are in their Portland, Oregon, studio, they work to the sounds of Africa. Sometimes they listen to tapes of African music, but more often Wague regales Ronna with an uninterrupted stream of African songs and lengthy folktales.

One of Wague's sagas, the story of a young woman who marries a river serpent by mistake, was featured in *My Dinner with the Devil Snake*. Ronna's sculptures animate this short 1989 film feature, which was commissioned by "Live from Off-Center," a nationally broadcast Public Broadcasting System TV program. Ronna and Wague collaborated with two friends in Portland on *My Dinner with the Devil Snake*, filmmaker Jim Blashfield and 3-D animator Joan Gratz. In the film, Wague tells his tale during a dinner with Ronna and three friends. As he begins, Ronna protests, "Wague, this is a very long story. I've heard this story," in the tone of an indulgent but long-suffering wife forced to listen over and over to her chatty, charming husband's favorite yarns.

After Wague arrived in Portland in 1985, Ronna's work changed; for the first time in her career, she started sculpting the human figure. "The minute Wague came," says Ronna, "I couldn't do anything else. I had to do people. I don't know what flipped it." Her first pieces in this new vein were abstracted versions of the human form, but gradually they became more recognizable. In fact, Ronna even began creating some portraits of people she had met in Africa.

One such work is *Assa, the Stubborn* (1988), which portrays the headstrong daughter of a merchant, a man who is considered part of Wague's family. The girl stands, hands on hips, proud nose in the air, doing

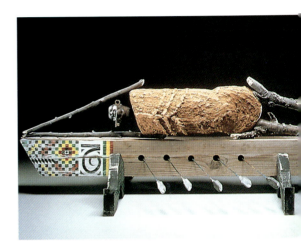

Ship's Hold, 1988. Earthenware, adobe, wood, metal, key, and acrylic. H. 19" x W. 62" x D. 24". Photo by Mel Schockner.

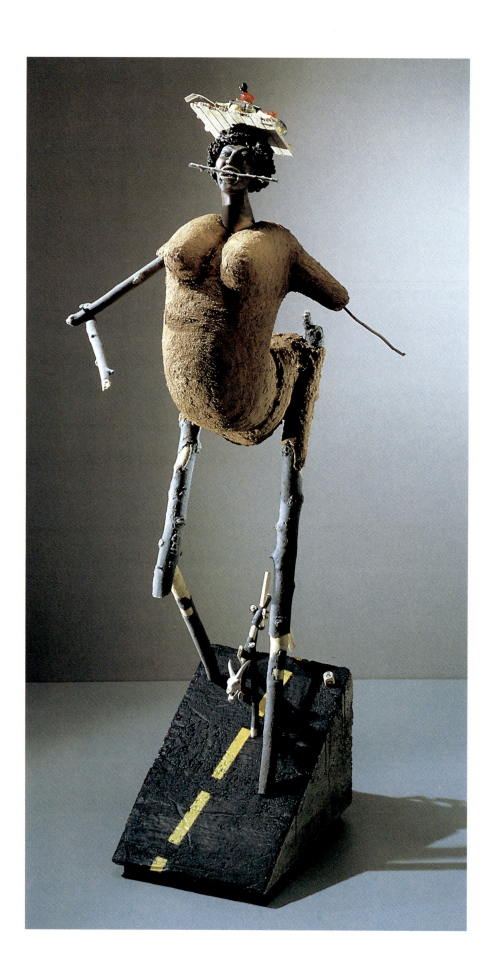

Nipping at the Heels of Progress, 1988. Adobe, earthenware, concrete, and found objects. H. 48" x W. 24" x D. 18". Photo by Mel Schockner.

the impossible — balancing one egg on the edge of a bowl. Like most of Ronna's figures, Assa's sticklike arms and legs are made of clay cast from branches. Ronna is presently working on a sculpture that depicts Assa's younger twin sisters, Adama and Awa (Adam and Eve), in their characteristic pose of sitting face to face and feeding each other.

In *Hearing Both Sides,* an adobe and earthenware female figure holds stick hands to her ears, as if listening to the two grinning, skull-headed animals — Ronna calls them "demon dogs" — crouching on either side of her feet. Ronna made this piece in 1988, and it sparked a new direction in her work. Unlike her previous work, which featured squared-off torsos, this figure is more voluptuous, with breasts, a protruding stomach, and a wasp-like abdomen. The texture is grittier, too — before, she smoothly troweled the surfaces of her sculptures — like the built-up adobe layers that Ronna saw on re-mudded mosques in Africa.

Hearing Both Sides inaugurated a different, richer look in Ronna's work, but she initially resisted the new trend. "I thought the piece was bad," she says, "and I couldn't figure out a way to make it work visually. I was just trying everything on it. I mean, wildly running around and grabbing materials and throwing things on it. I was a total hysterical mess, I thought there was no way to salvage it, that it had been ruined. Wague finally dragged me out the door and said, 'Leave it.' I felt that I had really failed this piece. But I came back the next day and very calmly looked at it and said, 'Yes, this is working.' "

Ronna and Wague have traveled back to Africa twice since he emigrated in 1985. In 1987 they stayed for six months; during that time, Ronna studied with women potters and learned more Bambara, the trade language of West Africa. In 1989 she and her husband spent three months building a new home for his family in Bamako. Ronna produces a snapshot of Wague taken during their last trip; he's standing in front of a fishing boat whose hull is painted with brightly colored squares, a decoration based on the patterns Mali's weavers use in their blankets.

This same pattern is repeated on the prow of *Ship's Hold*, a chillingly powerful piece about the slave trade that Ronna made in 1988, after finding a rusted latchkey on the beach opposite Goree. This island in the Atlantic Ocean off the coast of Dakar, Senegal, is where shanghaied Africans were imprisoned until they were shipped to America. The slaves were stacked into the ship's interior, shackled and lying on their sides, as the figure in Ronna's piece is portrayed. His mouth grimly clenches the old key that Ronna discovered on the beach.

Although Ronna and Wague do not collaborate on pieces, they often talk together about their work. Ronna occasionally derives ideas from elements in Wague's drawings. For example, the potbellied posture of a female in one of Wague's black-and-white paintings inspired the figure's stance in Ronna's *Nipping at the Heels of Progress*. The 1988 piece depicts a woman straddling the center line of a road, a bonnet of plastic gimcracks on her head, a "demon dog" pacing at her feet.

Sometimes, Ronna and Wague slightly alter each other's preliminary sketches of new pieces. "I know that people tend to talk about stealing ideas or rip-offs and that has always annoyed me," says Ronna. "I think that people are inspired by other people and I think that your imagination is triggered by many, many things. It could be a conversation, or reading a book, or traveling and seeing another culture. I do not think that art comes out of nowhere." ◆

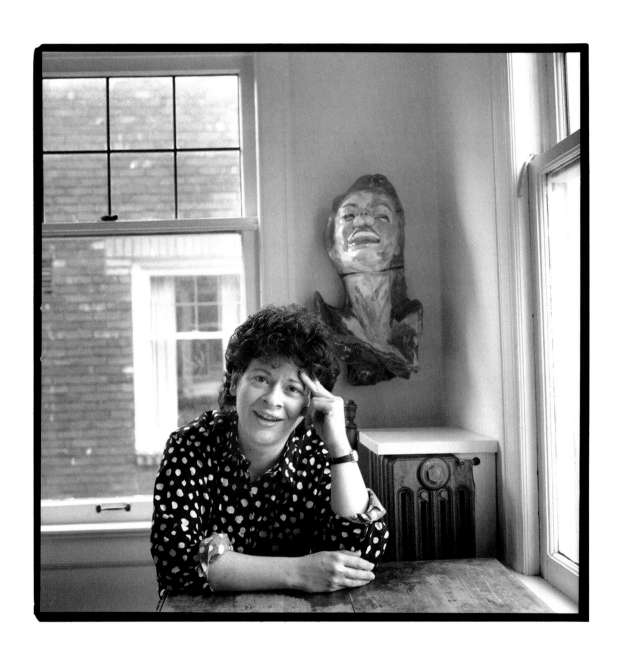

ANNE PERRIGO
Ceramist

ANNE PERRIGO

AS SOON AS SHE SPOTTED IT, Anne Perrigo knew she had hit pay dirt. It was late at night, and Anne was curled up under a blanket in her Seattle apartment, engaged in a few of her favorite pastimes — watching TV reruns and idly paging through vintage *True Confessions* and *National Geographic* magazines. In scanning old magazines, Anne was after a corny, dramatic gesture she could use in modeling figures in her ceramic sculptures. She often got some of her best ideas in this way.

For example, a woman's Jekyll-and-Hyde faces in an ad for Midol, a pain medication for menstrual cramps, had supplied the theme for a 1982 piece, *Betty's Sad/Betty's Glad*, twin busts of a smiling, flower-headdressed woman and her unadorned, frowning counterpart. A detergent ad highlighting a housewife's humiliation over gray laundry sparked *I Was So Embarrassed I Wished the Floor Would Open Up and Swallow Me*. In this 1985 sculpture, a mortified woman — hands to her face, surrounded by ceramic floor tiles — is shown in the process of getting her wish.

As Anne watched reruns of "The Alfred Hitchcock Show," she picked up a 1941 *National Geographic*. And there it was, near the front of the magazine — a full-page ad for Hamilton watches. It pictured a formally attired father comforting his tearful daughter, the bride-to-be, as her mother anxiously peered out the church door, hoping to see the overdue bridegroom. The copy read, "I'm the groom who was late to his own wedding! Sure, that's one for the gag books, but it wouldn't be so funny if it happened to you."

The ad's portrayal of a tardy bridegroom as a full-fledged crisis intrigued Anne and so did the triangular shape of the bride's veil. It reminded her of the huge, tiered wedding cake atop a popular Seattle bakery, and she envisioned making a sculpture of a woman wearing a wedding-cake skirt. She knew that she would sculpt the figure's head and torso in stoneware clay, which she would then cut apart, hollow out, and reassemble;

I Was So Embarrassed I Wished the Floor Would Open Up and Swallow Me, 1985. Clay, glaze, china paint, tile, wood, and googly eyes. H. 30" x W. 19" x D. 17". Photo by Roger Schreiber.

that was her usual method. But she couldn't figure out a way to make the skirt layers. Constructing the skirt with coils of clay would make it too heavy for Anne to lift by herself. And plaster over chicken wire, although light in weight, would chip too easily.

It wasn't until five years later, in 1987, when she was working as a resident artist at the Bemis Foundation — a nonprofit organization in Omaha, Nebraska, that provides studios, housing, and a monthly stipend to selected visual artists for periods up to one year — that Anne discovered a solution. While visiting another artist's work space, she noticed an overturned, galvanized-tin washtub, and immediately realized she could build a tiered wedding dress simply by stacking three washtubs of graduated sizes. Once she solved her design problem, Anne assembled her piece in three months in 1988. She called it *Late*, in memory of the Hamilton watch ad.

Like many of Anne's ceramic sculptures, *Late* features the figure of a red-haired woman, bedecked with objects that Anne found in Salvation Army and Goodwill shops. For example, the woman wears a yellow plastic wristwatch. Mounted in front of her belly is a turquoise clock, the embodiment of the phrase "biological time clock." A length of copper wire suspends a bouquet of plastic flowers over the figure's head, as if she has just tossed it to the unmarried women at her wedding reception. The life-sized torso rests on a three-decker, washtub skirt covered with glued-on metal and plastic numbers. At either end of the bottom and largest washbasin are the bride and groom figurines that usually sit atop wedding cakes.

Anne's sculptures often poke fun at the roles American culture assigns to women. The pressure to marry is the subject in *Late*, and quite a few of its details contribute to the sense of urgency, from the frantic expression on the figure's face, to the two timepieces on her body, to the countdown numbers on the washtubs. The three washbasins serve a double purpose: they not only structurally support the figure, but they also allude to a chore that still is considered women's work. *Late* subverts society's idealization of the wedding day by depicting the bride as a harried washerwoman.

Romance also takes its knocks in Anne's work. *Magnetic Attraction* (1985), for instance, is a nightmare version of love, its male and female figures yoked together not by mutual captivation but by narcissism and blind need. The female entwines her arms around a male whose face is half Mexican-tin-can mask, half mirror. She gazes into the mirror. Both figures are encrusted with toy magnets, and he sports a crew cut of lethal-looking, spiral-twist dry-wall nails.

In the same way that Anne ransacks thrift shops for castoffs to use in her sculptures, she also mines American speech for clichés and colloquialisms, which act as a springboard for some pieces. *You Catch More Flies with Honey Than with Vinegar* (1986) is the literal depiction of that homily. It shows the heads and torsos of two women coated with a runny ceramic glaze that resembles honey. Stuck here and there on the women's hair and arms are oversized plastic insects that are simultaneously colorful and repellent.

Anne herself experienced those two warring emotions when she first saw the mixed-media sculptures of Edward Kienholz at the Los Angeles County Museum of Art in 1969. The show included several of Kienholz's scathing sculptures, including *The Illegal Operation*, which depicts an abortion. Although Anne couldn't figure out what the Kienholz piece was about — she recalls she was "an exceptionally sheltered" sixteen-year-old

Late, 1988. Clay, glaze, china paint, washtubs, house numbers, clock, copper wire, and plastic flowers. H. 60" x W. 48" x D. 30". Courtesy of Mia Gallery. Photo by Bill Batson.

when she saw the show — she was fascinated by the glossy fiberglass resin that coated the sculpture. "The surface was very much like ceramic glaze," she remembers. "It was really attractive. I wanted to touch it and I didn't want to touch it. Like a strange insect, or a reptile, or an amphibian, it was a little bit repulsive."

Anne Perrigo isn't afraid of putting her finger on the tawdrier aspects of American culture. The rag-and-bone woman of Northwest ceramic sculptors, she scavenges shopworn expressions and possessions and transforms them into art. She comes by her recycling instincts naturally. During her childhood in California, the burgeoning Los Angeles freeway system condemned for demolition whole neighborhoods of houses near her home. Every weekend, her parents raided the yards of these abandoned houses for everything from plants to sprinkler pipes to patio bricks, which they then installed on their own property. As soon as they finished these improvements, the Perrigos would sell their house and move to another. During the three years that Anne attended junior high school, for instance, her family moved three times.

An only child, Anne was often dragged along on her parents' instant landscaping forays. "My father would go back several weekends in a row if he had a particular palm tree he wanted to dig up," Anne recalls. "I mean, these things were HUGE! One time he dug up a ten- or twelve-foot banana plant and transplanted it to our yard."

To this day, Anne is a connoisseur of garden bric-a-brac. "You see more concrete deer in the Seattle area," she says solemnly, as if she were discussing eighteenth-century architectural ornaments. "But in California it's more Mexicans sleeping by burros and tiki torches on the patio."

Because they lived near Anaheim, Anne's family would squire visiting relatives to Knott's Berry Farm and Disneyland. As usual, Anne had her eyes open. Two of her pieces refer to the titillation of funhouses in amusement parks, including *That Delicious House of Mystery* (1988), in which a busty redhead sits atop a doghouse that serves as her skirt. Peering inside a lighted keyhole at one end of the doghouse, you'll spy the redhead's shapely legs and rhinestone-covered highheels, a voyeuristic peepshow under her skirt, into the House of Mystery.

The redheaded, curvaceous cuties in Anne's sculptures recall forties and fifties calendar pinups, as well as steamy illustrations in detective or romance novels or magazines such as *True Confessions*. Sex is the subtext in Anne's sculptures. Using stereotypically erotic female postures and body types, Anne transmogrifies sexual stimulation into visual hyperstimulation by gunking up her sculptures with garish gewgaws. These are affixed to the piece with an adhesive after it's fired.

Anne first combined knickknacks with ceramics as an undergraduate student at the University of Washington in Seattle, where she studied with the ceramic sculptors Howard Kottler and Patti Warashina. Warashina is known for her tableaux satirizing male/female relationships, Kottler for his outrageous use of tacky materials such as Last Supper decals. Their students would cruise Seattle's huge Goodwill store every afternoon, searching for discounted discards. It was there that Anne found a cup and saucer she later used to make a piece that parodied ads for objects "so small they fit in a teacup." Anne made a tiny ceramic Chihuahua and placed it in her found teacup.

"I'm really uncoordinated," says Anne, whose stately, womanly voice camouflages a slyly subversive sense of humor. "It was hell learning to

Magnetic Attraction, 1985 (detail). Clay, glaze, china paint, magnets, nails, mirror, and metal toys. H. 27" x W. 26" x D. 16". Photo by Roger Schreiber.

throw clay on a wheel. I knew it would just take forever to throw a cup and saucer. So it was easy to go down to the Goodwill and pick up a cup and saucer and just put the wet clay dog in the cup and fire it — because glaze sticks to glaze when it's remelted. And it was a good thing to do because I learned that you can put *anything* together."

After she graduated with a B.F.A. in ceramics from the University of Washington in 1976, Anne attended the University of California at Davis. She studied with the Funk ceramic artist Robert Arneson, famous for scatological sculptures and nonheroic busts such as *George and Mona in the Baths of Coloma* (1976), which pairs a leering George Washington with an enigmatic Mona Lisa.

A friend in graduate school presented Anne with a stack of *True Confessions* magazines from the 1940s and 1950s that he had picked up in a used bookstore. "It just changed my life," says Anne. "It was exactly what I needed. It took what I was already attracted to and gave it an emotional content and a format. These magazines had a story line that was close to those in comic strips. What I liked was the lowest common denominator, being able to get down and dirty. And we all know about that era, so it triggers an expectation, and then I can throw in a twist."

Since receiving her M.F.A. in sculpture from the University of California in 1978, Anne has moved as often as her gypsy parents. Although she considers Seattle home, she has worked as a resident artist in nonprofit, visual arts centers from Portland, Oregon, to Sun Valley, Idaho, to Sheboygan, Wisconsin. She has also taught ceramics in various schools in Seattle and in Omaha, Nebraska. Her latest teaching stint was at the University of Southern California in Los Angeles.

As a Northwest exile temporarily living in California, Anne spent her time visiting museums and tourist attractions such as the La Brea tar pits. Because thrift shops in Los Angeles were overpriced, she scouted hardware stores for items like lawn ornaments, and unearthed a cache of "nicely colored" birds. It's likely they will turn up someday in a piece by this black humorist, this connoisseur of American lowbrow culture.

"A lot of people hate the stuff I do because it's in bad taste," says Anne. "Well, of course it is! But it's human." ◆

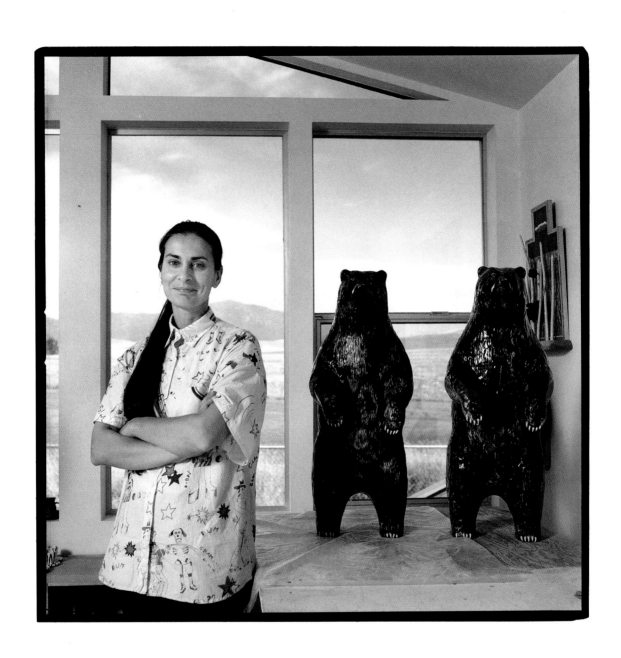

MARILYN LYSOHIR
Ceramist

MOSCOW, IDAHO

MARILYN LYSOHIR

AT FIRST, MARILYN LYSOHIR misunderstood what the man said. Marilyn knew him slightly; an expert on World War I, he was the director of a small museum near her storefront ceramics studio in Palouse, Washington. This November day, he dropped by Marilyn's studio to see her work-in-progress — a monumental, twenty-four-foot-long battleship she was constructing of earthenware-clay blocks and slabs, with wood supports. The smaller clay pieces that would accompany this battleship were already finished: a life-sized, towel-clad female figure; a pedestal sink; and a bathtub containing a four-foot model of a battleship. Marilyn considered her installation an anti-war piece, and she hoped that the incongruity of viewing bathroom fixtures juxtaposed against a battleship would make people realize that no one is safe in today's weapons-crazy world, not even in the most private room of the house — the bathroom.

Marilyn planned to cover her huge battleship with the same colorful, geometric patterns she had painted on her bathtub battleship, patterns she appropriated from an antique folk-art ship she bought some time ago in Sharon, Pennsylvania, the steel-mill town where she grew up. In fact, this little toy battleship had inspired her current piece, which she was making for an upcoming show at the prestigious Asher/Faure Gallery in Los Angeles.

When the historian visited her studio, Marilyn had already been working for over a year on her installation, painstakingly hand-building every section of the piece. After all that labor, it's understandable that Marilyn mistook the historian's admiring comment on her bathtub battleship — "Boy, that is dazzle" — as a compliment. But then he explained that the decoration she had copied from her folk-art toy ship

The Dark Side of Dazzle, 1986 (ship). Clay, wood, and sound. H. 108" x W. 288" x D. 52". Photo by Susan Einstein.

Bad Manners, 1983 (detail). Clay and wood. H. 50" x W. 126" x D. 84". Photo by Rick Semple.

to her bathtub battleship was a marine camouflage used during World War I and called "dazzle camouflage." Unlike the earth tones and amorphous shapes of the army's woodland camouflage, dazzle camouflage was composed of brightly colored, geometric designs. Because it exaggerated distances and speeds, the Allies painted dazzle camouflage on the sides of their battleships to confuse enemy ships, said the historian — a crucial strategy during a time when sea battles were still fought with guns that had to be aimed by eye.

The historian's story so intrigued Marilyn Lysohir that she called her piece *The Dark Side of Dazzle.* And by the time the large ceramic installation was displayed by the Los Angeles gallery in August 1986, it included seven parts that were decorated with dazzle camouflage: the twenty-four-foot-by-nine-foot-by-four-foot-four-inch battleship, the four-foot bathtub battleship, three small battleships in the medicine cabinet, a washcloth crumpled on the top of the sink, and a towel wrapped around a six-foot female figure. The colorful design helped to pull together all the disparate ceramic pieces of this visually complicated piece, Marilyn's largest to date.

In addition, the piece included twenty-four chairs arranged along one side of the huge battleship, so that people could sit and listen to a half-hour-long tape of war stories told by Marilyn's friends and family. The men who recounted their experiences had served in World War II and the Korean and Vietnam wars. Many of the tales are not for the fainthearted, especially one of a battle in Italy during World War II:

"We took the dead and we stacked them in piles of 90, like cordwood. You crisscrossed them, like a box-shape of four. And most of the dead were without legs, without arms. Some — most of them, a lot of them — were headless, and it was just a real nightmare."

In stories begins Marilyn Lysohir's art. She was born in 1950, the granddaughter of four Ukrainian immigrants, and she grew up listening to her grandparents' reminiscences, her father's tales of trench warfare in Europe during World War II, her mother's sunnier remembrances of serving as a sergeant in the Women's Marine Corps. Marilyn commemorated her mother's wartime service in a piece she made in 1980 called *The B.A.M.s,* the acronym for "Big-Assed Marines," the derogatory nickname for the female marines. At her mother's request, Marilyn portrayed the uniformed female marines in *The B.A.M.s* as trim; six of them stand behind five others who are seated, with toy soldiers on their laps.

Marilyn's soulful Slavic face has the kind, attentive look that marks her as a good listener, a look that must have impelled many people over the years to confide in her. When she worked as a teenager in Daffin's Candies, a chocolate shop in her hometown, owner Pete Daffin spent many an hour regaling her with his World War II adventures. Marilyn included one of his most interesting tales in *The Dark Side of Dazzle* — of the time he saved Florence, Italy, from bombing by the Allies, who thought that a German Panzer division was encamped in the city. Pete's advance reconnaissance convinced an American battalion commander otherwise, and Pete says a plaque in Florence thanks him for the favor.

After Marilyn graduated from Ohio Northern University in 1972 with a B.A. in art education and had spent a year teaching art history and mechanical drawing in a local high school, Pete asked her to build a large chocolate rabbit for a shop display. He wanted it to stand four feet tall, but Marilyn goofed and made an eight-foot rabbit. Customers liked it so well that Pete commissioned her to make a matching female rabbit, as well as a

huge chocolate rhinoceros, a turtle, geese, and elephants. All of Marilyn's creations are still displayed in the store, although over the years, the animals' legs have acquired tiny bite marks from their pint-sized admirers.

Big chocolate bunnies may seem a far cry from *The Dark Side of Dazzle,* but both attest to Marilyn's facility as a sculptor. Although she originally preferred painting classes in college, a professor once glanced at some of her sketches and pronounced her a sculptor. "I thought I was a painter," says Marilyn. "I really did like painting. And I did clay, but I didn't see clay as sculpture. It was all vessel-oriented. And this professor — he was a sculptor himself — looked at my drawings and said, 'You're not a painter, you're a sculptor.' I don't know how he could tell, but he was right." After that, Marilyn switched her course emphasis to ceramics.

In the summers between college semesters, Marilyn came back to her hometown and studied with the ceramist Chick Mangus, whose wife had been Marilyn's high school art teacher. After college, Marilyn taught art at her alma mater and various high schools for four years, then entered graduate school at Washington State University in Pullman, where she majored in ceramics and minored in sculpture.

It was when she was in graduate school, where she studied with the ceramist Patrick Siler, that Marilyn began making large ceramic sculptures, such as her 1978 piece *Bed and Board,* in which food — everything from bananas and brownies to cabbages and cupcakes — is messily piled all over a bed covered with a white chenille bedspread.

Since receiving her M.F.A. in 1979, Marilyn has continued creating ceramic sculptures, many of which include trompe l'oeil effects that make people wonder whether they are made of clay. And once they realize, for instance, that the Crest toothpaste tube lying on the pedestal sink in *The Dark Side of Dazzle* is indeed a ceramic item, they often ask "Why clay?" — a question that exasperates Marilyn. "I could just punch them right in the nose when they say that," she admits. "Because it's like, why paper? Why paint and canvas? Why metal? That's not the issue anymore — it's just whatever you're trained in, and I was trained in clay. And so I continue to work in clay. If I have that talent, then I'm going to use it."

In 1988 and 1989, Marilyn was an artist-in-residence at the Kohler Company in Kohler, Wisconsin, one of a handful of ceramists chosen each year by this manufacturer of porcelain bathroom fixtures. Artists in the prestigious arts/industry program have full access to Kohler's extensive factory facilities. While Marilyn was a resident at Kohler, she worked on a number of pieces she called "The Last Immigrant" series, which consisted of porcelain bear heads and statues of bears. The series culminated with a seven-foot-eight-inch cast-iron bear. Because of Marilyn's experience sculpting large chocolate animals, she didn't find it daunting to sand-cast the huge bear. "That was the first thing I thought," she remembers. " 'Oh, this will be nothing because I've done eight-foot rabbits.' "

"The Last Immigrant" series memorializes Marilyn's mother's mother, who died in 1987 at age ninety-nine, the last surviving grandparent of four who had emigrated from the Ukraine. Marilyn's grandmother came to the U.S. when she was sixteen years old and traveled to Sharon, Pennsylvania, where many Ukrainians worked in the town's factories and steel mills. The bear, of course, is an old symbol for Russia, but Marilyn was not conscious of that connection. She chose the bear for its powerful visual image. In addition, she associated the animal with her grandmother because both bears and her grandparents' generation of

immigrants used to be numerous in this country, but now their numbers are dwindling.

By coming to the U.S. in the early 1900s, Marilyn's grandparents escaped the fate of millions of Ukrainians who starved to death in the 1930s, the result of crop failures in the U.S.S.R.'s bread basket and Stalin's grain seizures, which were meant to punish the Ukrainians for protesting state control of their farms. As the granddaughter of Ukrainian immigrants, Marilyn Lysohir is keenly aware that food can be used as a weapon, and many of her pieces feature food as a menacing presence. For example, in *Bed and Board*, the effect of piles of food heaped on a virginal bedspread is disturbingly surrealistic.

Bad Manners, which Marilyn made five years later, in 1983, shows the dark side of abundance in the land of plenty. It's a nightmarish Thanksgiving feast presided over by four headless, life-sized figures — two male and two female — sitting at a six-foot-long table completely covered with a sickening assortment of food: cakes and pies, a turkey and ham, a watermelon, a stack of pancakes, an entire fish, a bowl of spaghetti topped with an ear of corn, a hot dog on a layer cake, a slice of pizza resting in a salad bowl. And sprinkled over everything are dozens of chocolates, a sly reference to Marilyn's days at Daffin's Candies.

Food also figures in Marilyn's 1981 piece, *The Fourth Sister.* In it, three life-sized brides in full regalia primly incline toward individual, four-tiered wedding cakes, their dainty mouths open in anticipation of the next bite. Marilyn made the piece to commemorate her mother's four unmarried sisters. She only featured three women in the piece because she thought four brides and four cakes would be visually overwhelming. But she called it *The Fourth Sister* to create dramatic tension. Oddly enough, Marilyn's piece was prophetic — three years after it was completed, one of her mother's sisters married, when she was in her sixties.

Marilyn herself married at thirty. Her husband is the artist Ross Coates, who makes mixed-media assemblages. Both now work in their Moscow, Idaho, home — Marilyn's studio is in the garage, Ross's is through the laundry room, at the rear of the house — and eat lunch together every day. Marilyn's marriage inspired the 1981 piece *Alligator's Wife,* in which a bride slumbers on the back of a fifteen-foot alligator atop a bed of wedding rice. Bright lights frame the piece, making it as lurid as a cinema marquee. *Alligator's Wife* is both as titillating as Fay Wray's abduction by King Kong, and as unsettling as the fairy tale "Sleeping Beauty."

Sitting in her kitchen, studying a color slide of *Alligator's Wife,* Marilyn explains: "She's not really dead, she's in a state of limbo, sleeping. The piece is about transition, the end of something and the beginning of something else. It's also about the fear of marriage — will it work or not? It came from World War II, too, from that idea of the war brides left behind. They could do nothing except wait, they were helpless. The stringing of the lights came into the design of the piece after I saw *Apocalypse Now.* There was this scene where men were in a foxhole and they had these lights strung up."

There's a story behind the alligator in *Alligator's Wife,* of course, and Marilyn produces the evidence: a photo of her father taken during a vacation in Florida. It shows a young man smiling and squinting into the sun, crouched behind a stuffed alligator — a snapshot sent to the woman who would later marry him and bear his six children, the second oldest of whom would grow up to transform this moment into art. ◆

The Fourth Sister, 1981 (detail). Clay and Plexiglas. H. 69" x W. 144" x D. 96". Photo by Margaret Ford.

PATRICK SILER
Ceramist

PULLMAN, WASHINGTON

PATRICK SILER

"LOOK FOR THE YARD with the sunflowers," Patrick Siler had said on the phone, but as I drive along his residential street outside Pullman, Washington, all I see is a wilderness of tract houses, each with a compulsively neat lawn that could have been copied from a *Sunset* magazine spread. Just ahead, though, something gaudy nods against the bright blue sky, its face the size of a roasting pan — a sunflower — one of dozens engulfing a suburban house that resembles the rest on the block, minus the lawn. Undergrown by assorted spiky, weedy flowers such as cosmos, the sunflowers range from mastlike giants to shrubby bushes. It's as if the owner had transplanted a messy replica of Van Gogh's beloved French countryside to eastern Washington.

The front door opens, and the mustachioed occupant himself appears, looking as disreputable as the 1955 Chevy pickup parked under his carport. Here is what Patrick Siler wears today, south to north: cowboy boots, jeans, a red sleeveless T-shirt, and a black cap that should bear the name of a farm implement manufacturer. As Patrick's short, compact body ambles toward me, it's impossible not to notice that he's missing his left front tooth.

He may dress like a good old boy, but when Patrick talks, he reveals himself as a walking compendium of art history, one who can thoughtfully discuss everything from Japanese Shino tea ware to the instructional quality of Renaissance paintings. If you mistook him for a yokel, the joke would be on you, for Patrick Siler is one of the Northwest's most sophisticated sculptural ceramists. His vessels and slab sculptures — covered with images done in an inimitable funky style — have been displayed in museums and galleries from California to Chicago, from Seattle to New York. Patrick is also an associate professor at nearby Washington State University, where he has taught drawing and ceramics since 1973.

If the outside of Patrick's house is reminiscent of Van Gogh's *Sunflowers* on steroids, the inside looks like a suburban homemaker's nightmare — June Cleaver on acid. Patrick has subverted the original floorplan by converting his entire house — save for bathroom, kitchen, and bedroom — into one big studio. The floor of what was once the living and dining area is covered with a wall-to-wall carpet of paint-spattered cardboard boxes and old paintings turned face down. Pinned

A Rude Awakening for the Surveyor, 1990. Stoneware plate with colored slips. Dia. 16⅞". Courtesy of Leedy-Voulkos Gallery. Photo by Al Surratt.

to the walls and ceiling are stencils Patrick has used to transfer images to his clay pieces: three seated figures draining liquor bottles into their mouths, a man running from another, a leaping naked woman wearing highheels, a skeleton pushing a lawnmower. Propped up along one wall is Patrick's latest piece, *Gesturing Men* (1989), an eight-foot-high, ten-foot-wide mural made of large, painted ceramic tiles. Quite a few tiles are arranged in groups of four to create different scenes. In one, a man in a prison cell holds out his arms in front of himself, as if measuring something; in another, a scroungy dog hiding behind a table watches a man waving his hands around.

Patrick Siler has been called "the Studs Terkel of the ceramic world," and the description is apt. Like the author of *Working,* Patrick documents the workaday lives of working folk, from briefcase toting to cruising in cars, from drinking beer to cooking chili. All of Patrick's figures have the antic quality of cartoon characters; even sedentary TV watchers or radio listeners bristle with energy. His stenciled silhouettes against a cream-colored, crackle-glazed clay surface are as edgy and stylized as the figures on Greek vases, and they are often shown participating in equally Dionysian activities. For example, the naked-from-the-waist-down male potter in *Kiln Room Debauchery* — one plate in Patrick's 1981 series of plates and tiles that depict the ceramic process, from wedging the clay to watching the kiln — resembles a naked Greek warrior, but he carries a wine bottle, not a spear, as he faces a panty-clad female holding a wineglass.

Originally trained as a painter, Patrick also makes wood-block prints and ink drawings, which are often rudely funny in their disregard for the censoring conventions of "good taste." The American teenager's favorite recreational gross-out, "shooting the moon," is the subject of *Mooners of the Palouse Prairie.* This 1986 wood-block print shows several naked rear ends pressed up against a car window; in the background is the moonlit landscape of the Palouse, as the wheat-growing region where Patrick lives is called.

Among his artistic influences, Patrick cites German expressionist paintings and prints, which he likes for their "intensity and severity." He also admires Chinese brush paintings and the visual economy of comic strips such as "Krazy Kat" and "Nancy." "Think of all the interpretations of the figure that you see in the comics," Patrick says. "I mean, it's pretty weird. Nancy as a figure? It's bizarre that that's supposed to represent a human being. Her legs look like a couple of macaronis. The cartoonist has this drawing shorthand, devices that suggest things without really drawing them. This suggests hair, this suggests the mouth, this suggests the shirt-tail. It's very to the point and effective."

When you ask him a question about his work, Patrick has a habit of crossing his arms and gazing in a sidelong way. Despite that glance, it's clear that those eyes don't miss much. Patrick seems to sop up visual images the way sunflowers soak up ultraviolet rays. Even what he describes as the "strong repeated form" of six urinals in a men's room catches his eye.

He's inspired by diverse everyday images, such as people gabbing on the telephone or driving. He sometimes gets ideas for his art from listening to country-western music. "A lot of country-and-western music is so damn maudlin and sappy that you can't stand it," he says. "It's just such drivel. But then, sometimes when you hear a song, it strikes you as so true that you think, 'That's the way it is.' "

As an example, he mentions the words, "Give me back that old

familiar feeling," from a country-western song. "It wasn't such a great song," says Patrick, "I only heard it once, but that phrase made such an impression on me." In fact, he liked those seven words so much that he depicted them emanating from an old-fashioned radio in his 1987 send-up of capitalism, *Pillars of Enterprise*. This huge wall — seven feet high and fourteen feet wide — is made of seventy-eight irregularly shaped ceramic blocks covered with stenciled figures. The four corners are occupied with people engaged in frenzied recreation — a honky-tonk pianist, a chili maker, beer drinkers in cars, and a man puffing on an enormous stogie.

A skyscraper, a pillar of enterprise, dominates the center of the piece. It obviously controls the lives of the male pillars of enterprise who rush toward it, as if late for work. The eighteen businessmen all wear fedoras and suits and carry briefcases, but their bodies are shown in different attitudes of haste. One leaps, one climbs, some stride, but most keep their heads down as they trudge, as if leaning into a strong wind. "I thought that guys going to work with briefcases was a very droll situation," explains Patrick. The piece also has a darker meaning, as exemplified by a briefcase-laden skeleton at the bottom right of the skyscraper. Like medieval dance-of-death murals, *Pillars of Enterprise* reminds us of our fate as we blithely pursue the American Dream.

The automobiles, appliances, and apparel in *Pillars of Enterprise* date from the 1940s and 1950s, the years of Patrick's childhood. He was born in 1939 in Spokane, Washington, but his family moved west to Tacoma soon after so his father, a welder, could work in the shipyard there. His mother taught in an elementary school. Patrick made up his mind early he would be an artist. "When I was a kid in grade school," he remembers, "I liked to do art and that was what I knew I wanted to do. If I had listened to other people closely, I could have gotten talked out of it, because nobody was saying, 'Be an artist, that's a great life.' But I always wanted to do it 'cause I was intrigued by it."

He continued to be interested in art in high school, even though he was a poor student, like most of his friends. The kids he palled around with as a teenager were the kind of people he often portrays in his art: car-cruising, cool dudes, who wore their hair slicked back and their cigarette packs rolled up in a T-shirt sleeve.

Although Patrick's parents pressured him to go to college, he says, "I liked it immediately. I really got intrigued by learning. It was a big surprise to me." Patrick attended a local college for one year, and then transferred to a school on the eastern side of the state — Washington State University, where he now teaches. At WSU, Patrick studied with the painter Gaylen Hansen, among others. He received his B.A. from that school in 1961, and then attended the University of California at Berkeley. There, Patrick studied abstract expressionist painting, a dominant artistic movement in California at the time.

After receiving his M.A. in 1963, he switched his loyalties and began drawing recognizable images that were influenced by German expressionism. The early sixties were heady, radical days at Berkeley; the Free Speech Movement organized the nation's first major college demonstration there in 1964. Patrick began to hang out in the "Cal pot shop," presided over by another radical, the ceramic superstar Peter Voulkos. Ten years earlier, Voulkos had revolutionized American ceramics by treating pots — which he slashed, poked, painted, and punctured — as abstract expressionist canvases. From 1967 until 1971, Patrick worked as Voulkos's teaching

Jivin' Man Jim — Come to the Bar, 1990. Stoneware obelisk with colored slips and glazes. H. 38 ½" x W. 22" x D. 17". Courtesy of Leedy-Voulkos Gallery. Photo by Al Surratt.

assistant. He left Berkeley in 1973 to return to Washington and teach at Washington State University.

Today, most of Patrick's ceramics bear pictures, yet these images float in space, as the businessmen do in *Pillars of Enterprise*. Although he has abandoned abstraction, he attributes his loose handling of spatial relationships to his training at Berkeley in abstract expressionist painting.

"When you do nonobjective painting," he says, "you can put anything anyplace. You're just kind of manipulating form and space and color. If you want to make a red diamond in the top middle, you can do that. If you want to make blue circles in the bottom two corners, you can do it. You can do whatever you want. So if you work with that idea of manipulating forms and space in this kind of free fashion, then when you start using subject matter it's a lot easier to do the same thing, to put things wherever you want them to go, not necessarily the people at the bottom and the sky at the top. That had a great deal of influence on most artists of my generation."

It was while he was a student at Berkeley that Patrick developed the habit of taking a late afternoon coffee break, a practice he continues to this day in the coffee shop of a nearby motel, which he likes for its anonymity. There he spends a couple of hours drinking java and reading, or watching people and drawing in his journal. Currently all of Patrick's ceramic pieces begin with a doodle or drawing sketched in one of three bound notebooks; Patrick keeps one at home, one in his car, and one at school. Even though he divides each eight-and-one-half-inch-by-eleven-inch page into quarters, he fills up a notebook every few years. "I jot down ideas in here all the time," he says. "Even if it's the middle of the night, I'll get up because I don't want to forget anything. Of course, I've got more ideas than I'll probably have time to do, but you never can tell."

As he shows his notebook drawings, Patrick repeatedly chuckles with delight, like a chef appreciating his own cooking. When he comes to a doodle of two beer-bellied men standing near a curb, he laughs out loud. "I was driving one day," he explains, "and there was this guy on the street who had a HUGE stomach. It really caught my eye. But it turned out, a fraction of a second later I drove by again, and it was two guys! They were standing in such a way that I could only see one head, but both of their stomachs. It was funny."

He continues flipping through pages of drawings. Many show people in cars, which Patrick considers "an intriguing subject. It just looks really interesting — a human being in a machine." Patrick often uses the word "intriguing" to describe visual images, including humble, ordinary sights most people would take for granted. He reveals he came up with the stairstep pants worn by Mr. Jiggy-Jaggy Man, a scampering figure who graces many of his vessels, when he was trying to draw herringbone-patterned pants. "You know, lines going this way, lines going that way," says Patrick, as if anyone could have invented Mr. Jiggy-Jaggy Man's distinctive pants. "Kind of an exaggerated tweed. So it came out being kind of a meandering zigzag."

A sketch of a man entering a doorway was done just a few days ago, after Patrick saw someone going into a local restaurant. "It struck me as a real strong image," he says. "The door, of course, has all kinds of symbolic connotations going back thousands of years. But this figure doing this simple thing — really, you could do drawings and paintings based on that for years."

Gesturing Men, 1989. Stoneware wall with colored slips and glazes. H. 98" x W. 126" x D. 2½". Photo by Lisbeth Thorlacius.

A number of doodles depict a buglike creature as an artist, a series inspired by all the ants around Patrick's cabin in southeastern Colorado, which he and two friends constructed of adobe bricks. The one-room, passive-solar cabin has no heat, electricity, or running water; Patrick spends at least a month there every year, drawing in the journal that he carries wherever he goes. For example, when he visited a friend in Chicago, he drew storefronts and paper-littered streets. In St. Louis, he sketched brick factory buildings, and in Omaha, water towers.

On his cross-country trips, he collects different varieties of sunflower seeds, which he then sows in his own fecund garden. A proliferation of sunflowers mingles with fruit trees Patrick planted in the backyard when he first bought his house. Standing underneath a tree laden with wine-dark plums, he urges me to taste some. They're not quite ripe, but that doesn't deter Patrick. "I like 'em kind of tart," he says, picking another handful from the tree. And then Patrick Siler — the visual omnivore who notices everything from cars to ants, from water towers to beer bellies — polishes off those plums in great greedy gulps, savoring each and every bite. ◆

JEWELRY

IT'S NO COINCIDENCE that some of the country's most inventive contemporary jewelry is made by artists who live and work in the Pacific Northwest. Part of the credit for the region's glowing reputation among museum curators and gallery owners is undoubtedly due to the excellent metalsmithing and jewelry programs in universities and colleges throughout Montana, Oregon, Washington, and Idaho.

Nevertheless, the primary reason the Northwest is renowned for its contemporary jewelry is directly attributable to the creative atmosphere fostered by two extraordinary teachers and jewelers, Ruth Penington and Ramona Solberg. Solberg studied with Penington in the University of Washington's metal design department in the 1940s and 1950s, then taught there herself until 1983, thirteen years after Penington retired from the school.

Through their teaching and work, these two women helped spawn an innovative, no-holds-barred attitude toward jewelry that is now considered indigenous to the region's artistic climate. If contemporary jewelers in the Northwest feel comfortable about including materials as diverse as typewriter keys, chamois leather, and bits of rubber hose in their work, they have Ramona Solberg and Ruth Penington to thank. Both women long ago abandoned the assumption that only precious metals and gems should be used in jewelry. For example, Penington has mounted humble beach pebbles in her work. And Solberg, who pioneered the use of found objects in contemporary jewelry, is well known for her love of everyday items such as old-fashioned underwear buttons and dominoes.

The contemporary Northwest jewelers who view the entire body as open territory for ornamentation are indebted to Solberg and Penington, too. Although these two women have concentrated on traditional jewelry forms such as pins, necklaces, earrings, and bracelets, they never sacrificed a bold statement to finicky daintiness. Solberg's pins and necklaces — witty assemblages all — possess the dramatic visual impact of the ethnic jewelry she admires. Penington's work, which has a more sculptural quality, was sometimes rejected by juries because it was considered too big to be worn comfortably.

Although both Solberg and Penington favor large-scale jewelry that includes unusual materials, they always pay attention to wearability as well as craftsmanship. Solberg, for example, is known for affixing necklace clasps on the sides of neckpieces, to make fastening easier. This

Ruth Penington. Bracelet, 1938. Forged and hinged silver. W. 1¼". Courtesy of the Bellevue Art Museum. Photo by Joe Manfredini.

design detail is typical of her practical nature, which is also expressed in her habit of photographing her necklaces and pins against backgrounds of colored terrycloth towels.

When Ramona Solberg calls herself "the Henry Ford of jewelry," she isn't comparing her creation of one-of-a-kind pins and necklaces to the assembly-line production method invented by the American automobile manufacturer. It's just that, like Henry Ford, Solberg designs her work to be affordable. In her typically down-to-earth, forthright way, she once said, "I don't like to make jewelry that is so elaborate or fancy that you can only wear it to the Governor's Ball. I want women to be able to wear it to the grocery store." For that reason, she composes her jewelry of nonprecious materials — antique buttons and beads, compasses and coins, mah-jongg pieces, and even Chinese lice combs.

Solberg finds beauty in these everyday yet exotic and old objects, many of which she buys in junk stores, antique shops, or street fairs and bazaars during her extensive travels. A populist at heart, Solberg is drawn to folk art and collects ethnic jewelry from all over the world. She thinks of her own work as ethnic, too, and many of her assemblages include nineteenth-century American amulets such as folding rulers, compasses, and ebony dominoes — tiny talismans that reveal this culture's fetish for measurement, exploration, gamesmanship, and play-as-political-theory.

Born in 1921 in Watertown, South Dakota, Solberg was raised in Seattle, where her family moved when she was one and one-half years old. Both her B.A. in art and her M.F.A. in jewelry and metal design were awarded by the University of Washington in Seattle. She was dubbed "typically American" in the early 1950s when she studied jewelry and enameling at the State Arts and Crafts School in Oslo, Norway, and it's true that her work demonstrates a maverick American attitude toward jewelry, which has historically been fabricated solely from precious metals and gems. Solberg's love of inexpensive, ordinary materials liberated entire generations of jewelry students during the thirty-two years she taught in public schools and colleges in Washington state. Two of the numerous students who were influenced by Solberg are the Seattle jewelers Laurie Hall and Ron Ho, both of whom are profiled in this book.

Ramona Solberg's first name means "wise protectress," and that is how she is widely perceived by her former students. "Ramona is someone who always taught with love," says Ron Ho. Solberg retired from teaching in 1983, after sixteen years as a professor of jewelry design at the University of Washington. Before that, she taught for eleven years at Central Washington University in Ellensburg and five years in Seattle public schools.

Solberg's teacher at the University of Washington, Ruth Penington, was born in Colorado Springs, Colorado, in 1905 and moved to Seattle with her family shortly after. She came from a family of talented craftspeople: her mother was a dressmaker, and her father's father built carriages, airplanes, and cars. Penington was handy, too, even as a small child; when she was just three years old, she sewed a pocketed apron for a doll.

In high school in Seattle, Penington's art teacher was Lulu Hotchkiss, who had studied composition and design with Arthur Wesley Dow, the head of the Fine Arts Department at Columbia University's Teachers College in New York City. According to an article by the curator LaMar Harrington in the *Archives of American Art Journal* (Vol. 23, No. 2, 1983), Dow was one half of a team that included the philosopher-historian Ernest Fenollosa. The duo, who greatly influenced arts education in America, didn't concentrate on painting alone in their teachings, but also focused on all three-dimensional work — including non-Western art — as well as all materials. Their theories, as taught by Hotchkiss, had an important impact on Penington, according to Harrington. She writes: "Her options for a career in art were wide open in a liberated atmosphere where no one suggested that any one art form or medium was more important than another."

Penington gravitated to metalwork as a student at the University of Washington, and then taught there off and on until she retired in 1970. She received advanced training at Teachers College, the Rhode Island School of Design, and the University of Oregon. In addition to jewelry, Penington has fabricated metal holloware pieces such as wine goblets, vases, and bowls; sterling-silver flatware such as cocktail forks, iced-tea spoons, and ladles; and liturgical items such as chalices.

Like her former student Ramona Solberg, Penington incorporates articles from other countries into her jewelry. For example, her necklaces, pins, rings, bracelets, and earrings have included such curiosities as Peruvian spindle whorls, Peking glass trade beads, and Egyptian tomb beads.

Despite a parallel fascination with the material culture of other lands, Ruth Penington and Ramona Solberg do not make similar work. For one thing, Penington occasionally employs precious materials such as gold, diamonds, and emeralds in her jewelry. And Penington, unlike Solberg, also includes bits and pieces of the natural world in her jewelry — bird feathers and shells, as well as pebbles from the beach near her Puget Sound cabin studio.

The diversity of work shown in the following section of this book attests to the adventurous spirit afoot in contemporary jewelry, a spirit nurtured by such artists as Ruth Penington and Ramona Solberg, two Northwest pioneers who helped undo corseting conventions and thus bequeathed to younger generations of jewelers more breathing room. ◆

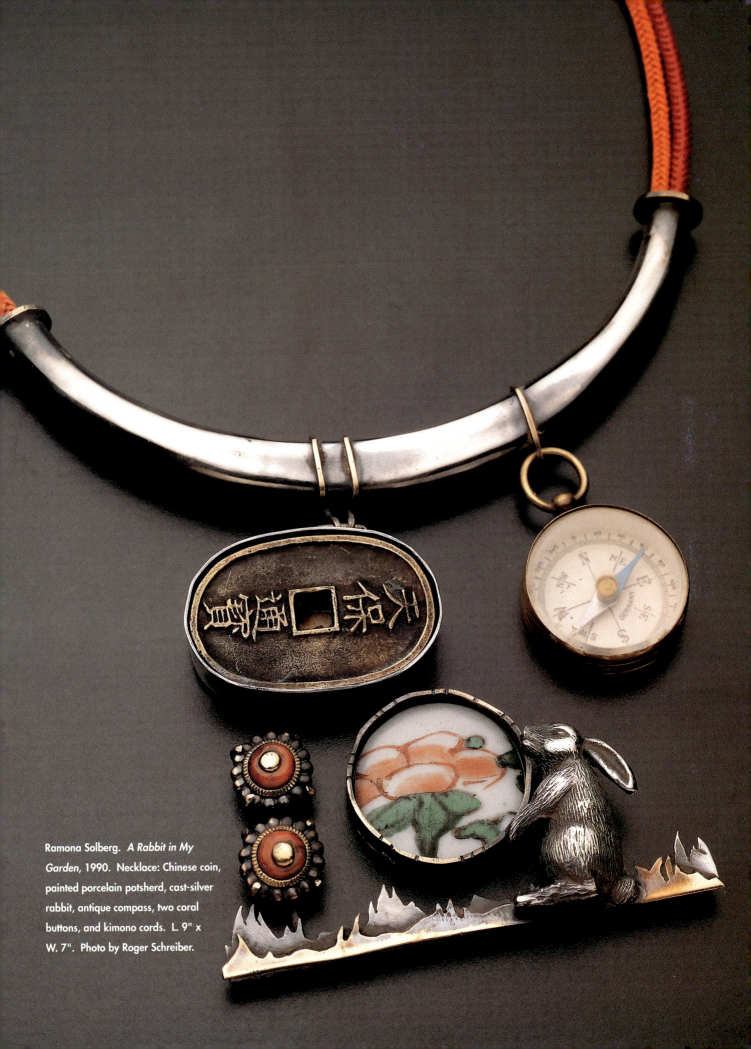

Ramona Solberg. *A Rabbit in My Garden*, 1990. Necklace: Chinese coin, painted porcelain potsherd, cast-silver rabbit, antique compass, two coral buttons, and kimono cords. L. 9" x W. 7". Photo by Roger Schreiber.

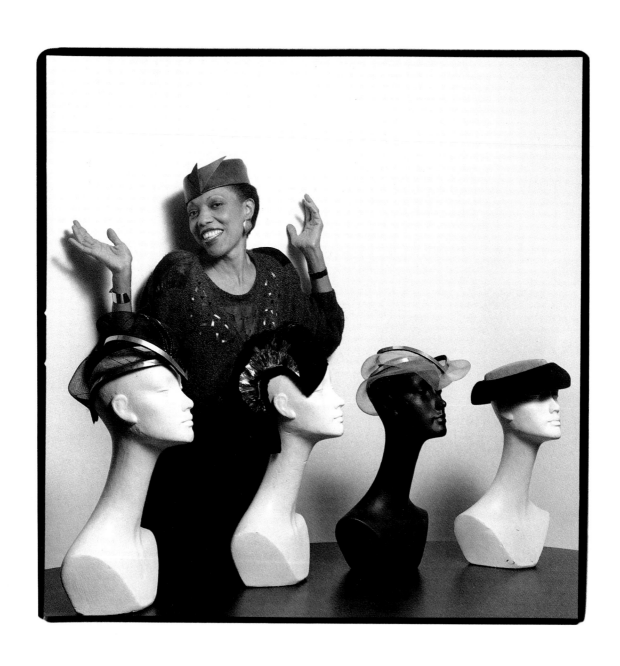

FLORENCE BAKER-WOOD
Jeweler

SEATTLE, WASHINGTON

FLORENCE BAKER-WOOD

FROM THE TIME SHE WAS old enough to attend Sunday school, Florence Baker-Wood loved wearing a hat when she dressed up for church. Unlike her three sisters, Florence particularly relished the ritual of donning a bonnet on Sundays. In those days — Florence was born in 1948 — girls and women didn't dare set foot in the house of God without covering their heads. Florence's family attended St. Phillip's Lutheran Church in Cleveland, Ohio, and every Sunday, after her brother and father doffed their fedoras at the door, Florence held her hatted head high as she strode down the aisle, surrounded by a sea of stylish chapeaus. In the winter, the pews were lined with women decked out in felt fedoras and crushed-velvet cloches, silk toques and turbans. Summer meant pillboxes and panamas with brims as crisp as Lena Horne's phrasing of the song "Stormy Weather."

Easter, of course, was the high holy day of hats. Florence still lovingly recalls a straw hat her mother once bought her for Easter; its brim dipped down over one eye like a wave. Florence and her sisters usually sported store-bought pastel confections on Easter Sunday, but sometimes they hazarded the more boldly colored creations of their father's mother, whose hobby was millinery. Florence was named for this grandmother, and as a girl she spent many an hour watching her "Ma Baker" steam fur felt and straw over a huge kettle filled with boiling water. She also observed her grandmother shape or "block" these fabrics on head-sized forms called hat blocks.

Today, some of those old cork and wood hat blocks sit in Florence's home studio in Seattle, along with more modern ones crafted of rigid urethane. Like the grandmother for whom she is named, Florence Baker-Wood makes hats, which she calls headdresses. Trained as a jeweler, Florence's flamboyant headdresses combine disparate materials in a way that undoubtedly would have delighted her grandmother, who is no longer living. Fabricated and forged metals such as brass, bronze, and aluminum grace the headdresses, and so do dyed fish skins, leather, suede, velvet, and even feathers. Florence not only shapes and steams fabrics just as her grandmother once did, but she also pieces together less conventional materials such as fish skins and leather, which she sponge-dampens before she blocks. The

A Head of Her Class, 1988. Fur felt and forged brass. H. 5½" x W. 9" x D. 10". Photo by Roger Schreiber.

asymmetric lines of Florence's headpieces echo the slanted brim of her favorite Easter hat of girlhood.

As a kid spending time with her grandmother, Florence never considered making hats herself; she was more interested in watching her grandmother to learn how to sew. A quick study, Florence made her first jumper when she was ten years old. Even at that age, Florence was considered a whiz with her hands. Although she had an older brother, it was Florence whom her father taught how to change fuses and light the furnace pilot. She once fixed a small TV set that had long stumped her father, whose hobby was repairing electronic appliances. Another time, determined to learn how to play the piano, she made a keyboard for herself out of a bed footboard she found in the attic. She taught herself chords by simply studying a book.

In junior high school, Florence won a summer scholarship to the Cleveland Institute of Art. But when she arrived to sign up for classes, the two that most interested her — drawing and painting — were already full, so she stubbornly declined to register at all. Although art continued to interest her, she didn't take art classes in high school or in college at Kent State University in Ohio, where she majored in psychology from 1966 to 1968.

"One reason I didn't really consider art as a profession," explains

Headdress Trio. Photo by Roger Schreiber.
FROM LEFT:
New York Style, 1986. Embossed leather and fabricated brass. H. 2" x W. 7½" x D. 9½".

Celebration Headdress, 1985. Forged bronze. H. 7" x W. 5" x D. 9".

Angles That Rhyme, 1988. Leather, copper, and brass mokume. H. 3" x W. 7" x D. 10".

Florence, "is because a lot of black people my age were first generation in their families of even going to college. And parents weren't really interested in sending you to school to become a starving artist. If you were able to get into college, they wanted you to do something significant, to be able to support yourself. They didn't want a beatnik child. I never discussed that with my parents, but somehow that's kind of what I grew up perceiving, probably by looking at the people who were black people of renown, like the few congresspeople or the doctors or the lawyers or the teachers. I didn't know any artist who was black who had been successful, so that wasn't really a reality."

After her sophomore year at Kent State, Florence moved to Bloomington, Minnesota, to spend some time with an older sister. This sister, married to the captain of the Minnesota Vikings football team, introduced Florence to a rookie on the team named Harrison Wood. Three months later, he and Florence married. They moved to Seattle shortly after, in 1970, so Harrison could finish his undergraduate degree at the University of Washington. The couple are now separated; they have two sons, born in 1974 and 1976.

As a newlywed in Seattle, Florence worked in a variety of jobs, including modeling. She also sewed handmade garments and sold them at street fairs. After her first son was born, Florence decided to go back to school at

the University of Washington. She enrolled as a psychology major, but soon switched to the art department. Still worried about acquiring a marketable skill, she entered the interior design program to learn how to handcraft furniture.

A battle over an art elective led to Florence's first encounter with metalsmithing. When a ceramics class she wanted to take was full, her advisor suggested one in jewelry instead. Just as she had once spurned enrolling in art classes at the Cleveland Institute of Art, Florence dug in her heels now. "All I could think of was stringing beads," she remembers sneeringly. "I said, 'I don't want to take a jewelry-making class.' " But the advisor insisted, and Florence reluctantly agreed.

It wasn't long before Florence realized that metalsmithing intrigued her more than crafting furniture. For one thing, unlike the woodshop, the university's metals shop was open at night, Florence's preferred working hours. For another, she appreciated metal's ductile qualities, which allow it to be reheated and reworked. "It kind of frees you up," says Florence, "because if something goes wrong, you know that you can correct it, or reuse the material."

During the years she studied with the metalsmith John Marshall and the jeweler Mary Lee Hu at the University of Washington, Florence primarily made holloware, or metal containers, although she also forged a few hair ornaments, including a comb and a crown. After graduating in 1981 with a B.F.A. in jewelry and metalsmithing, she worked as a counselor in the university's Office of Minority Affairs and accepted commissions from friends and acquaintances for jewelry such as wedding rings. In 1984, she enrolled in the university's graduate program in metal design.

A department party prompted her to dress up and wear a hat, which in turn led a former student to mention that she was about to begin a hat-making class in the home of an elderly milliner. Florence signed up for the class, too, but simply as a means to an end; she wanted to learn how to block felts and straws so that she could use these materials as prototypes for her metal vessels and containers. "I like hats, but I usually buy them," explains Florence. "I didn't think I'd make any."

But after constructing a hat — her first try at her grandmother's art — she felt differently. "I thought, 'I should incorporate metal into hats,' " remembers Florence. "What I realized is that I like contrast, and combining metal with other materials gave me the ultimate contrast."

Since graduating with an M.F.A. in metal design in 1986, Florence has concentrated on her distinctive headdresses, which are primarily exhibited on the West Coast. She also teaches wearable art workshops as well as jewelry and metalsmithing in various Seattle area schools. As we talk in her home one day, she places one after another of her headdresses on her small, elegant head — snug caps of black and brown leather accented with brass, a swoopy armature of shiny aluminum, a teardrop-shaped dome of purple fish skin ribbed with polished aluminum. No matter how sleek and modern the materials, her headdresses all make Florence resemble an exotic priestess.

One hat, blue felt with brass accents, tilts up in the back, as if it's about to take wing. Florence modeled this hat on a 1930s-era hat block she borrowed from another milliner. The canted part in back was originally intended to be worn in front. Hat blocks are hard to come by — Florence knows of only one man in the U.S. who still makes new ones — so Florence fabricates her own by laminating disks of rigid urethane together and then

cutting them to the shape she desires.

But it's her grandmother's hat blocks she cherishes most. She acquired them in 1988, when she traveled back to Cleveland for her father's funeral. A gathering was held afterward in her grandmother's house, where her aunt now lives. Idly exploring the house where she had spent so much time as a child, watching her grandmother sew and make hats, Florence came across the hat blocks.

"As soon as I walked in the cellar," she says, "there were four blocks sitting right on a ledge, and my heart just leaped. Just the fact that they were there and I could use them and they were my grandmother's — it just brought it all back to me." ◆

Icecap, 1990. Fishskin and brushed and polished aluminum. H. 5½" x W. 7" x D. 8". Photo by Roger Schreiber.

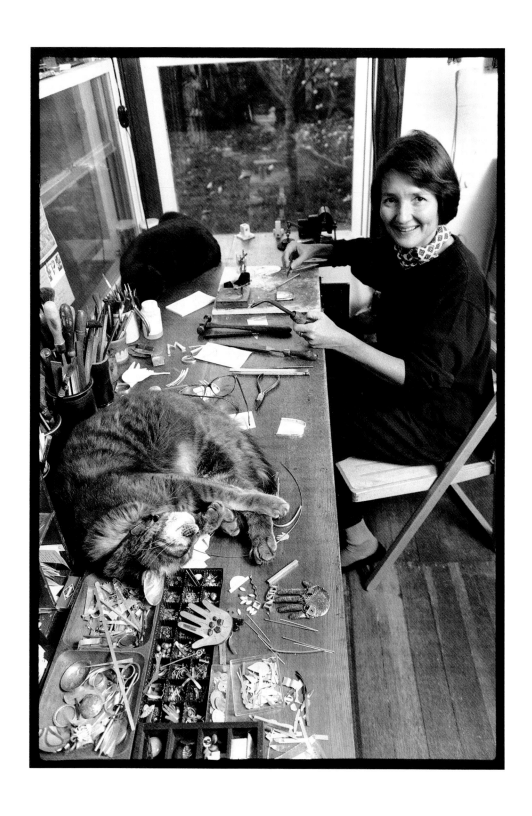

KIFF SLEMMONS
Jeweler

SEATTLE, WASHINGTON

KIFF SLEMMONS

IT ALL STARTED WITH one question on an otherwise routine survey: "Who were your childhood heroes and who are your heroes now?" When Kiff Slemmons first scanned the survey, that question intrigued her, but when she sat down to answer it, she couldn't recall any childhood heroes. And that bothered her. So she polled her family and friends and found that people her own age (she was born in 1944) could reel off lists of celebrities, but blanked out on heroes, whereas those of her parents' generation immediately named their idols — Amelia Earhart, for example, or Eleanor Roosevelt. Kids tended to revere comic-book characters, although one boy was even more conceptual: his hero was the publisher of Marvel Comics. What had happened to the heroes, Kiff Slemmons wondered.

For some time now, Kiff had wanted to use a familiar image in her jewelry — the hand — a symbol favored for centuries by metalsmiths from Mexico, where it's seen in tiny silver charms called *milagros* (meaning "little miracles"), to the Middle East, where it supposedly wards away the Evil Eye. Although Kiff was attracted to the immediacy of this recognizable image, she didn't want to use it in a hackneyed way. As she listened to stories about heroes, Kiff had an inspiration: "It just occurred to me to use the hand image in thinking about the whole idea of heroes," she remembers. "And I said one day, 'Well, I think I'm going to do hands of the heroes and depict or refer to a person through that image of the hand.'"

And that is how Kiff Slemmons came to spend two years (from 1987 to 1989) working on "Hands of the Heroes," the thirty-six-piece body of work that many people consider the masterpiece of the Seattle jeweler's twenty-year career.

All the hands are three inches long, or roughly half the size of a woman's hand, and can be worn as pins, although Kiff intended them to be exhibited together as parts of one piece. For example, twenty-three of the hands were shown at the Garth Clark Gallery in New York in the summer of 1989. Each hand — whether fabricated from ebony, slate, Plexiglas, or silver — is patterned from a cardboard template, so that all the hands are the same size and have the same simple shape, which looks like the traced outline of a child's hand laid

Satchel Paige, 1987. Pin: ebony, mastodon ivory, and sterling silver. H. 3" x W. 2½" x D. ½". Photo by Rod Slemmons.

William Carlos Williams, 1989.
Pin: copper, sterling silver, and scribed slate. H. 3" x W. 2½" x D. ⅛".
Photo by Rod Slemmons.

flat against a table. "I worked for a long time getting the shape of the hand just right," says Kiff. "I didn't want it to be too expressionistic."

Many of the "Hands of the Heroes" mirror Kiff's love of French and Russian literature and commemorate writers such as Colette, Marcel Proust, and Osip Mandelshtam. However, quite a few of the hands also reflect her fascination with the stories people told about their heroes, such as the admiring way one young woman spoke of the deep-sea explorer Jacques Cousteau. This woman's hero worship inspired Kiff to make two Jacques Cousteau hands, one with fish slithering over the palm and fingers; another with a tiny octopus, Coca Cola bottle, and seashells cupped in the palm, under Plexiglas that is wittily sculpted like a scuba diver's mask.

Other explorers featured in "Hands of the Heroes" include Roald Amundsen, who discovered the South Pole in 1911, and Marco Polo. Amundsen's hand is made of Plexiglas that Kiff scratched all over until it resembled ice. She often chose materials that specifically related to the heroes. For instance, one of her Buddha hands contains gold foil from Thailand that is meant to be rubbed on temple statues of that Indian philosopher. The hand of pianist Glenn Gould contains ebony and ivory, as does the hand of Martin Luther King. In the past Kiff has used ivory from a mastodon found by a friend who prospected for gold in Alaska in the 1920s, but like many jewelers today she now avoids ivory as demand for it leads to the slaughter of African elephants for their tusks.

After she saw the South African musical *Sarafina!* in New York in 1987, Kiff gave Nelson Mandela's ebony hand as an appreciation to Mbongeni Ngema, the show's writer. Another black man whom she honors in "Hands of the Heroes" is the baseball player Satchel Paige, who pitched for touring black teams and teams in the Negro leagues for more than twenty years, until he joined the major leagues in 1948.

"My father's father was a minor-league baseball player," says Kiff, "and so there was a lot of baseball talk when I was a kid. My grandfather traveled all around the country, and he liked the black players. I remember him saying they loved to play, and that's the main thing, they loved the game. And I was thinking of that, compared to now. In so many aspects of our lives, why we do something is for money or some other reason than loving to do it and doing it passionately."

Kiff Slemmons grew up in Adel, Iowa, a town of about two thousand people near Des Moines. Her father published the town's weekly newspaper. Sultry summers are one of Adel's specialties, and so are long summer evenings spent on front porches, rocking and revealing secrets in the dark. Now that she lives in foggy, maritime Seattle, Kiff misses those Midwest summer rituals, and she longs for the sounds of her childhood: the hum of a fan at an open window; flies pinging against screen doors; the roar of seventeen-year cicadas, their cast-off casings left behind on tree trunks, husked as they hastened to shed an old skin.

Two of these delicate, desiccated casings are in Kiff's bathroom, a reminder of her childhood collection of insects. "I loved their intricacy," she says. It's a word that could also describe her work, which often contains imagery that hearkens back to memories of Adel: a cicada pin backed by the number 17, for example, or a series of necklaces and pins devoted to the seasons, including a miniature electric fan complete with movable blades, the word *cool* inscribed across its center.

As a girl, Kiff spent hours examining the contents of her mother's jewelry box, and she particularly remembers a humble necklace made of red

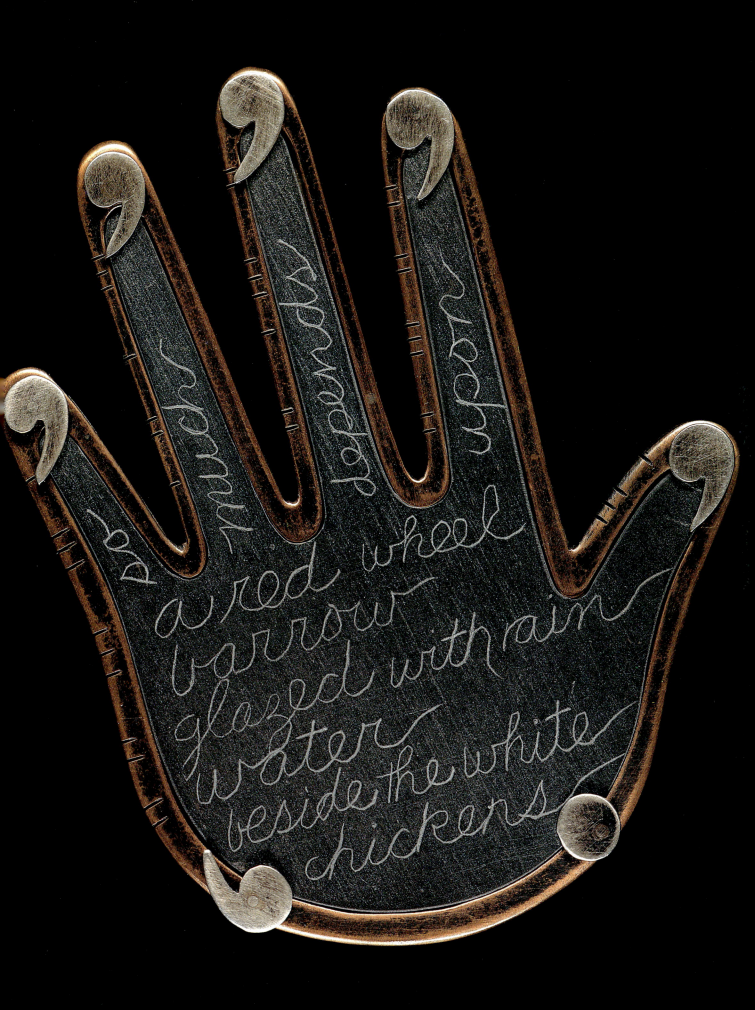

and black seeds that had belonged to her great-grandmother. "One half of each seed was black and the other half was red," says Kiff. "They were really like lacquered things. I loved that one little necklace and that's all it was, a string of those seeds, but it was different from the other things in the box and I didn't fail to notice that."

Despite her childhood interest in jewelry, Kiff didn't try her hand at any until 1968, during her last semester at the University of Iowa, where she majored in art. To help finance a trip to Mexico with Rod Slemmons, the man whom she married in 1966, Kiff made one hundred fifty pairs of brass-wire earrings and sold them at a school fair. She recalls selling fifty or sixty pairs of earrings at the Iowa fair. After returning from Mexico, Kiff continued making jewelry and thought about attending graduate school to study literature. But as time went by, she realized jewelry was what really interested her. "I couldn't stop," she says. "I had to be making things."

After seeing Kiff's meticulously crafted jewelry, which displays a range of techniques — from forging to fabrication to casting — it's surprising to learn that she is largely self-taught. For years she earned a living by working as a jewelry instructor and by making one-of-a-kind, commissioned pieces. She would devote the first six months of the year to her commissions before turning to the pieces she intended to exhibit in shows, the more experimental work that sustained her imagination. "People said to me, 'Well, why don't you just make sculpture?' But it was all those limitations of the jewelry that interested me," says Kiff. "I like that it is small, that it can be passed around."

During the 1970s, Kiff's work was influenced by folk and primitive jewelry and many of her necklaces contained beads from all around the world. In the early 1980s she worked on a series of twenty-one pieces called "In the Name of Friends" that represented a turning point in her development as an artist and anticipated "Hands of the Heroes." Each of the twenty-one pieces was named after a different friend and included images or materials that Kiff associated with that person.

Over the years, Kiff has also incorporated found objects into her work, such as in her 1987 necklace, *All Eyes*, made of beach pebbles centered in silver eye-shaped forms. Kiff Slemmons seems to have an almost animistic feel for objects, both natural and man-made. When friends gave her a couple of vintage typewriters, she planned to saw off the letters and use them in her work. However, she ended up carefully disassembling the entire typewriter.

"Once I was confronted with this beautiful old typewriter," explains Kiff, "I couldn't cut off the letters; it felt like amputating the keys from the typewriter. And, it's probably crazy, but I felt I owed it to the typewriter to take it apart until I got to the keys. If I was going to dismantle this thing that was both beautiful and useful, I had to do it with some care and respect. And I want to put it back together as jewelry. I'm going to try and use all the different parts of the typewriter and reconstruct them as jewelry."

She holds up two long, slightly angled typewriter keys and observes, "There's something rather insectlike about them," then points out their resemblance to two grasshopper-leg pins she made a few years ago. "I'm thinking of trying to make a hat with the keys," she adds. "That way I could use the entire key."

Entering Kiff and Rod Slemmons's Seattle bungalow — where beautiful things such as thimble-small celadon teacups and thumbnail-sized

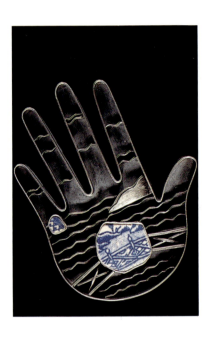

Marco Polo, 1989. Pin: sterling silver and porcelain shards. H. 3" x W. 2½" x ³⁄₁₆". Photo by Rod Slemmons.

books are arranged throughout the house like miniature still lifes — is like stumbling into the land of Lilliput. This illusion, enhanced by Kiff's doll-like face and five-foot-two-inch height, is only broken when six-foot-one-inch Rod Slemmons appears. The photography curator for the Seattle Art Museum, he also photographs all of Kiff's work. He has come home to nail a trash-can lid to a pine tree as a new nest for a baby crow who has repeatedly fallen into the yard.

In Kiff's neat workroom, which is one of the bungalow's bedrooms, two hand-colored railroad-survey prints of crows hang above a table laden with pieces-in-progress, including four ebony crow pins bearing typewriter letters in their beaks. Although Kiff sees the crow prints every day, she didn't connect them with her crow pins until her friend, the jeweler Ramona Solberg, visited and commented on the prints. "That happens all the time," says Kiff. "I'll see something occur in my work and I'll wonder where I came up with that and then I look up in front of me and it's right there."

There are times when Kiff, an articulate, thoughtful woman who is bothered by the status connotations of jewelry, worries that she has cluttered her house with too many things. "But I grew up in an environment jammed with old stuff," she says. "And here, I work with it all the time. I realized that it's like drawing in some weird way. I put things together in different ways and I look at them for a while and it is a funny kind of studying how they work — the textures, the colors, what happens when they're juxtaposed."

In the same way that she collects tiny treasures for her house, Kiff also likes to collect stories: hero-worship stories, stories about reactions to her jewelry, women's memories of looking through their mothers' jewelry boxes. An avid reader whose dining table is perennially piled with books, Kiff Slemmons obviously loves words. In fact, she used words in a few of her "Hands of the Heroes." For example, she wrote one of William Carlos Williams's short poems, "The Red Wheelbarrow" ("so much depends/upon/a red wheel/barrow/glazed with rain/water/beside the white/chickens") on his slate hand, which also features copper commas on the fingertips.

Kiff originally wanted to exhibit the series of hands in Books & Co., a New York bookstore, but the display and insurance arrangements were too complicated. "It may still be possible with the word pieces," she says, referring to the work she is doing now, which includes the crows with typewriter letters stuck in their beaks. She has mulled over the idea of an installation, with the crows feeding a person letters. As she reveals this plan, she laughs, as if the idea thoroughly delights her. "But I don't know," she adds quickly, as if to placate the muses. "It's still beginning to take shape."

Even though she displayed a hint of superstition about her new work, Kiff Slemmons seems remarkably sane about the difficulties of creativity. When she finished her "Hands of the Heroes" series, another Seattle jeweler jokingly asked what she was going to do to top that body of work. It's a question that might have caused a less confident artist to be frightened about the future, but Kiff didn't see it that way.

"With the 'Hands of the Heroes,' I pulled together things I had been trying to do for years, and they are good," she says. "But I've been making jewelry long enough to know that it doesn't all come together like that very often. So it's back to the bench and another long haul until maybe it happens again." ◆

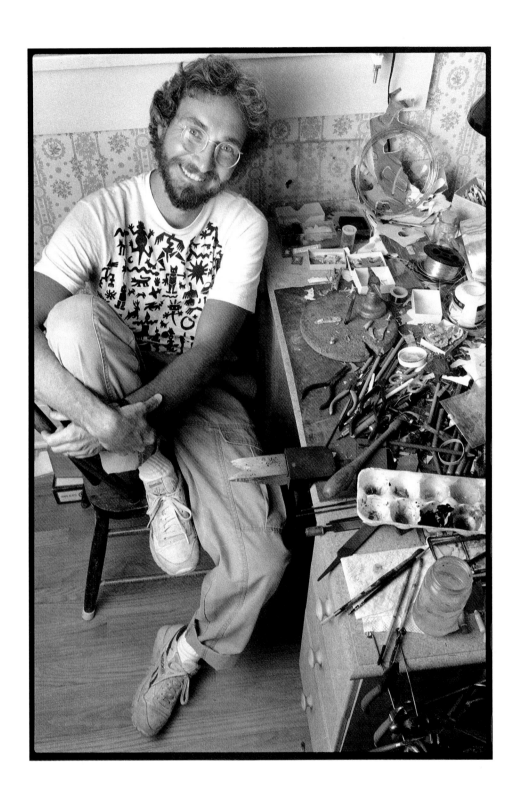

Ken Bova
Jeweler

BOZEMAN, MONTANA

KEN BOVA

WHEN KEN BOVA WAS A KID growing up in Houston, Texas, he and his younger brother would spend entire days in the back room of their mother's florist shop, playing amid buckets of fragrant flowers, bolts of multicolored ribbon, and jars of glimmery glitter. "Something beautiful is always remembered" was his mother's business motto, and Ken recalls how carefully she composed floral arrangements, combining, say, daisies and chrysanthemums with ribbons and ferns or baby's breath. She would call his attention to sensual details — the velvety petals of long-stemmed roses or the crispness of crinkly carnations. While she worked, Ken made toys for himself by gluing ribbon scraps and glitter on styrofoam forms. After he started school, his mother assigned him chores around the shop: making bows, wiping dusty ivy leaves with a cotton swab dipped in baby oil, and dyeing white carnations homecoming blue or St. Patrick's green. One of his duties as a teenager was to script names or school slogans on corsage ribbons with glue and then sprinkle them with glitter.

Ken never wanted to become a florist, but years later, when he began making jewelry, it seemed only natural to incorporate a lot of disparate materials into his work, in the same way that his mother arranged flowers, or that he had cobbled together styrofoam toys.

Today, Ken Bova is still playfully assembling snippets to make the bright nosegays that are his pins, pendants, and earrings. They not only include bits of precious or rare gems, metals, and minerals — sterling silver, pearl, jasper, coral, and topaz — but also the humble twigs and pebbles and pieces of dog-gnawed bone that Ken pockets on his daily walks around Bozeman, Montana. And his work is as likely as not to contain some of the many found objects that people have given him over the years: duck feathers and butterfly wings, dried flowers and Nepalese rupees, abalone shells and wasp nests.

These oddities are all squirreled away in a small standing box with clear plastic drawers, the kind that hardware stores stock with screws and bolts. His baby teeth are in there, too, wrapped in

Mr. Dream Man Returns, 1989. Pin: sterling silver, amethyst, aquamarine, hematite, abalone, paper, and paint. H. 3½" x W. 2½" x D. ¼". Photo by Ken Bova.

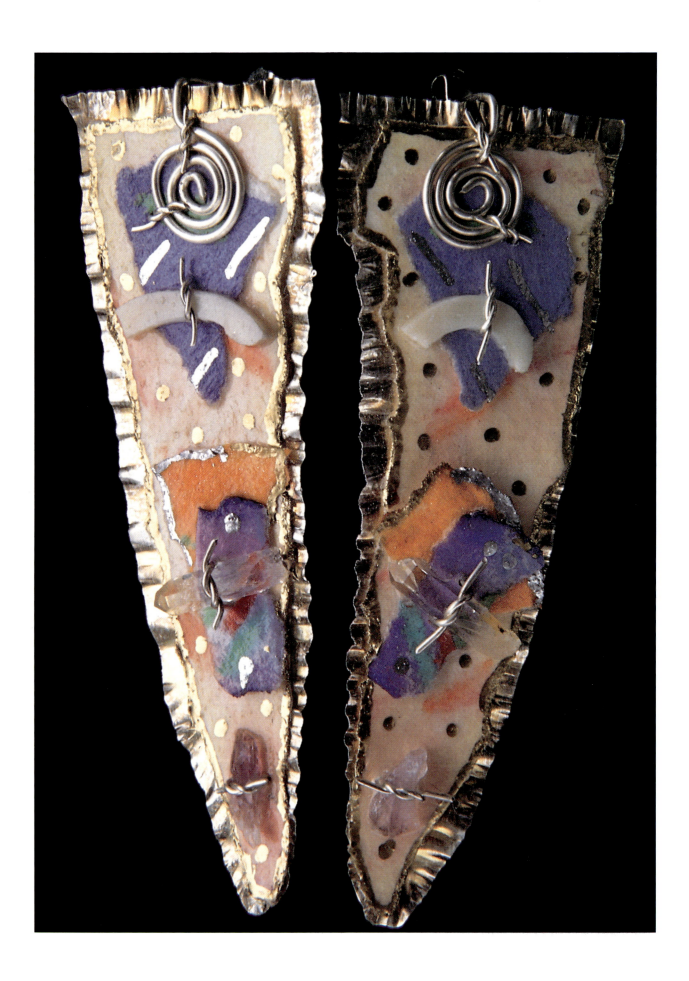

a strip of paper that bears an identification written in his mother's hand: "Kenneth's baby teeth, saved for the good fairy."

Of the Bovas' four sons, two are artists — Ken and an older brother, Joe Bova, a ceramist who teaches at Louisiana State University — and both have traced their interest in art to observing their mother make things, even though they disagreed with her home decorations. "My mother had her own aesthetic," says Ken. "She collected what she liked, and filled the house with what would be called kitsch — knickknacks and porcelain birds and little candelabras and scented candles and cast porcelain doodahs. I mean it was stuff that was so bad, it was almost good. I used to be embarrassed by my mother's house, especially as an art student. But she didn't care. Everything that she put in there was something that she thought was beautiful and it didn't matter if anybody else thought it was or not."

His mother's taste may have bothered Ken, but her aesthetic confidence obviously helped him learn to trust his own artistic judgment. And in his judgment, a beautiful object is not necessarily one that is made of expensive materials. "I try to get people to question why they wear jewelry and what is beautiful and what is not," says Ken. "If someone looks at my work and says, 'Well, it's just paper and a twig and a couple of gemstones and found things — does it have any value or not?' my response is, 'Well, you have to make that decision yourself.'"

Ken is his mother's son in other respects, too. For instance, he seems to have inherited her comfort with clutter. His studio, one small room of the bungalow he owns with his wife, Ellen Sanford, is as disheveled as a teenager's bedroom. An unpainted pressboard desk, the kind you would buy for a fourteen-year-old, serves as his workbench. Jammed into a corner of the room, its top is strewn with a jumble of tools, bits of wire and painted paper, egg cartons filled with pistachio shells, a box of pastels, an automobile taillight reflector, gold and silver foil, pin clasps, and much, much more. Although he was born in 1953 and sports a mustache and beard, when Ken hunches his slight frame over his messy desk, he resembles a high school student concentrating on an unusual art assignment.

Unlike many metalsmiths, Ken does not solder his jewelry. Instead, he anchors each element of the composition by tying or sewing it into place with silver wire, a process he refers to as "soft technology." "Technically, anyone could do what I do," he says. This simple method allows Ken to work quickly and finish one piece at a sitting. Conversely, if a piece doesn't meet his expectations, he can take it apart and start all over again. "I like immediate gratification," says Ken, who admits he doesn't have the patience for most of the time-consuming techniques that metalsmiths use to work traditional metals such as silver or gold, or space-age metals such as niobium or titanium.

Ken's frequent use of painted paper in his mixed-media jewelry collages hints at his undergraduate training in painting and drawing at Sam Houston State University in Huntsville, Texas. In his last semester there, in 1975, Ken helped a professor build a studio, and in exchange, the man taught him small-scale jewelry casting. This first exposure to making jewelry was what Ken calls a "eureka experience," one that convinced him he wanted to study jewelry in graduate school. After spending one year at the University of Houston acquiring enough technical skills to build a portfolio, Ken was accepted into the M.F.A. program in jewelry/metalsmithing at Montana State University in Bozeman, where he studied with the artist Richard Helzer.

Earrings, 1989. Sterling silver, bone, quartz, amethyst, paper, and paint. L. 2½" x W. ¾" x D. ¼". Photo by Ken Bova.

While he was in graduate school, Ken discovered that the clean, slick surfaces and limited color palette of most metalwork bored him. He didn't like the obsession most jewelers had with fussy techniques, either. Frustrated with school, he took up fly-fishing for trout as pure escapism. He soon became mesmerized by the freckled fish flesh, which he photographed in close-up shots. The more Ken fished and photographed, the more he noticed that fish scales resembled metal decorated with abstract patterns and shimmery colors. For four months, he was in a fishing frenzy. Unaware that he could catch and release fish, he ate everything he caught until he couldn't eat any more. But he couldn't stop fishing. So he froze trout, and when his freezer was full, he smoked them.

By the time he started his last year of graduate school in 1979, Ken Bova was thoroughly sick of trout, but he felt renewed as an artist. His fascination with fish skin had validated his interest in complicated surfaces, and Ken now incorporated unusual, nonprecious materials into his work for the first time: aluminum foil, thin strips of brass from auto supply stores, and sticks and twigs and colored bits of paper.

His work today still demonstrates his love of elaborate surfaces and textures. For example, *Mr. Dream Man Returns,* a pin Ken made in 1989, shows a paper face in profile, its cheek area ornamented with brilliant, watercolored swatches of yellow and purple paper and a little galaxy of amethyst, bone, hematite, aquamarine, and abalone. Ken based this pin on a character in a recurring dream as well as the insecurity he felt as a small, wiry man surrounded by muscular dreamboat males when he was scuba diving in Cozumel, Mexico.

It wasn't until 1987 that Ken started titling his assemblages, which made manifest the narrative, emotional element in his work. For example, his 1988 pin *Nightwalk* is shaped like a foot, which commemorates the therapeutic midnight walks Ken took around Bozeman after his father died. It bears a number of amulets that Ken associates with that time of transition and with nighttime.

"Even in a small town like Bozeman," says Ken, "there's this night life that goes on. I mean, windows that are illuminated, the crescent moon coming up, that color shift from all the warm daytime colors to all the cool evening colors. The cool evening air, which is totally different from the warm daytime. And on my walks I'd pick up little things, like the cross section of bone that is in *Nightwalk*. It's just a little dog bone, some steak bone or dog bone that was on the sidewalk. And the piece has those cool night colors — violets and blacks — and starlit night and crescent moon and the whole thing. I like *Nightwalk* a lot."

Picking up things and putting them in his pockets has been a pastime of Ken's ever since he was a Boy Scout. In fact, Ken partially attributes his interest in making small objects to the pleasure he used to derive from collecting merit badges when he belonged to Troop 24 in Houston. He vividly remembers his troop's emblem, a white skull and crossbones on a black field, a design he echoed in a skull pin he made as a Halloween present for his wife in 1988. It's called *Another Sleepless Night,* and despite its macabre image, it's as festive looking as a Mexican sugar skull.

In that same year, Ken made another piece for Ellen, a charm that contains many personal tokens: a lock of his hair, Chinese paper to mark her interest in the Chinese language, the mathematical symbol for pi (shorthand for "Sweetie Pie," one of her pet names for Ken), and a chunk of horse tooth. When Ken met Ellen in 1981, she worked as a thorough-

bred foaler on a ranch west of Bozeman. He had just received his M.F.A. and was leaving Bozeman to teach at Oklahoma State University in Stillwater. But he came back that summer to be with Ellen and work on the ranch, an experience he now recalls in the awed tone of someone describing a tribal rite of passage or a bizarre courtship ritual.

At first, Ken hauled hay onto a moving flatbed truck every day until his arms underwent an out-of-body experience. Then the foreman assigned him the Augean chore of cleaning horse stalls and leading the horses back from the paddock. After withstanding the kicks and bites of the high-strung thoroughbreds, Ken was asked to help brand calves.

"By now I was real suspicious," says Ken in his sweet drawl, the voice that marks him as an old-fashioned Southern storyteller. " 'What does this involve?' I asked. They said, 'When the calves come out of the chute, Joe will throw them down and bulldog them. All you have to do is grab their hind legs and hold them while we stick the brand on them. It only takes about ten seconds. Piece of cake.' Well, they didn't tell me that they were first going to castrate these young calves and then inoculate them with a needle that was easily the size of a bread knife. I mean, it was as big around as my fist. They were bleeding like crazy, bellowing like nuts, and that's what they just had cut off of them. Then they were swatted on the ass with a two-by-four, run down a chute, and by the time I got to them, they were seriously psychotic.

"You know those little devices in hospital labs that shake test tubes back and forth to separate blood serum? That's how I was that day. It was just back and forth, back and forth. I mean, those calves were kicking and I was trying to hold them down as they were branded with a red-hot iron. Well, after the third or fourth calf, I was shaken up so bad that my muscles didn't care anymore. I was real loose. But after fifteen calves at the end of the day, I felt just like rubber. And the next day, I couldn't move. Literally. I was totally rigid, I couldn't move my arms. My muscles were so stiff I could not bend my elbows, my hands wouldn't make fists, I couldn't twist. I called Ellen, who was making coffee in the other room, to come help me get out of bed.

"In retrospect," Ken muses as he pets one of his four cats, "I think what the foremen and the ranch hands did that summer, is they got up one morning and they said, 'Let's kill Ken Bova. Let's just beat him into the ground, to show him what real ranch work is about.' "

After his summer ordeal, Ken could hardly wait to leave for his teaching job in Oklahoma. Ellen quit her job at the ranch and followed him to Stillwater, but both of them missed Montana. So after the school year was over, they moved back to Bozeman in 1982. To support his art, Ken has taught a number of jewelry courses at Montana State University, and from 1986 to 1989 he was the executive director of the Beall Park Art Center in Bozeman, one of Montana's many community arts centers.

But throughout it all, he has continued to do what he loves best: tying bits of branches, baubles, and burnished bone together until he transforms them into a bright boutonniere of a pin or the dangling posies that are his earrings — Ken Bova's remembrance of something beautiful, his tiny tributes to the floral bouquets his mother arranged long ago. ◆

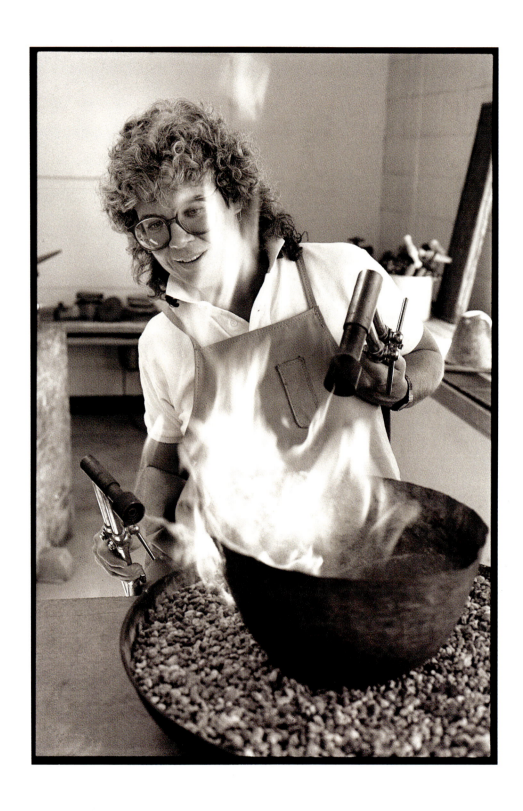

GAIL FARRIS LARSON
Jeweler

POCATELLO, IDAHO

GAIL FARRIS LARSON

IN ITS HEYDAY, the six-thousand-acre IX ranch near Bixby, Oklahoma, ran six hundred head of cattle and raised one hundred thoroughbred horses, says Gail Farris Larson. Her father, Bluford Farris, had grown up there. Later, he lived in Tulsa, twenty miles away, but most every weekend he and his wife came back to the ranch with their identical twin daughters, Gail and Jean, who were born in 1947. The two girls were named after their grandmothers, and those names proved prophetic. Jean, the twin bearing her maternal grandmother's name, was as musically gifted as that side of the family. And Gail was artistic, just like Bluford Farris and his mother, a full-blooded Creek Indian.

This grandmother — who painted watercolors when she wasn't cooking and attending to the chores of running a ranch — pampered her namesake with cakes and cookies and little presents such as jewelry and purses. Gail herself sewed a leather drawstring purse when she was six years old, modeling it after the war bags containing good luck charms that she had seen in a tribal museum. She filled her pouch with childhood talismans: rocks, twigs, and bits of broken glass, all of which she wrapped in foil peeled from gum wrappers. She became so attached to her handmade bag that she wore it like a necklace, a habit that provoked some teasing from her uncles and cousins. But Gail didn't care: she liked having her secret treasures next to her at all times, even when she rode her palomino horse.

The pouch also held Gail's most beloved trinket, which she made after spending time in the Tulsa jewelry shop where her mother worked as a bookkeeper. This shop seemed like a magical world to Gail, one with trays full of shiny bracelets and bright-colored gems in the front, and buffing machines, pots of bubbling acid, and coils of solder wire in the back. When the owners dismantled their window display at closing time, they would let Gail stack all the rings on her fingers. It's not surprising that the pouch possession Gail favored above all others was a ring she formed from a horseshoe nail, an object that not only wedded her father's and mother's worlds but also anticipated her life's work.

Today, Gail Farris Larson lives in Pocatello, Idaho, and divides her time between teaching metalsmithing at Idaho State University and making jewelry. (Her twin sister, a

Brooch, 1989. Anodized titanium, niobium, and brass. H. 6" x W. 3" x D. 1". Photo by Gail Farris Larson.

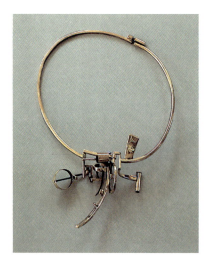

Neckpiece, 1972. Fabricated brass. L.. 10" x W. 8" x D. 1½". Photo by Gail Farris Larson.

Neckpiece, 1972. Fabricated brass. L.. 14" x W. 10" x D. 1½". Photo by Gail Farris Larson.

professional musician, lives in Austin, Texas.) For fifteen years, Gail fulfilled a childhood dream and raised Appaloosa horses, until she and her husband divorced in 1985. Though horses are no longer a daily part of her life, Gail continues to make secret containers, just as she did when she was a girl.

For example, many of the metal pins and boxes in her ongoing "pocket series" have tiny openings, so that it's impossible to peek inside. Sometimes, Gail enhances the mystery by squirreling metal scraps, pebbles, and found objects into the pocket pins and then sealing them inside. Although the tiny items are hidden, they rustle in a tantalizing way whenever the wearer of the pin moves.

It was while she was sewing in 1983 that Gail got the idea for her pocket series. For some time, she had wanted to create containers that weren't round and didn't look like they were constructed of metal, and the texture and diverse shapes of cloth pockets provided her with a design solution. "One of the things I've been trying to do," says Gail, "is to make metal look very soft and sensual and fabriclike." Her *Soft Pocket* pin of 1984 is particularly successful in fooling the eye; you almost have to touch it before you realize that the velvet-black copper is not made of pliable, puckered leather.

Once Gail's friends realized her predilection for pockets, they began ripping them out of old clothes and presenting them to her. Some of Gail's pins are patterned after these gifts. "The idea of a pocket, that small interior space, has been intriguing to me," she says. "When you put your hands in your pockets, it's a way of being close to yourself. You can keep little private things in a pocket and no one else will know. For some reason — I don't know if it has to do with being a twin — that's real important to me."

Although they now live fifteen hundred miles apart, Gail and her sister, who dressed similarly until the fifth grade, visit each other once a year and talk on the phone every week. Gail has often had the eerie experience of picking up the phone to call her sister, only to discover that she is already on the line.

Gail and her sister were also undergraduate roommates at Pittsburg State University in Pittsburg, Kansas, where Gail majored in art. As soon as she took her first jewelry class in college with the noted innovator Marjorie Schick, Gail realized her calling. "I didn't even want to date," she remembers. Gail received both her B.F.A. in art and her M.F.A. in jewelry design from Pittsburg State. After teaching jewelry for one year at a junior college in Missouri, Gail was accepted into the prestigious program in jewelry design and metalsmithing at Indiana University in Bloomington, where she studied with the well-known metalsmith Alma Eikerman.

"I've had a history of being around real strong women," says Gail, "from my mother to Marjie to Alma. All of these women knew how to encourage me at the right time, and they've all had a great influence on my life. I've patterned a lot of my work habits and goals and aspirations after theirs. I saw that if you're committed to what you do, you order your life so that it can happen." Gail graduated from Indiana University with an M.F.A. in 1974, and was immediately hired to teach at Idaho State University, where she now heads the art department.

Although she's at least twenty years older than most of her students, Gail Larson is as energetic as a teenager. But her large office in Idaho State's fine arts building is no dorm room. Mounted on the wall behind her desk are two necklaces that Gail made shortly after she joined the faculty; constructed of brass, they resemble eccentric musical instruments. Closer

Brooch, 1989. Anodized niobium/titanium. H. 6" x W. 4" x D. 1". Photo by Gail Farris Larson.

inspection reveals that one is assembled from bullets, screws, and car parts. The aptly named banana gourds hanging nearby are a present from Gail's mother in Oklahoma. Scattered on shelves are various containers, including several linen or raffia baskets woven by Gail and two wooden box toys that she fashioned for her daughter, Becky, who was born in 1981. On Gail's office door are many of Becky's crayon pictures — "pitchers" is how Gail pronounces the word, and her soft Oklahoma twang is so homey you wish she would say it again.

Until her daughter was born, Gail worked exclusively with copper, silver, and brass, all of which require significant amounts of time-consuming heating and hammering. When her new baby limited her working time, Gail's response was typically pragmatic — she simply hauled Becky's crib and playpen into her studio and switched to using the space-age metals niobium and titanium, which do not require heating.

"Becky's birth propelled me to move in a different direction," she says. Although she never used color before in her work, Gail has taken full advantage of the capacity for subtle coloration in niobium and titanium. Her elegantly colored and patterned pins made of those materials are pierced with long, thin brass or plated-gold fasteners inspired by looking at telephone poles and radio antennas during cross-country trips. Gail also makes jewelry now from brightly hued Color Core, a plastic cabinetry material made by the Formica Corporation and used by many contemporary jewelers.

She may fabricate her jewelry from space-age metals, but Gail still uses the old-fashioned tools that her mother's jewelry partners bequeathed to her when they retired, which include tiny tweezers, vises, and hammers, as well as chamois and felt buffs. And she still works with the tools her mother bought for her shortly after she began her first jewelry class in college. "That was her stamp of approval," says Gail.

Whenever her students ask for career advice, Gail tries to encourage them in the same way that her mother and father did as she was growing up in Oklahoma. "My parents always used to tell me," she recalls, "'If you find what you want to do and you do it really well, everything else will take care of itself.'" ◆

KEN CORY
Jeweler

ELLENSBURG, WASHINGTON

KEN CORY

JUST FOR THE FUN of it, Ken Cory once took a pencil-sized piece of silver wire and spent an afternoon pulling it through a series of sixty gradually smaller holes in a jeweler's drawplate, until he ended up with a fifty-two-foot thread of shimmering silver wire. Another time, after he read that Navaho metalsmiths once hammered silver dollars into spoons, Ken followed suit with a handful of copper pennies.

Still another time, he fashioned one hundred different variations of twisted copper wire by drawing strands through dies of diverse

Coffee, 1987. Pin: sterling silver, 22-karat gold, and stone inlay. H. 1" x W. 1⁷⁄₈" x D. ½". Photo by Ken Cory.

shapes. Ken stores the results of this experiment in a glass jar, and when he unscrews the top, the copper twists tumble out, like a bundle of fancy pick-up sticks.

There are single strands and double strands; a couple of the more baroque twists have up to six wires twined together. Some twists resemble coppery braids of hair, silky rope pulls, or sinewy rawhide. Others look like the lassos used by cowboys at the annual rodeo in Ellensburg, Washington. This small town in the center of the state is where Ken Cory lives, teaches, and creates his inventive jewelry, small pins that demonstrate a wide range of techniques and sometimes include snippets of twisted copper wire as well as other ingeniously fabricated embellishments.

Like many contemporary Northwest jewelers, Ken shuns precious gems because he equates their use with boring, mass-produced jewelry, although he once irreverently threatened to set a diamond in plastic. In the late 1960s (he was born in 1943), Ken exclusively used such ordinary materials as copper, Plexiglas, and leather — one early pin sported

a leather flap that resembled an impudent, stuck-out tongue. However, he recently began incorporating small, semiprecious stones such as topaz and garnets into his pins, although they never constitute the piece's focal point. Sculptural form is Ken's true love, and he excludes any elements that would obscure that aspect of his work. For example, he prefers textured to mirror-shiny surfaces because he feels they highlight form.

The contoured forms of Ken's jewelry resist categorization. Neither geometric nor organic, they are reminiscent of mysterious hieroglyphic symbols. And while his pins are as small as pillboxes — on average, they are two inches tall, one and one-half inches wide, and one-half inch deep — they have an imposing presence. They manage to look both little and massive, so perhaps it's not surprising to learn that their creator has an Alice-in-Wonderland attitude about scale. "I think small things are like big things in a way," explains Ken. "Big objects fill your field of vision, and so do small ones, when you focus in on them."

Ken has been making jewelry since 1963, when he was a freshman at Washington State University in Pullman, his hometown college in eastern Washington. Not long after he enrolled, he happened to drop in on a school workshop where students were crafting jewelry. Seeing the process was a revelation to Ken.

"Before that, I thought jewelry came out of factories," he remembers, "and it was something you needed big machines to make. Because it was such a completely new thing to me, I got excited about it. So I took a jewelry class and all of a sudden, it was like magic. I was making things out of metal with just a few simple hand-tools. And I thought, 'Boy, here is a whole area that hasn't been explored yet.'"

After one year, Ken left sleepy, rural Washington and transferred to the California College of Arts and Crafts in Oakland. He soon found that the San Francisco Bay Area was an exhilarating place to be in the mid-1960s. The same year that Ken arrived in Oakland, the radical Free Speech Movement organized the nation's first major college demonstration at the University of California at Berkeley. Soon after, the San Francisco neighborhood of Haight-Ashbury achieved worldwide fame as the Mecca for hippies. Those were also the days of sleek, minimalist art as well as Funk ceramics, a messy, cheeky style that originated in the Bay Area and dominated American ceramics during the late 1960s and early 1970s. Even though Ken favored meticulous craftsmanship in his own work, he got a creative charge from Funk.

"I was looking at a lot of Funk ceramics," he recalls, "and I think that it was somehow influencing me, but it was more the attitude, the idea that it really challenged what conventional ceramics should look like. And so I thought, 'Well, yeah, fine — I'll challenge what conventional jewelry looks like.'" It was during this time that Ken made the saucy pin that features a tonguelike tab of leather.

After he graduated in 1967 with a B.F.A. in metalsmithing and jewelry, Ken returned to Washington State University for graduate school. It wasn't that he came back to study with a particular metalsmith; he simply wished to concentrate on his work in a supportive environment. "I wanted to be left alone to develop on my own," Ken says. "It was a perfect two years. There were other people to talk to, but they let me go in the direction I wanted."

During his years in graduate school, rather than using a traditional lost-wax casting process, Ken invented a technique of his own for casting

Face, 1986. Pin: copper, sterling silver, 24- and 18-karat gold, and andalusite. H. 1 1/8" x W. 1 3/4" x D. 1/2". Photo by Ken Cory.

copper pins. Instead of making a wax model, he constructed balsa-wood models of geometric shapes such as triangles. He covered these models with plaster, and then burned out the wood, which left the impression of the wood grain behind. Then he cast copper pins on this rough surface, which reminded Ken of the weathered siding he saw on barns in nearby wheat fields.

"I was interested in the relationship between man-made things and decay," he says. "It came from looking at all those wonderful old barns and thinking about minimalist art, when I saw the different shapes of the roofs. But the barns didn't have the slickness of minimalist art. They were falling over."

The copper pins Ken made in graduate school, which he oxidized until they were a wood-brown color, mirror a young man's fascination with disintegration. The pins look almost corroded; some sport fissures that look like cracks in a cement sidewalk. Sprouting from these clefts are snaky coils of clear and colored Plexiglas that sometimes resemble plant tendrils, sometimes extruded toothpaste.

The pins also reflect Ken's more abiding interest in textured surfaces and minimalism. While the shapes of those early pins are more geometric than Ken's current work, his enthusiasm for trig forms was apparent even then. One of Ken's pins from this era was included in "Objects U.S.A.," a Smithsonian-sponsored exhibition that toured this country and Europe in 1969, the same year Ken received his M.F.A.

Before he left graduate school, Ken met Les LePere, a painting student who used the pen name "Lead Pencil" in his humorous illustrations for an underground newspaper in Seattle. When Ken and Les discovered they had similarly wacky senses of humor, an unusual partnership was born that has persisted off and on ever since. The duo, who dubbed themselves "The Pencil Brothers," collaborated on designing and making such proletarian items as ashtrays, belt buckles, and lightswitch

plates. Many of these quirky enameled objects include depictions of pencils or thumb-sized versions of the real McCoy.

The Pencil Brothers don't produce much work together these days because Ken teaches jewelry design full time at Central Washington University in Ellensburg and Les concentrates on drawing when he isn't running his family's farm in eastern Washington. However, Ken is still preoccupied with pencils, which he describes as "the American yin-yang symbol — creative on one end and destructive on the other." In the living room, a table he crafted has four different carved legs: a snake, a rope, a bark-stripped branch, and of course a pencil, sharpened end down. Ken even saves pencil nubs in a glass gallon jar; ever curious, he wants to see how long it will take to fill the container.

If Ken Cory weren't a jeweler, it's probable he would be a curio dealer. Stashed all over his house are tidy collections of everything from tiny, cast-iron ashtrays in the shape of frying pans to Chinese games to glass custard molds. Ken has a mania for organization, too. Lining a bookcase in his study are identical black notebooks of sketches, neatly numbered from one to thirty-five, although Ken has only partially filled notebook twenty-three.

At odds with his organizational instincts is Ken's haphazard attitude about titling his work. In order to make it easier for gallery owners to identify particular pieces, he reluctantly assigns each pin a one-word caption, which he arbitrarily changes from one show to the next. In addition, he doesn't view these captions as descriptive, and in fact, he once tagged a pin with a title designed to confuse the viewer. This sterling-silver pin, which Ken called *Saw* (1988), recalls the streamlined shape of an aluminum car trailer, complete with hitch.

Another sterling-silver pin, which resembles a bicycle lock, is called *Dress*. Made in 1988, its elegantly chunky form is topped with a loop of twisted copper wire as well as one of twenty-two-karat gold encasing a blue topaz. Despite this pin's title and locklike shape, Ken had a different image in mind as he created it. "I was thinking about all these third-world countries that are soon going to be capable of putting satellites in space," he confesses. "And I kept wondering what satellites from Bangladesh would look like. Or Ghana. It's a whole new field of design."

Coffee, a 1987 sterling-silver pin that resembles a sack stuffed with coffee beans, is more aptly named. "When I was a little kid," Ken says, "I had a coloring book from some coffee company, and in it were pictures of coffee-bean bags. Coffee was also the first word I learned how to spell. What I liked about it was that it had so many letters that were almost alike." Ken stops fidgeting with a pencil long enough to print a blocky, capitalized version of the word on a sheet of paper. "*C* and *O* are almost alike," he points out, "and then you've got two *F*s and two *E*s. What attracted me was the visual element."

Although his childish eye was drawn to the straightforward stockiness of the word *coffee,* as a mature artist, Ken Cory favors more oblique images, ones that delicately dodge the boundaries between representation and abstraction.

"In my pieces," Ken concludes, "I'm trying to combine a number of images that you can almost identify, but not quite. You think there's something there, but you can never quite solve the mystery." ◆

Dress, 1988. Pin: sterling silver, copper, 22-karat gold, and blue topaz. H. 2¼" x W. 1⅜" x D. ¼". Photo by Ken Cory.

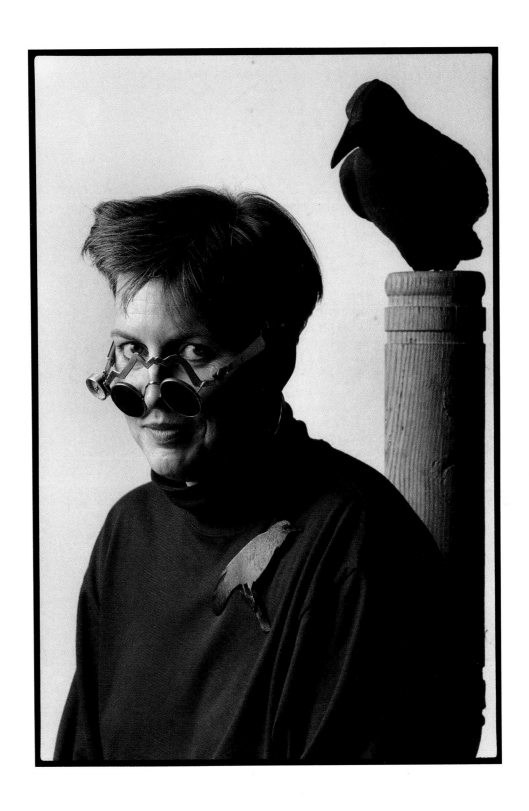

LAURIE HALL
Jeweler

SEATTLE, WASHINGTON

LAURIE HALL

Cubist Cafe, 1987. Necklace: fabricated sterling silver, cast fish, and oxidized finish. L. 12" x W. 6" x D. ½". Photo by Richard Nicol.

AS USUAL, LAURIE HALL was doing too many things at once. With just three days left before the opening of a show, she was not only feverishly finishing one final piece but having her photo taken at the same time. As if that weren't enough, her new work looked entirely different from anything she had ever attempted before. Not that radical departures are new for this inventive Seattle jeweler. Laurie's last show featured eyeglasses, but not the kind you'd wear to read a magazine. No, these were glasses that would have suited the flamboyantly bespectacled rock star Elton John. One pair, called *How Far Will You Go?*, was shaped like a bicycle, and its spoked wheels were the lenses. A tiny ebony hand plucked the strings of *My Spanish Guitar . . . La-La, La-La* (named for a song Laurie's mother used to sing); the round opening in the middle of the sterling-silver instrument served as a monocle. Other eyepieces were rigged with such doodads as antique compasses and rulers and a visor made of half an old 45-rpm record.

For her upcoming show, Laurie planned to bust the boundaries of conventional jewelry yet again by exhibiting three pairs of chamois gauntlets. Today she and one of her students — Laurie teaches as a full-time art instructor in a suburban Seattle high school — were silk-screening the Lucky Strike cigarette logo onto buttery chamois leather. That done, the student, whose name was Susan Ishii, would cut out and sew the gloves; Laurie would then decorate them. For three hours, as Susan worked in the dining room, Laurie shuttled cheerfully between the first and second floors of her duplex apartment. Between bouts of supervising Susan, Laurie dashed upstairs to don some of her spectacles and mug for the camera, chatting all the while about everything from the booming Seattle real-estate market to dating. Occasionally, a plaintive call for "Miss Hall" would signal that something was awry downstairs; once the silk screen clogged with red ink and ruined a length of chamois.

Two hours before the jewelry show opened in late 1989 at the Mia Gallery in Seattle, Laurie finally finished her third pair

of gauntlets, much to the relief of the gallery owner. For all their whimsy, at least two of Laurie's gloves pack a potent political punch. Her Lucky Strike gloves, entitled *Strike-Out*, sport cast sterling-silver matches formed into *X*s, and cuffs bordered with the surgeon general's warning against cigarette smoking pressed into aluminum. Miniature guns grace her anti-firearms gloves, *Arms Control*, and so do red bull's-eye targets. Her *Newcomers* gloves, which bear a silk-screened map of downtown Seattle as well as a compass, would probably help orient the California refugees flocking to the Northwest's largest city.

Laurie Hall is one of several Northwest artists currently redefining contemporary American jewelry. Like many of these innovators, Laurie studied with the esteemed jeweler Ramona Solberg, a former University of Washington professor whose necklaces and pins include beads, buttons, bone, game pieces, coins, and other found objects. Solberg's free use of materials inspired her students and others to incorporate nonprecious objects into their own jewelry, a magpie approach that fits Laurie like a glove. "I'm a natural primitive," says Laurie. "I go from my guts, with the materials around me, with the time that I have."

Madcap maven that she is, Laurie seems to inspire hyperbole. She has

How Far Will You Go? 1989. Glasses: sterling silver and rubber hose. H. 2" x W. 6" x D. 5". Photo by Richard Nicol.

been called everything from a rustic folk artist to the Cyndi Lauper of American jewelry. Ramona Solberg has said that "dealing with Laurie and her art is like sticking your finger in an electric socket." To draw yet another analogy, Laurie Hall could be called the Admiral Peary of contemporary jewelry, because she seems bent on exploring uncharted territory in her exuberant work.

As far as Laurie is concerned, the entire body, from head to foot, front and back, is open country for ornamentation. *Help, Help, House on Fire* (1984) seems like a straightforward necklace, albeit one with a Dalmatian at the foot of an attached brass ladder, until one realizes that the ladder curves over the wearer's shoulder. It ends in a flame-engulfed window dangling over the right shoulder blade.

A few of Laurie's other pieces, such as *Rah, Rah, Sisboombah* (1985), drape over the body like an advertising sandwich board. In front, a bare foot kicks an old, painted tin football over a goalpost; in back, hordes of hands hold pennants and a megaphone. The unshod foot hearkens back to her college days in Salem, Oregon. "The Hawaiians who went to my school, Willamette University, always kicked with a bare foot, so that was why I did that," Laurie says, her throaty voice increasing the revelation's

exoticism. She adds, "It was sort of a joke, too, on the sports emphasis of Mercer Island High School," the school where she has taught since 1968.

Personally, Laurie prefers baseball. She has depicted the subject in several pieces, including two made in 1988: *Between 1st and 2nd,* a pin with tiny turned-wood baseball bats, two balls, and a glove wedged between first and second base, and *Take Me Out!,* a necklace of sterling-silver baseballs. "I love baseball," says Laurie, pointing to her baseball mitt from the seventh grade, which hangs on a coatrack. "That's my favorite sport. I like the ball park and I like how the people who go to a ball game are just ordinary people. It's all-American."

"All-American" is a compliment from an artist whose work has portrayed such indigenous images as a wild Appaloosa horse, a boxing match, and a canoe. Although an ancient sculptor could have modeled the bust of a Roman senator after her full, sensual lips and large head, Laurie Hall is all-American, too; her mother's family settled the fertile Willamette Valley in Oregon as pioneers in 1862. Her father's family arrived fifty years later. Laurie's maternal grandfather collected Northwest Native American artifacts, many of which she now owns. These include cornhusk bags and an archery bow made by a Native American chief.

Strewn around Laurie's gloriously messy basement workshop are other heirlooms, such as her grandfather's screwdriver with a turned-wood handle of his own making and her grandmother's scissors. "I need all that stuff around me," says Laurie. When she was growing up in a suburb of Portland, Oregon, Laurie spent a lot of time with her mother's father, whose hobby was carpentry. In Laurie's kitchen sits a redwood bench that she designed in the seventh grade and her grandfather constructed. The two made spice racks together, too. "I liked making things," says Laurie. "I've always been a project-oriented person." As a kid, she enjoyed dressing up in costumes, as well as drawing, and her parents applauded her creative efforts by pinning up her artwork.

After the school year ends, Laurie spends a month each summer in her parents' home outside Portland, making jewelry and attending her nephews' baseball games. Although she was born in 1944, the middle child of three, Laurie still has the unfettered imagination of a child. "When I make my jewelry," she shyly confesses, "I feel sort of like they're friends. It's like I'm having conversations with them." Her rollicking pieces do, indeed, seem to have a life of their own; in fact, it's fun to imagine them roistering in Laurie's workshop at night.

As an art major in college, Laurie took one jewelry class, but had no significant training in metalsmithing. Immediately after she graduated from Willamette University in 1966, she began teaching art in a Seattle-area high school. Two years later she transferred to Mercer Island High School, where she has worked full time as an art instructor ever since. After hearing Ramona Solberg speak on jewelry at an educators' conference in 1970, Laurie decided to study with her. "When I saw Ramona's jewelry," says Laurie, "it didn't look like jewelry to me, it looked like art." The following year Laurie went back to school at the University of Washington for her M.A., which took her three years to earn because she continued teaching.

One of her jewelry professors in graduate school told Laurie she was very creative, but dismissed her craftsmanship. But then there was Ramona Solberg.

"She just let me do what I wanted to do," recalls Laurie. "I think the best thing a teacher can be is an inspiration. Ramona was a sounding board.

She was real helpful if I couldn't figure out how to put something together. She said everything I did was great. I had made very little jewelry and I didn't really know how, so to get ready for my first critique I worked every afternoon after I finished teaching until three in the morning. When I came to the critique Ramona said, 'We have one person here who is indeed a designer,' and then she told everybody it was me and my heart just leaped."

In the late 1970s and early 1980s, Laurie's work often took the form of a narrative tableau, and sometimes related to events in her personal life. For example, a 1979 necklace of little bone hands, *Clap Hands, Here Comes Charlie*, celebrated a new relationship, just as a 1980 bear-and-fishes necklace, *Bear Up a Creek*, recorded its demise. "Bear up a creek without a paddle," says Laurie, repeating an old American saying, "that was really me up a creek because I'd lost my boyfriend."

In 1984, the same year that her neck scarf of painted pigskin and incised and inlaid bone won honorable mention in the prestigious annual *Ornament* magazine awards, Laurie enrolled in a summer workshop in Lake Placid, New York, and studied with the noted jewelry designer Robert Lee Morris. Two years later, she spent the summer working at Artwear, Morris's commercial-jewelry studio in New York City. Morris was an encouraging mentor, but duplicating his designs convinced her that she liked making her own, one-of-a-kind jewelry. "Just doing the same thing, over and over again — I just couldn't stand that," says Laurie. "What I find enjoyable is having an idea and needing to complete it to see if it works."

When it comes to ideas, Laurie Hall's quirky mind works in wondrous ways. In speaking about *K.O.* — her 1985 necklace of two antique folk figures with dukes up in a boxing ring — Laurie says, "Just the idea that someone would be wearing a whole boxing match on her chest is funny." Another necklace, *Cubist Cafe* (1987), which depicts a coffee mug steaming against a window as well as skewed chairs and tables, came about because of Laurie's fascination with cubism, the abstract-art movement founded by Pablo Picasso and Georges Braque. She also liked the idea of incorporating architectural details into jewelry.

"I thought, 'Wouldn't it be great if people were wearing rooms?'" Laurie asks, flashing her large, awesomely perfect teeth as she continues to spin out her fantasy. "I want people to wear rooms. They could wear windows, too. They could even wear a scene like looking out a window at the mountains or an airplane. Or they could wear windows with shutters like Matisse did."

Like many creative people, Laurie is easily bored with repetition. It was boredom with the conventional forms of jewelry that impelled her in 1989 to create her spectacular spectacles, a body of work she calls "Frames of Mind." "I didn't want to make jewelry," she explains. "I didn't want to make a ring. I didn't want to make a bracelet. I *particularly* did not want to make another necklace."

After she finished the eyeglasses, a traveling exhibit of Alaskan and Siberian artifacts, including leather gauntlets, inspired Laurie to make gloves. "It brought back to me my old love of Indian things," she says.

Laurie Hall's blithe spirit and love of new challenges will probably continue to keep contemporary jewelers and gallery owners wondering what she will dream up next. "I might make some headdresses," she speculates, "or coats with a Hudson's Bay coat shape. I don't quite know what I'm going to do and that's the most exciting thing. I don't like feeling very comfortable." ◆

Arms Control, 1989. Gloves: painted chamois, oak, sterling silver, and copper. L. 9" x W. 5" x D. 2". Photo by Richard Nicol.

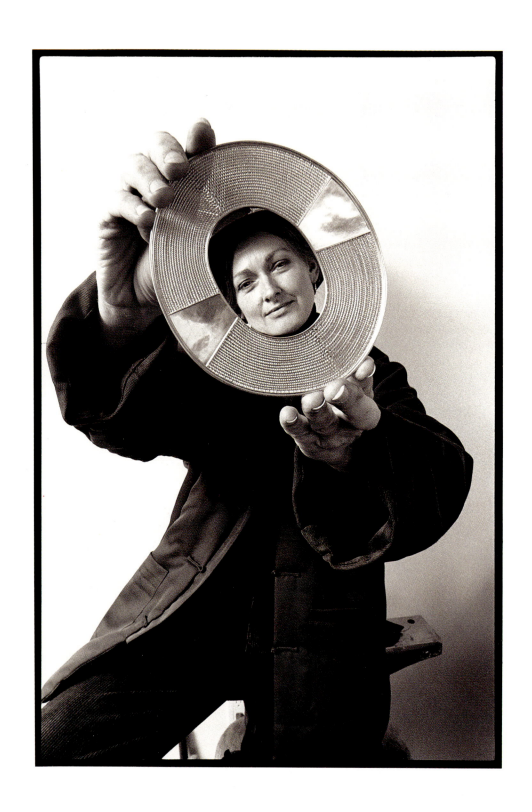

MARY LEE HU
Jeweler

SEATTLE, WASHINGTON

MARY LEE HU

Bracelet #37, 1986. Twined and constructed 18- and 22-karat gold and lapis lazuli. H. 2¾" x W. 3¼" x D. ½". Photo by Richard Nicol.

IT WAS 1966, Mary Lee Hu's final year of graduate school in the metalsmithing and jewelry design department at Southern Illinois University in Carbondale, and she had yet to produce a body of work for her thesis show. Although Mary was well versed in most metalsmithing techniques, she still hadn't found a unique style all her own. Now it so happened that in addition to her jewelry classes, Mary was also taking a weaving course as an elective. She discovered she liked weaving repeated patterns; it was like drawing with strands of yarn. In fact, the warp and weft of woven fibers resembled the crosshatches in her sketches, a drawing style she had developed as an undergraduate metalsmith major at the prestigious Cranbrook Academy of Art in Bloomfield, Michigan.

However much Mary enjoyed her graduate weaving class, though, she wasn't about to give up metal for fiber. For one thing, she didn't like fiber's fuzziness because it obscured linear detail. And for another, she had set her heart on becoming a jeweler ever since 1959, when she was sixteen years old and took her first jewelry class in a summer art camp. Right from the start, Mary liked metal's lustrous quality, and the challenging resistance it offered when she worked it.

Two months into her final year of graduate school, Mary devised a clever way to combine fiber techniques with jewelry: she would use metal wires as if they were strands of fiber to make jewelry. A pragmatist, she also intended her wire jewelry to fulfill requirements for both her weaving class and a course with the metalsmith Brent Kington. Kington, who also headed the metals department, approved Mary's idea, but insisted that she make two pairs of wire earrings each week for the rest of the school year. In the course of carrying out that assignment, Mary developed a repertoire of techniques that have since catapulted this jeweler, who now lives in Seattle, to international fame.

Initially, Mary tried tying macrame knots in brass strands. But the wire proved too hard to knot tightly, so she switched to fine silver, which is purer and more pliable than sterling silver. At first it took Mary approximately two days to finish each week's assignment, but by the end of the school year, she could complete the two pairs of earrings in just a few hours. As she became more proficient, Mary adapted more and

143 | ARTISTS AT WORK

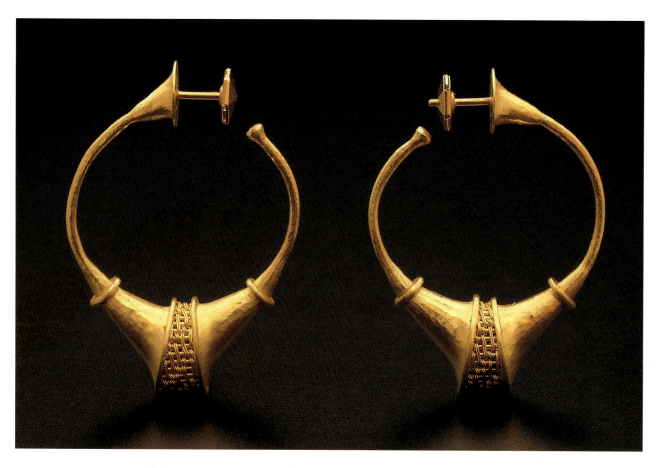

Earrings #126, 1988. Twined, forged, and constructed 18- and 22-karat gold. L. 1 3/4" x W. 1 1/4" x D. 1/2". Photo by Richard Nicol.

more fiber techniques to metal wire. Before long, she was weaving, wrapping, looping, and twisting strands of wire to form the earrings. Her fingers were her only tools. This labor-intensive, yet low-tech approach required only a minimal use of solder; to join the ends of the wire, Mary simply fused them together by heating them with a torch.

Early on, she decided to use only round wire instead of square or flat wire. Not only did the shape of round wire resemble strands of fiber, but it was also more resilient than flat or square wire and produced a cleaner line. "In many cases," Mary explains, "what I was doing was making an outline, or drawing with wire, so I wanted the wire as much like just a line as possible."

During those last ten months of graduate school, Mary taught herself many of the techniques she still employs in constructing her stunning, stately jewelry. One of the few contemporary jewelers to adapt fiber techniques to metal, Mary Lee Hu is an acknowledged master of this meticulous art form. Today, some twenty-five years after she made her first silver wire earrings, Mary now twines gleaming strands of 18- and 22-karat gold into superbly symmetrical earrings, chokers, and bracelets whose exquisitely balanced proportions are as awe-inspiring as the "fearful symmetry" of the "tyger" in William Blake's famous poem.

After graduating with an M.F.A. from Southern Illinois University, Mary married Tah-Kai Hu. They stayed on in Carbondale for the next two years, while Hu completed his Ph.D. in mathematics and Mary taught in the art department. In 1969, the couple moved to Bellingham, Washington, where he taught at Western Washington University for two years. Mary continued working with silver wire, which she now used for

neckpieces and small sculptures of animals as well as earrings.

In 1971, they flew to Taiwan, intending to live there for one year. But weeks before they were due to come back to the U.S., Mary's husband died, so she stayed on in Taiwan with her Chinese mother-in-law for another year. In 1973, she left Taiwan and traveled with her father for three months throughout fifteen Eurasian countries before returning to her hometown of Olmsted Falls, Ohio, near Cleveland.

Until Mary traveled outside the United States, she didn't realize that her work carried on an ancient tradition of using metal wire for ornaments. For example, the Greeks plied wire to decorate fibulas, clothing clasps resembling safety pins. Everywhere Mary went, she took photographic slides of metalwork, intending to use them in teaching jewelry when she came home. After her return, Mary taught at several universities in the Midwest before she was hired in 1980 by the University of Washington in Seattle, where she teaches jewelry to this day. In the classroom, the tall, elegantly imposing Mary alternately exhibits a brisk manner and a dry wit.

Inspired by belts of knitted metal that she bought in India, Mary began knitting wire with a crochet hook in 1973. The following year, she started twining, or twisting together two single strands of wire. In addition to employing fine and sterling wire to construct her earrings and neckpieces, Mary also experimented with colored copper wire, which is used to wind electromagnets in motors. Mary's brother, an electrical engineer, first introduced her to this material, which she then bought in electronic surplus stores. But by 1978 she decided that she wasn't a colorist and so renounced the coppery reds, greens, and blues of magnet wire in favor of silver's more lunar glow.

From the late 1960s through the mid-1970s, Mary primarily concentrated on neckpieces and chokers, which grew longer and more elaborate as time went by. Dragons, phoenixes with trailing feathers, and octopus tentacles all figured in these pieces, some of which drape sinuously over the breastbone. Many of Mary's neckpieces and chokers from this time recall the organic, sensual shapes depicted in glass and jewelry of the Art Nouveau period.

Influenced by the numerous shows of ancient gold objects that toured major museums in this country during the 1970s, Mary turned to more restrained forms in silver modeled after the torque, a metal collar formerly worn by Celtic peoples. After a series of torque-shaped chokers, Mary adapted the form to bracelets in 1981 and continued in this vein for the next three years. To make the bracelets, Mary twined fine and sterling silver into finger-wide tubes, then sliced the tube into three or four sections of equal length. She soldered these sections to triangular or ring-shaped joints, some of which were made of 14-karat gold.

After several years of basing her silver chokers and bracelets on ancient torques made of gold, Mary abandoned silver, the material she had used for the past twenty years, and switched her allegiance to gold. The change came about because a New York gallery asked for a gold necklace for a 1985 show commemorating famous divas for the fiftieth anniversary of the Metropolitan Opera Guild. Mary was assigned Elisabeth Rethberg, a soprano most famous for her role as the Ethiopian slave Aida in Giuseppe Verdi's opera of the same name. *Aida* is a Romeo-and-Juliet story set in Egypt.

For some time before this request, Mary had dreamed about fabricating a necklace composed of negative diamond shapes. She came up with

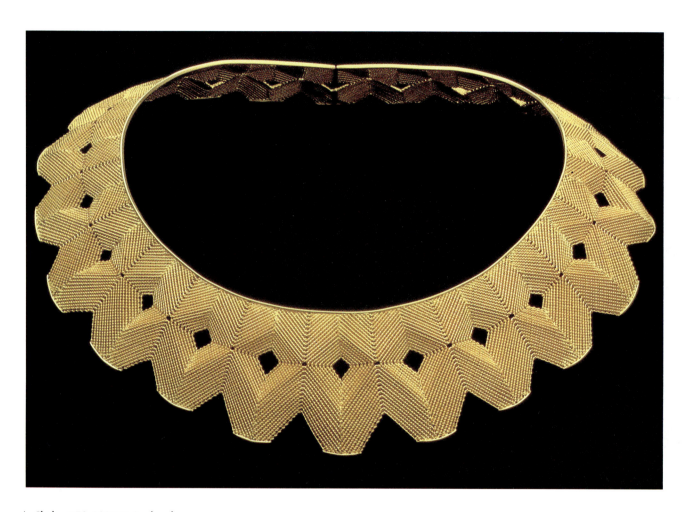

Choker #70, 1985. Twined and constructed 18- and 22-karat gold. W. 9½". Photo by Richard Nicol.

this idea by accident, when she joined two silver *X* shapes to make a pair of earrings and discovered that the space between the two *X*s formed little negative diamonds. She resisted translating this idea into a larger piece, however, because she knew it would present some difficult design problems. Not only would she have to twine a series of tapered, symmetrical shapes, but she would also have to solder them perfectly to form a necklace.

While she was pondering these problems, trying to decide if she wanted to attempt the project at all, the gallery mailed Mary a photo of Elisabeth Rethberg costumed as Aida. The photo showed Rethberg wearing a neckpiece of glass tubular beads strung together in such a way that they formed a series of *diamond shapes*. Taking this as a sign, Mary decided to go ahead with the necklace she had long wanted to make. As a test run, she fabricated one-third of the complicated design in silver, to work out any kinks. Then she weighed this section and calculated how much gold she would need. Two months of long days later, she produced *Choker #70*, a regal collar of 18- and 22-karat gold. Composed of twenty-two twined, *X*-shaped elements, the choker tricks the eye into seeing only diamond shapes. *Choker #70* is the opposite of a diamond in the rough — it refines geometry into an even more sublime symmetry.

Though her work has long been renowned for its technical perfection, Mary insists that working in gold has further polished her skills. "The gold demanded it of me," she says. "Somehow if you're going to do high-karat gold, it shouldn't be sloppy. If you hold any one of my silver pieces up to the light, you can see where there's solder near the edges. You don't see that with gold. I'm much more careful. I put on smaller pieces of solder and I put them only where they need to be."

Since she finished *Choker #70* in 1985, Mary has made a number of other chokers as well as bracelets and earrings made of high-karat gold. But she fondly remembers her elation when she completed *Choker #70*, her first piece constructed entirely of gold.

"I just thought I had done something wonderful," she recalls. "There are very few times when you finish a piece that you're just amazed. It is a very good feeling. Technically, that piece is not as well done as some of the later ones, but design-wise I think it's a knockout. And I liked the thought of finally being a goldsmith. I've sort of been working up to it all my life." ◆

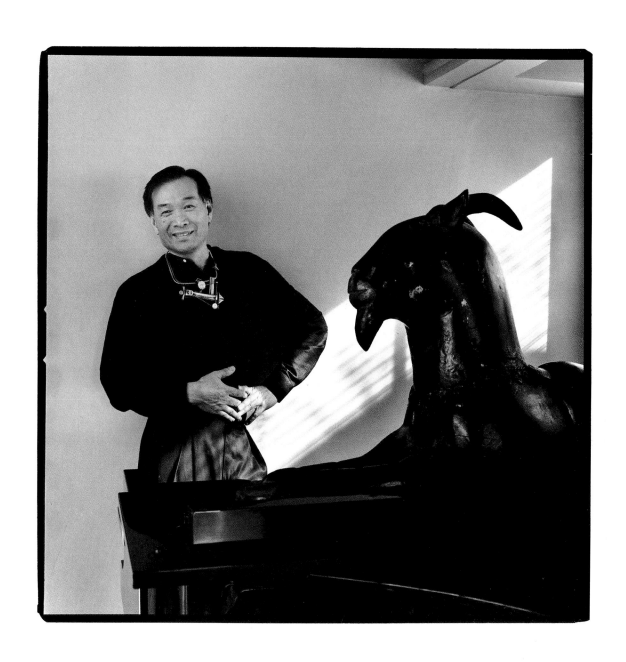

Ron Ho
Jeweler

SEATTLE, WASHINGTON

RON HO

ONCE UPON A TIME, so the Chinese legend goes, Buddha summoned all the beasts in creation before him one New Year. Although he promised to reward those who obeyed his order, just twelve animals answered the call. First the rat came, followed by the buffalo, and then the tiger, the cat, the dragon, the snake, the horse, the goat, the monkey, the rooster, the dog, and finally, the pig. When it became clear that no additional animals would attend, Buddha proposed a present. He offered to forevermore name the years after each of the assembled animals, in the order in which they had appeared before him. The animals accepted Buddha's gift, legend says, and that is why the Chinese years are consecutively named for one after another of those twelve animals.

Chinese astrologers believe that each animal exercises its influence over people born during its year, just as some Westerners think the zodiac affects the personalities of people born under a particular sign.

The son of Chinese-American parents, Ron Ho was born during Year 4634 on the Chinese calendar, or 1936, a Year of the Rat. According to Chinese astrologers, "Rats" typically hoard material goods, and Ron, a jeweler who lives in Seattle, is no exception. Filling every room of his compact international-style house, built the year of his birth, are curiosities collected during his extensive travels to such countries as Afghanistan, Thailand, Nepal, and Indonesia. In his studio, his drawers are crammed with small wonders: a shell hair ornament from Mauritania, a Japanese porcelain doll face, and an Eskimo crampon carved from reindeer bone. And each tiny compartment of a huge Korean apothecary chest holds beads made of materials as diverse as amber, carnelian, and buffalo bone.

Sooner or later, it's likely that some of these objects will find their way into Ron's sumptuous

All Fall Down, 1968. Necklace: bone domino, bone collar and underwear buttons, and ebony with forged and fabricated silver. L. 11" x W. 5½" x D. ¾". Photo by Rod Slemmons.

149 | ARTISTS AT WORK

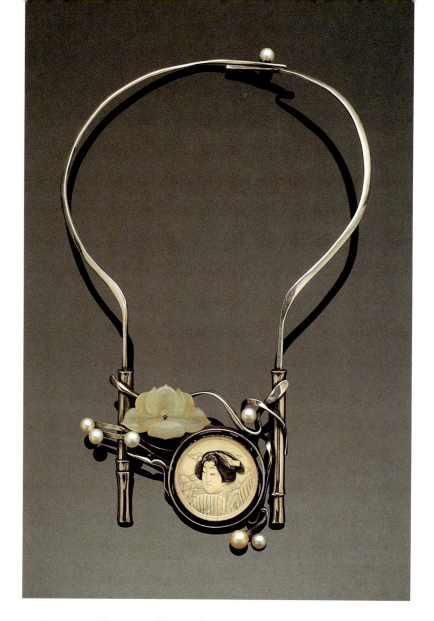

necklaces, which are as elaborately decorated as robes embroidered for Oriental royalty. Antique Chinese jades, Eskimo scrimshaw, Afghan charms, a Lapland knife case, and a harpoon tip have all figured as pendants in Ron's neckpieces. Once, he even included an Indonesian sword hilt in a necklace.

Ron Ho's background is as exotic as his necklaces. Raised in Honolulu, he is the grandson of Chinese immigrants who came to Hawaii in the late nineteenth century to replace a native work force decimated by diseases unwittingly introduced by Christian missionaries. One of Ron's early memories is of his maternal grandmother bending and binding her broken toes to make her feet smaller, a painful ritual she had undergone since childhood. As the eldest son among four children, Ron was expected to choose a pragmatic occupation, even though he had always been drawn to art. But when he arrived in Tacoma, Washington, to attend his older sister's alma mater, Pacific Lutheran University, he compromised by selecting art education, a major that balanced his parents' concerns with his own interests. Ron has taught art to elementary and high school students ever since he graduated with a B.A. in 1958. He is now an elementary art specialist in Bellevue, a suburb of Seattle.

In 1962, Ron enrolled at the University of Washington in Seattle to

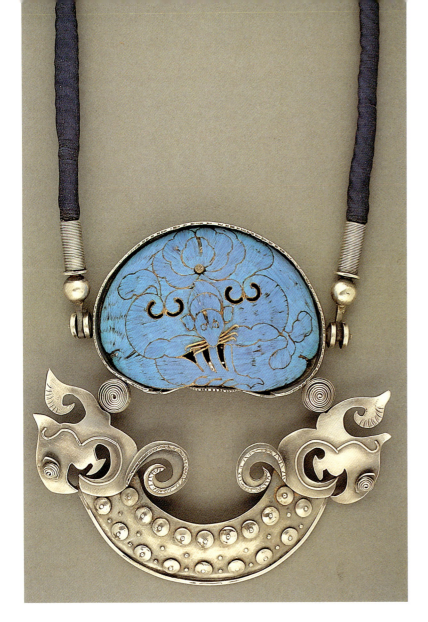

OPPOSITE:

Treasures of the Orient, 1979. Necklace: carved ivory, kagami-buta, carved Chinese jade button, freshwater pearls, and forged and fabricated silver. L. 9" x W. 3½" x D. ¾". Photo by Roger Schreiber.

ABOVE:

The Kingfisher and the Tiger, 1988. Necklace: antique Chinese kingfisher hair ornament, silk, with forged and fabricated silver. L. 13" x W. 4½" x D. 1". Photo by Rod Slemmons.

earn his master's degree in art education. In the four years since he had graduated from college, he had painted, exhibiting his work at juried shows in the Northwest. But in his last quarter of graduate school, Ron took a class with the jeweler Ramona Solberg, and he soon switched his allegiance from painting to jewelry. A dynamic teacher whose work is nationally known, Solberg has influenced a generation of Northwest jewelers. Eschewing precious stones in jewelry, she instead advocates the use of humble found objects such as buttons and game pieces, as well as beads and other items made by native peoples around the world.

"Ramona introduced me to ethnic jewelry," says Ron, "which became a whole different world. I had never seen this other side of jewelry. In my travels, I had collected folk art, and then Ramona made me realize that these things I had collected could become pieces of jewelry."

Ron received his M.A.T. in 1968, and that same year constructed his first necklace, *All Fall Down*, with four bone items given to him by Ramona — a domino, one shirt-collar button, and two old-fashioned underwear buttons. Even though this earliest pendant necklace includes one square and three round geometric shapes, Ron arranged them asymmetrically. Two bone buttons are centered on the forged silver neckpiece, but they are of different sizes. The domino is set into a silver box, and suspended to one

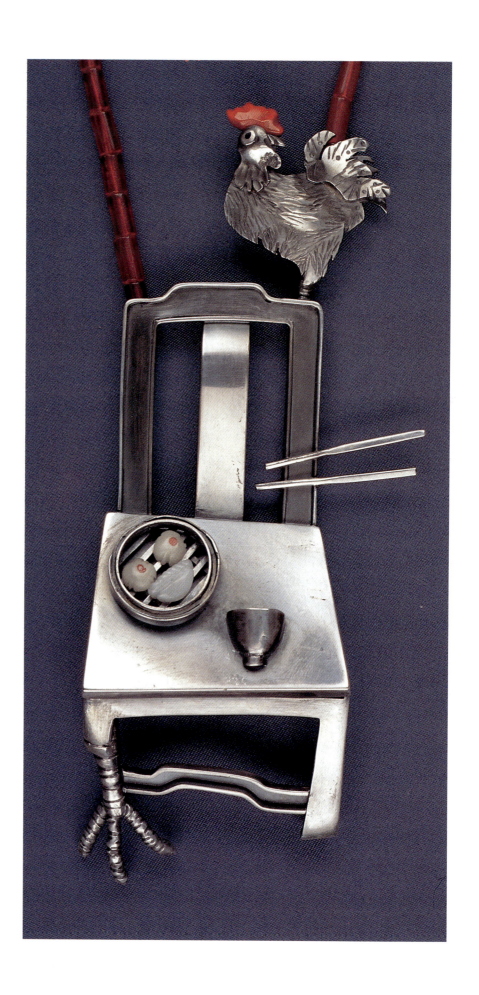

side is another button. Underneath these elements are mounted clamshell beads, which look as if they have been randomly scattered, like dice on a table. Ron gave this necklace to Ramona Solberg in appreciation, and when it was stolen from her home, he remade it. From 1981 to 1983 it traveled throughout the U.S. and South America as part of the Smithsonian-sponsored exhibition "Good as Gold."

Over the years, Ron has continued to incorporate found objects rather than precious stones in his work, but whereas he originally used ordinary buttons, he now includes gorgeously esoteric items such as bright blue kingfisher feathers. The curved lines of his compositions, which have been compared to calligraphy, not only recall the sinuous swirls in Art Nouveau designs, but also that era's emphasis on fluid forms found in nature.

Ron himself attributes his design sensibility to his background and his travels throughout Asia. "When I was painting," he says, "I never thought about being very Chinese. But as I started working in jewelry, I started getting into the feel of Asian design, the intricacy. I came to terms with my heritage."

Quite a few of Ron's necklaces bear names that either refer to places in China, such as the imperial *Forbidden City* (1988), or to mythological Chinese creatures such as phoenixes and dragons. *Dragon Gate* (1982) features a small dragon Ron forged and fabricated from silver, coupled with an antique ivory cigarette holder decorated with a dragon. The necklace, commissioned by the owner of a publishing company, bears the company's name, which is based on a Chinese parable of a carp turning into a dragon. The necklace also includes a carp carved from ivory.

Dim Sum at the On-On Tearoom, a whimsically titled 1990 necklace, shows a tiny wok and steamer and chopsticks resting on a silver chair suspended from red glass beads. The necklace commemorates one of Ron's favorite weekend activities: eating dim sum, or bite-sized steamed dumplings, at Chinese restaurants in Seattle's Asian neighborhood, which is known as the International District. "Being Chinese means you're really into food," jokes Ron, who loves to cook. His own best model, he often wears one of his dramatic necklaces when he entertains in his home.

Although Ron's work is frequently exhibited in Northwest galleries and museums, he usually sells to friends and acquaintances who commission necklaces. For instance, he made *Treasures of the Orient* (1979) for a Japanese friend. Ron doesn't customarily include precious jewels in his work, but he accepted this friend's offer of seven pearls for the necklace because they complemented the hue of a Japanese ivory carving and a carved jade button Ron bought in London.

Working on commissioned pieces allows Ron, a full-time teacher, a more leisurely schedule than that afforded by gallery shows. In addition, selling necklaces to acquaintances means that Ron Ho experiences the pleasure of occasionally glimpsing his work at parties or other gatherings. "There's nothing nicer than walking into a room and finding that someone is wearing one of your pieces," says Ron. "It's like seeing an old friend again." ◆

Dim Sum at the On-On Tearoom, 1990. Necklace: carved Plexiglas with forged and fabricated silver and glass beads. L. 12" x W. 4" x D. 1". Photo by Rod Slemmons.

BIBLIOGRAPHY

Chihuly, Dale. *Chihuly: Color, Glass and Form,* foreword by Henry Geldzahler. Tokyo: Kodansha International Ltd., 1986.

Clark, Garth. *American Ceramics: 1876 to the Present* (revised edition). New York: Abbeville Press, 1987.

———. *The Eccentric Teapot: Four Hundred Years of Invention.* New York: Abbeville Press, 1989.

Diamondstein, Barbaralee. *Handmade in America: Conversations with Fourteen Craftmasters.* New York: Harry N. Abrams, Inc., 1983.

Frantz, Susanne K. *Contemporary Glass.* New York: Harry N. Abrams, Inc., 1989.

Hall, Julie. *Tradition and Change: The New American Craftsmen.* New York: E. P. Dutton, 1977.

Harrington, LaMar. *Ceramics in the Pacific Northwest: A History.* Seattle: University of Washington Press, 1979.

Mayer, Barbara. *Contemporary American Craft Art: A Collector's Guide.* Salt Lake City: Gibbs M. Smith, Inc., Peregrine Smith Books, 1988.

Morris, William. *William Morris: Glass, Artifact and Art.* Seattle: University of Washington Press (distributors), 1989.

Smith, Paul J. *American Craft Today: Poetry of the Physical.* New York: American Craft Museum, Weidenfeld & Nicolson, 1986.

ARTISTS' REPRESENTATIVES

For more information about the artists presented in this book, contact their galleries or artists' representatives. A partial list follows.

GLASS

SONJA BLOMDAHL
- **The Art Gallery at Gump's,** 250 Post Street, San Francisco, CA 94108
- **Brendan Walter Gallery,** 1001 Colorado Avenue, Santa Monica, CA 90401
- **Maveety Gallery,** 842 SW First Avenue, Portland, OR 97204
- **William Traver Gallery,** 2219 Fourth Avenue, Seattle, WA 98121

RUTH BROCKMANN
- **Kurland Summers Gallery,** 8742 A Melrose Avenue, Los Angeles, CA 90069
- **Maveety Gallery,** 842 SW First Avenue, Portland, OR 97204
- **William Traver Gallery,** 2219 Fourth Avenue, Seattle, WA 98121
- **The Works Gallery,** 319 South Street, Philadelphia, PA 19147

PAUL MARIONI
- **William Traver Gallery,** 2219 Fourth Avenue, Seattle, WA 98121
- **Brendan Walter Gallery,** 1001 Colorado Avenue, Santa Monica, CA 90401

WILLIAM MORRIS
- **Foster/White Gallery,** 311½ Occidental Avenue, Seattle, WA 98104
- **Maurine Littleton Gallery,** 1667 Wisconsin Avenue NW, Washington, DC 20007
- **Betsy Rosenfield Gallery,** 212 West Superior, Chicago, IL 60610
- **Brendan Walter Gallery,** 1001 Colorado Avenue, Santa Monica, CA 90401

GINNY RUFFNER
- **Heller Gallery,** 71 Greene Street, New York, NY 10012
- **Holsten Gallery,** 206 Worth Avenue, Palm Beach, FL 33480
- **Maurine Littleton Gallery,** 1667 Wisconsin Avenue NW, Washington, DC 20007

Brendan Walter Gallery, 1001 Colorado Avenue, Santa Monica, CA 90401

CERAMICS
SARAH JAEGER
Art Options, 2507 Main Street, Santa Monica, CA 90405
Joanne Rapp Gallery/The Hand and the Spirit, 4222 North Marshall Way, Scottsdale, AZ 85251

BETH LO
Joanne Rapp Gallery/The Hand and the Spirit, 4222 North Marshall Way, Scottsdale, AZ 85251
Simms Fine Art, 827 Girod Street, New Orleans, LA 70113

MARILYN LYSOHIR
Garth Clark Gallery, 170 South LaBrea Avenue, Los Angeles, CA 90036
Garth Clark Gallery, 24 West 57th Street, New York, NY 10019
Linda Hodges Gallery, 319 First Avenue South, Seattle, WA 98104

KERRY MOOSMAN
Ochi Art Gallery, 1322 Main Street, Boise, ID 83702

RONNA NEUENSCHWANDER
Susan Cummins Gallery, 12 Miller Avenue, Mill Valley, CA 94941
Maveety Gallery, 842 SW First Avenue, Portland, OR 97204

RICHARD NOTKIN AND AKIO TAKAMORI
Garth Clark Gallery, 170 South LaBrea Avenue, Los Angeles, CA 90036
Garth Clark Gallery, 24 West 57th Street, New York, NY 10019

ANNE PERRIGO
Mia Gallery, 314 Occidental Avenue South, Seattle, WA 98104

PATRICK SILER
Linda Farris Gallery, 322 Second Avenue South, Seattle, WA 98104
Leedy-Voulkos Gallery, 1919 Wyandotte, Kansas City, MO 64108

JEWELRY
KEN BOVA
Artifacts Gallery Ltd., 308 East Main, Bozeman, MT 59715
Gallery Eight, 7464 Girard Avenue, La Jolla, CA 92037
Gail Severn Gallery, 620 Sun Valley Road, Ketchum, ID 83340
Society of Arts and Crafts, 175 Newbury Street, Boston, MA 02116

KEN CORY AND LAURIE HALL
Mia Gallery, 314 Occidental Avenue South, Seattle, WA 98104

RON HO
Facere Jewelry Art, 1501 Fourth Avenue, Seattle, WA 98101

MARY LEE HU
The Merrin Gallery, 724 Fifth Avenue, New York, NY 10019

KIFF SLEMMONS
Susan Cummins Gallery, 12 Miller Avenue, Mill Valley, CA 94941
Julie: Artisan's Gallery, 687 Madison Avenue, New York, NY 10021
Mia Gallery, 314 Occidental Avenue South, Seattle, WA 98104
Sculpture to Wear, 8441 Melrose Avenue, Los Angeles, CA 90069

INDEX

References to color plates are printed in boldface type.

Abstract expressionism, in painting and ceramics, 41, 101–102
Alfred University, New York State College of Ceramics, 60–61, 72–73, 77
Archie Bray Foundation, The, ix, 51, 54, 59, 60, 73; annual "Brickyard Bash," 77; directors of, 41, 58; origins and founding of, 40, 57; seminal workshop at, 39–40, 58
Arneson, Robert, 66, 91
Art Nouveau, 21, 145, 153
Autio, Rudy, ix, **40–41, 58-59,** 77

Baker-Wood, Florence, **108–113;** photographed art works, **109–111, 113**
Ball, F. Carlton, 41
Bauer, Fred, 41
Bauhaus School, 40, 58
Block, 6
Blomdahl, Sonja, **4–9;** photographed art works, **5, 7–8**
Blowpipe, 6
Boise State University, 45, 47
Bonifas, Paul, 41
Bova, Ken, **120–**125; photographed art works, **121–122**
Bray Foundation. *See* Archie Bray Foundation, The
Brockmann, Ruth, **16–**21; photographed art works, **17–18, 20**
Bullseye Glass Company, glass-fusing workshop, 19

California College of Arts and Crafts, 25, 40, 132
Central Washington University (Ellensburg), 106, 135
Ceramic styles and techniques, 39–103; coiling large vessels, **43–48;** earthenware, adobe sculpture, **81–85;** "Fiesta" ware, 40; figurative slab sculpture, **69,** 72–73; functional wheel pottery, **51–55;** large installations/sculpture, **93–97;** large slab sculpture and vessels, 99–**103;** porcelain figures/stacking vessels, 76–78; sculpture with knickknacks, **87–91;** slipwork, **40,** 41; stoneware, wood-fired, 40, **58–**59, 61; stoneware, Yixing teapots, **63,** 64–67
Chihuly, Dale, ix, 11–12, 37; art and career of, 1, 2; and campus glass movement, 2; collaboration, 2; and Pilchuck Glass School, 1
Cory, Ken, **130**–135; photographed art works, **131, 133–134**
Cranbrook Academy of Art, 143

Dailey, Dan, 8–9
Dazzle camouflage, **93–**94
Dichroic glass, 27
Double-bubble technique, 5–7; and Checco Ongaro, 9
Dow, Arthur Wesley, 106

Earl, Jack, 77
Eikerman, Alma, 128
Expressionism (German), 100–101

Ferguson, Ken, 41, 52, 54, 58, 72–73
Frit, 21
Funk, and funk style, 29, 41, 66, 91, 99, 132

Gallery, Asher/Faure, 93–94
Gallery, Garth Clark, 73, 115
Gallery, Mia, 137
Gallery, Traver Sutton, 9
Glass, dichroic, 27
Glass Eye Studio, 9
Glass styles and techniques, 1–38; affixing drawings to glass, 25–26; built glass sculpture, 38; cast-glass sculpture, use of frit, 21; "cold" glasswork, 2; double-bubble, 5–7, 9, 38; fused glass, slumping, 2, 19–21; glass drawings on glass, 15, 37; lampworking, 30; leaded glass with photos, 24; sand-casting, 26; use of dichroic glass, 27; wire drawings on glass, 11–12, 14

Glassblowing, glassmaking: origins and types of, 2

Hall, Laurie, 106, **136**–141; photographed art works, **137–139, 141**
Hamada, Shoji, 40, 58–59, 61
Hansen, Gaylen, 101
Harrington, LaMar, 41, 106
Hauberg, Anne Gould and John H., 1
Haystack Mountain School of Crafts, 1
Helzer, Richard, 123
Ho, Ron, 106, **148**–153; photographed art works, **149–152**
Hot-glass movement, 25 (*see also* Studio-glass movement); university programs in, 2
Hotchkiss, Lulu, 106
Hu, Mary Lee, 112, **142**–147; photographed art works, **143–144, 146**

Idaho artists: Larson, Gail Farris, **126**–129; Lysohir, Marilyn, **92**–97; Moosman, Kerry, **42**–48
Idaho State University (Pocatello), 127–128
Indiana University (Bloomington), 128

Jack, 7, 38
Jaeger, Sarah, **50**–55; photographed art works, **51, 53, 55**
Jewelry styles and techniques, 104–153; clothlike metal, 128; tied or sewn metal, 123; twining precious metals, 143–147; use of found objects, 105–106, 118, 121, 124, 128, 138, 151, 153; wood-casting for copper pins, 132–133
Jewelry, contemporary, 105–106. *See also* Solberg, Ramona, and Penington, Ruth

Kangas, Matthew, 2
Kansas City (Missouri) Art Institute, 41, 52, 54, 64, 72
Kienholz, Edward, 89
Kington, Brent, 143
Kirkpatrick, Joey, and Flora Mace, **10**–15; photographed art works, **11, 13–14**
Kottler, Howard, 41, 90

Labino, Dominick, 2
Larson, Gail Farris, **126**–129; photographed art works, **127–129**
Leach, Bernard, 40, 58–59
Lipofsky, Marvin, 25

Littleton, Harvey, 2
Lo, Beth, **74**–79; photographed art works, **75–77, 79**
Louvre Museum, 1
Lysohir, Marilyn, **92**–97; photographed art works, **93, 95, 97**

Mace, Flora, and Joey Kirkpatrick, **10**–15; photographed art works, **11, 13–14**
Mangus, Chick, 96
Marioni, Dante, 26
Marioni, Paul, **22**–27; photographed art works, **23–25, 27**
Marshall, John, 112
Marver, 6
Mingei (Japanese folk-art movement), 40, 58
Montana artists: Bova, Ken, **120**–125; Jaeger, Sarah, **50**–55; Lo, Beth, **74**–79; Roorbach, Carol, **56**–61
Montana State University (Bozeman), 40, 73, 123, 125
Moosman, Kerry, **42**–48; photographed art works, **43, 44, 47, 49**
Morris, Robert Lee, 141
Morris, William, **34**–38; photographed art works, **35–37**

Nelson, Robert, 24
Neuenschwander, Ronna, **80**–85; photographed art works, **81, 83–84**
Notkin, Richard, **62**–67; photographed art works, **63, 65**

Ongaro, Checco, and double-bubble technique, 9
Oregon artists: Brockmann, Ruth, **16**–21; Neuenschwander, Ronna, **80**–85; Notkin, Richard, **62**–67
Orrefors Glass School, 6–9

Pencil Brothers, The, 133–134
Penington, Ruth, and contemporary jewelry, **105**–106
Perrigo, Anne, 41, **86**–91; photographed art works, **87–88, 91**
Pilchuck Glass School, ix, **3**, 5, 9, 12, 14–15, 32, 35, 37; description and founding of, 1; faculty, 1; hot shop, 38
Punty, 6

Rhode Island School of Design, 2, 106
Roorbach, Carol, **56**–61; photographed art works, **57–58**
Ruffner, Ginny, **28**–33; photographed

art works, **29, 31**
Saggar, 45
Schick, Marjorie, 128
Schulman, Norman, 2
Senska, Frances, 40
Shaner, David, 41, 58
Shunga woodblock prints, 69, 72
Signoretto, Pino, 1, 38
Siler, Patrick, 96, **98–103**; photographed art works, **99–100, 103**
Slemmons, Kiff, **114–119**; photographed art works, **115, 117**
Solberg, Ramona, ix, 119, 138–140, 151, 153; and contemporary jewelry, 105–**107**
Southern Illinois University (Carbondale), 143–144
Sperry, Robert, ix, **40**, 41
Stanwood, Washington. *See* Pilchuck Glass School
Stoneware: teapots, Yixing and heart-shaped, **63**–67; wood-fired (functional), 40, 58–59, 61
Studio-glass movement, founding of, 2

Tagliapietra, Lino, 1; collaboration with Dale Chihuly, 2
Takamori, Akio, 51, **68–73**, 78; photographed art works, **69–71**
Takehara, John, 41, 47
Teapots, Yixing and heart-shaped, **63**–67
Toledo Museum of Art, and studio-glass movement, 2
Troutner, Ann, 26

University of California (Berkeley), 25, 41, 101–102, 132
University of California (Davis), 64, 66, 91
University of Montana (Missoula), 41, 75, 76, 77
University of Washington (Seattle), 2, 41, 91, 105–106, 111–112, 138, 140, 145, 150
University of Wisconsin (Madison), and hot-glass program, 2

Venetian bubble technique. *See* Double-bubble technique
Venetian glass: beads, 30; goblets, 1; industry, 2
Venini Glass Factory (Murano, Italy), 2
Voulkos, Peter, 40–41, 58, 59, 101

Warashina, Patti, ix, **39**, 41, 90
Washington artists: Baker-Wood, Florence, **108–113**; Blomdahl, Sonja, **4–9**; Cory, Ken, **130–135**; Hall, Laurie, **136–141**; Ho, Ron, **148–153**; Hu, Mary Lee, **142–147**; Kirkpatrick, Joey, **10–15**; Mace, Flora, **10–15**; Marioni, Paul, **22–27**; Morris, William, **34–38**; Perrigo, Anne, **86–91**; Ruffner, Ginny, **28–33**; Siler, Patrick, **98–103**; Slemmons, Kiff, **114–119**; Takamori, Akio, **68–73**
Washington State University (Pullman), 40, 96, 99, 101–102, 132
Weiser, Kurt, 51, 58, 64, 78
Welsh, Bennett, 41

Yanagi, Soetsu, 40, 58, 59
Yixing ware (teapots), **63–67**

Many other fascinating books are available from Alaska Northwest Books™.
Ask at your favorite bookstore or write us for a free catalog.

Alaska Northwest Books™
A division of GTE Discovery Publications, Inc.
P.O. Box 3007
Bothell, Washington 98041–3007
Call toll-free 1–800–343–4567